THE ART OF
Trover™
SAVES tHE UNIVErSE

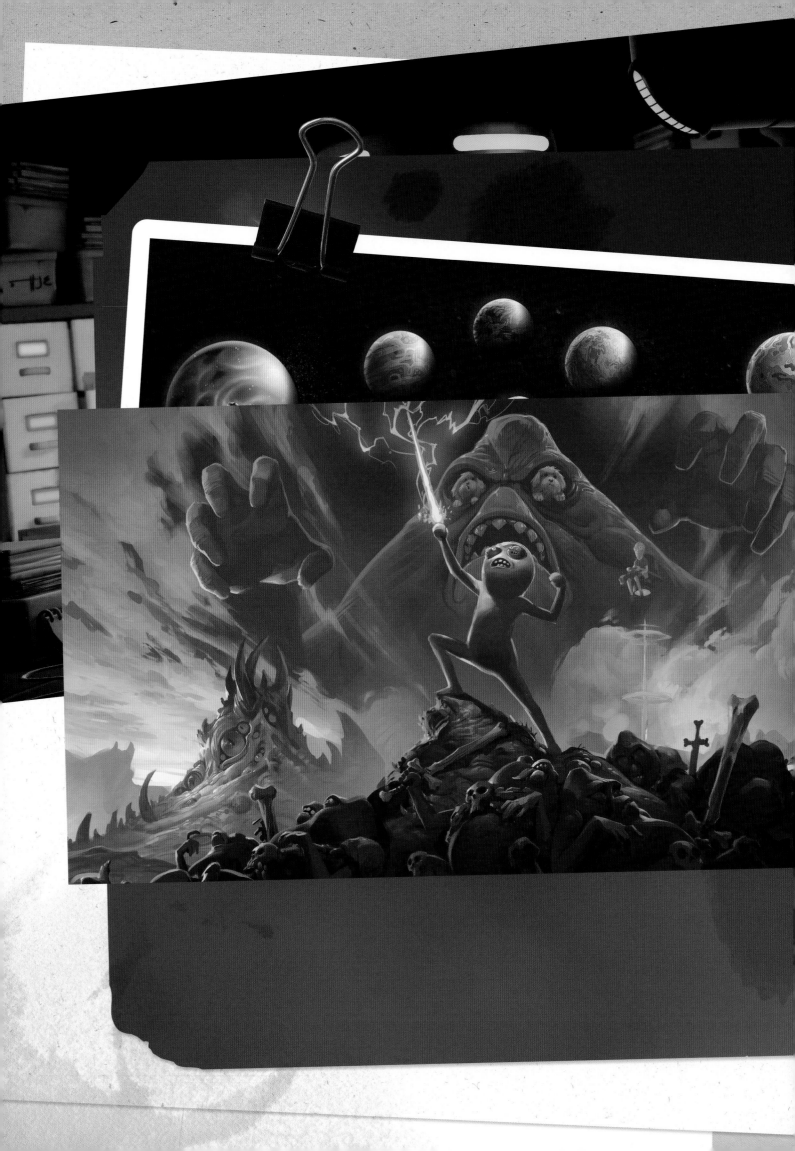

THE ART OF
Trover™
SAVES the UNiVERSE

DARK HORSE BOOKS

publisher **Mike Richardson**
editor **Ian Tucker**
associate editor **Brett Israel**
designers **Anita Magaña**, and **Ethan Kimberling**,
Justin Couch, May Hijikuro
digital art technician **Josie Christensen**

Special thanks to Zoe Morgan,
and JD Cragg at Squanch Games.

THE ART OF TROVER SAVES THE UNIVERSE

Published by Dark Horse Books
A division of Dark Horse Comics LLC

10956 SE Main Street
Milwaukie, OR 97222
DarkHorse.com

f Facebook.com/DarkHorseComics

Twitter.com/DarkHorseComics

First edition: May 2022
Ebook ISBN 978-1-50671-641-1
Hardcover ISBN 978-1-50671-640-4

10 9 8 7 6 5 4 3 2 1
Printed in China

Table of Contents

Introduction 7

Good Guys and Friends 9

Bad Guys and Jerks 35

Gizmos 55

The Universe 75

NG EQUIPMENT

ATION? SHOCKING STUDY INDICATES THAT NO, IT IS NOT.

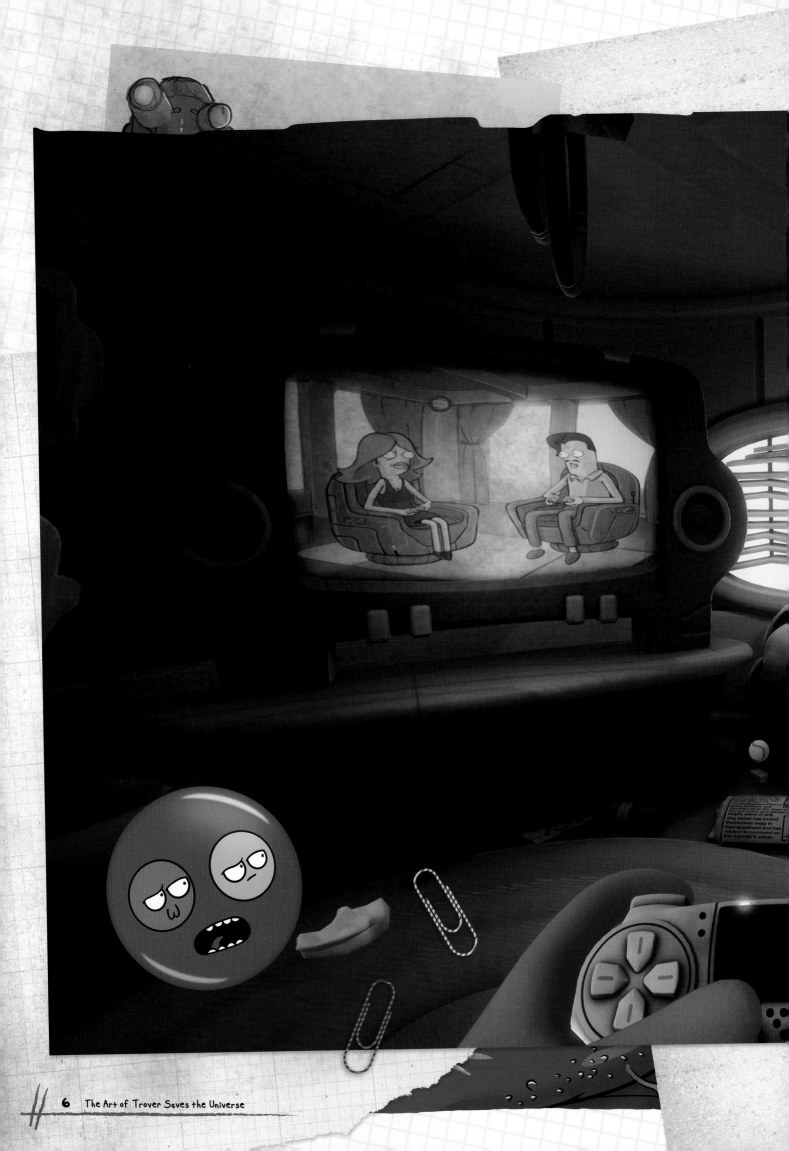

Introduction

GET PUMPED, TROVERHEADS, BECAUSE WE HAVE SOME REAL GOOD SHIT IN STORE FOR YOU.

NEVER-BEFORE-SEEN CONCEPT ART. EARLY DESIGNS. UNUSED IDEAS. GAME DEV SECRETS SO CLASSIFIED EVEN THE C.C.P. DOESN'T KNOW THEM. THIS IS SQUANCH GAMES' FIRST BIG TITLE, AND WE'RE THRILLED TO FINALLY COLLECT ALL THIS INCREDIBLE ARTWORK IN ONE PLACE FOR FANS LIKE YOU. PRESUMABLY YOU'RE A FAN, OR IT'S WEIRD THAT YOU'RE HOLDING THIS ART BOOK. IF YOU AREN'T A TROVER FAN, WELL, STICK AROUND BECAUSE WE MIGHT JUST WIN YOU OVER. I'M NUPPET THE NEPTOID AND I'LL BE YOUR GUIDE! THIS IS GONNA BE A WHOLE BIG ADVENTURE!

CHAIR UPGRADES

Good Guys and Friends

BIT OF A MISNOMER. "GOOD GUYS AND FRIENDS"? MORE LIKE *"JERKS AND...MORE JERKS."* YEAH, SURE, SOME OF THESE GUYS ARE KINDA HELPFUL, BUT THE REST ARE JUST NOT TRYING TO *KILL YOU*, AND THAT'S A PRETTY LOW BAR FOR A FRIEND. HECK, *TROVER* EVEN GETS TO MURDER SOME OF THEM! HARDLY B.F.F. BEHAVIOR.

ANYWAYS, THE NARRATIVE STRUCTURE OF THIS GAME GOT STREAMLINED A BIT. ORIGINALLY EVERY LEVEL WAS GONNA BE LIKE SHLEEMY WORLD, AND GIVE THE PLAYER A BRANCHING CHOICE WITH TWO EQUALLY UNPLEASANT OPTIONS. SO, THERE WERE GOING TO BE EVEN MORE N.P.C.'S LIKE *MR. POPUP* AND *VOODOO PERSON* THAT BESTOW MORALLY GRAY MISSIONS TO IGNORE. DIALING IT BACK WAS SMART. WE HAVE ENOUGH "FRIENDS" AS IT IS. TO BE DANGEROUS. LIKE, REALLY DANGEROUS. ANYWAY. ON WE GO.

BY THE WAY, I SAID READING THIS BOOK WAS GOING TO BE AN ADVENTURE A SECOND AGO. WHAT I DIDN'T MENTION IS THAT IT'S GOING TO BE DANGEROUS. LIKE, *REALLY* DANGEROUS. ANYWAY. ON WE GO.

TRUMMAR

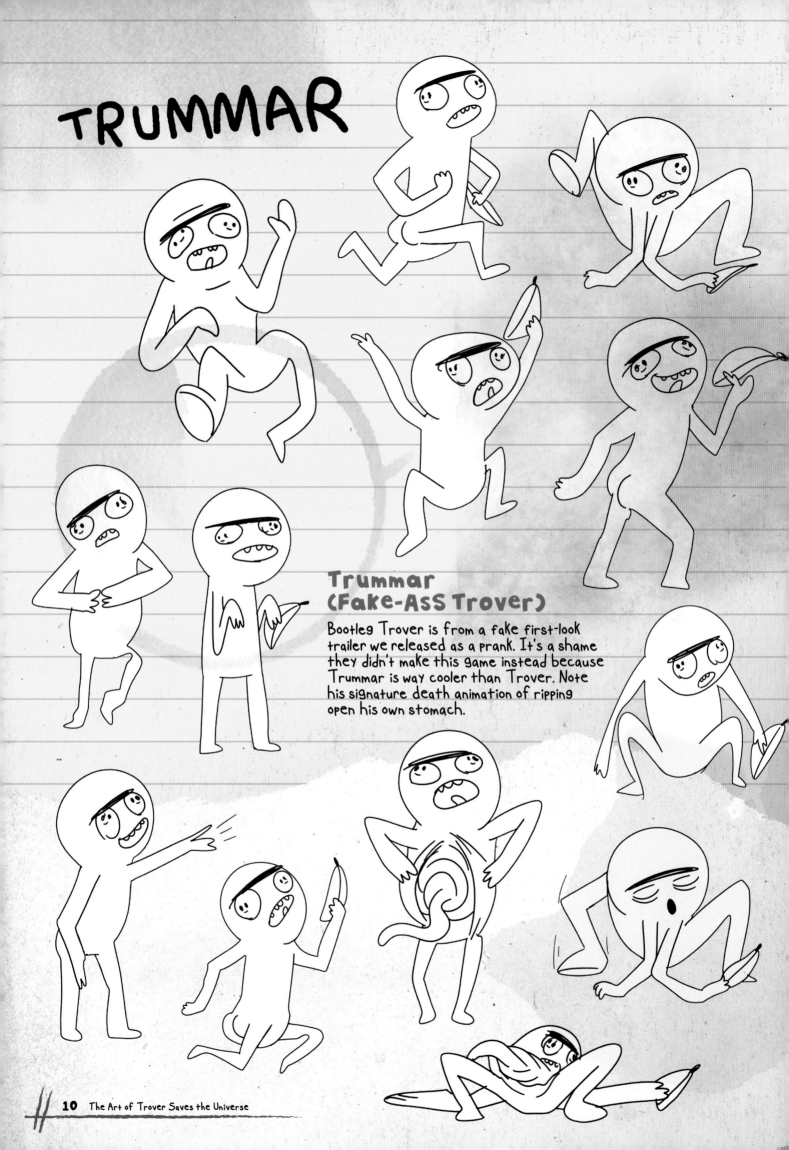

Trummar
(Fake-Ass Trover)

Bootleg Trover is from a fake first-look trailer we released as a prank. It's a shame they didn't make this game instead because Trummar is way cooler than Trover. Note his signature death animation of ripping open his own stomach.

Trover

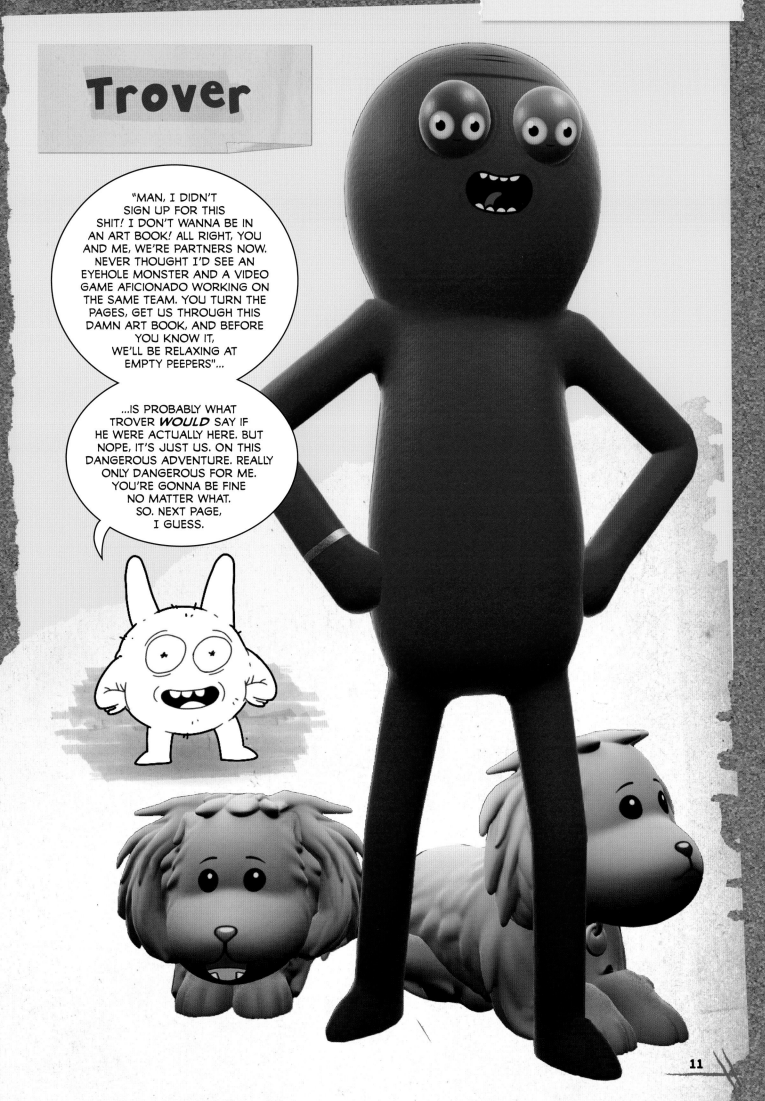

"MAN, I DIDN'T SIGN UP FOR THIS *SHIT!* I DON'T WANNA BE IN AN ART BOOK! ALL RIGHT, YOU AND ME, WE'RE PARTNERS NOW. NEVER THOUGHT I'D SEE AN EYEHOLE MONSTER AND A VIDEO GAME AFICIONADO WORKING ON THE SAME TEAM. YOU TURN THE PAGES, GET US THROUGH THIS DAMN ART BOOK, AND BEFORE YOU KNOW IT, WE'LL BE RELAXING AT EMPTY PEEPERS"...

...IS PROBABLY WHAT TROVER *WOULD* SAY IF HE WERE ACTUALLY HERE. BUT NOPE, IT'S JUST US. ON THIS DANGEROUS ADVENTURE. REALLY ONLY DANGEROUS FOR ME. YOU'RE GONNA BE FINE NO MATTER WHAT. SO. NEXT PAGE, I GUESS.

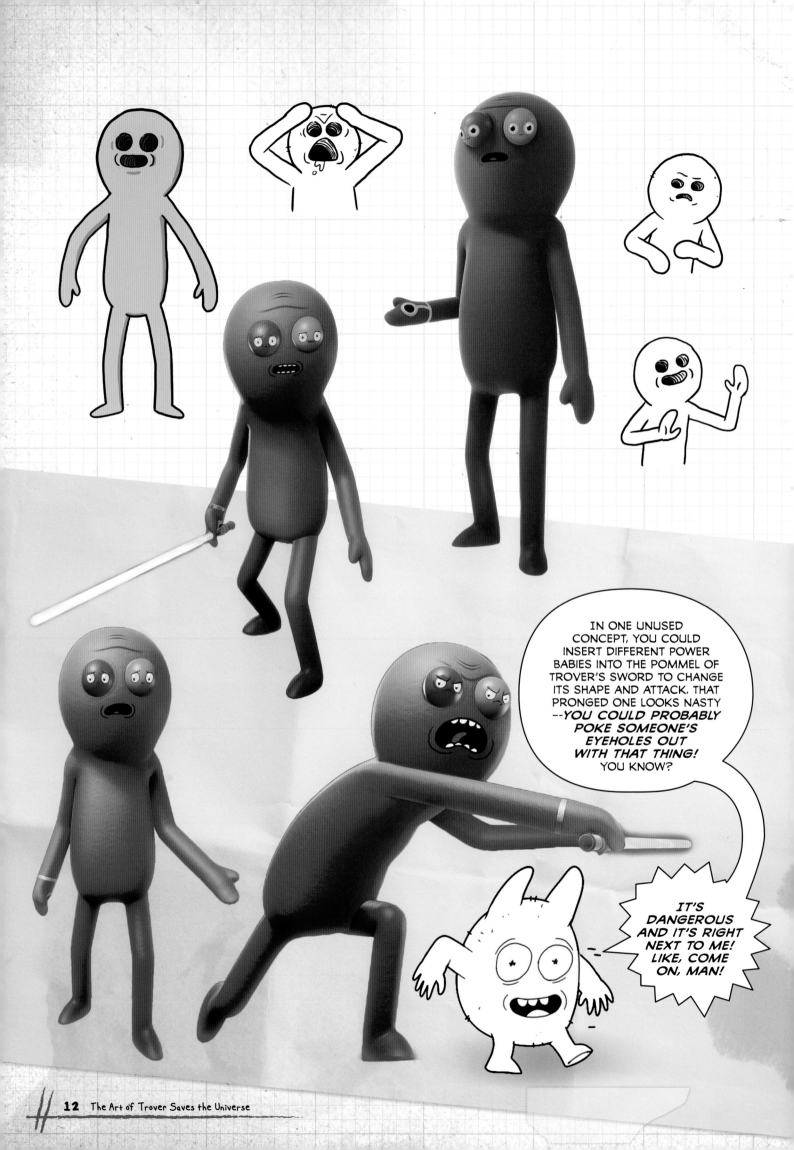

IN ONE UNUSED CONCEPT, YOU COULD INSERT DIFFERENT POWER BABIES INTO THE POMMEL OF TROVER'S SWORD TO CHANGE ITS SHAPE AND ATTACK. THAT PRONGED ONE LOOKS NASTY --*YOU COULD PROBABLY POKE SOMEONE'S EYEHOLES OUT WITH THAT THING!* YOU KNOW?

IT'S DANGEROUS AND IT'S RIGHT NEXT TO ME! LIKE, COME ON, MAN!

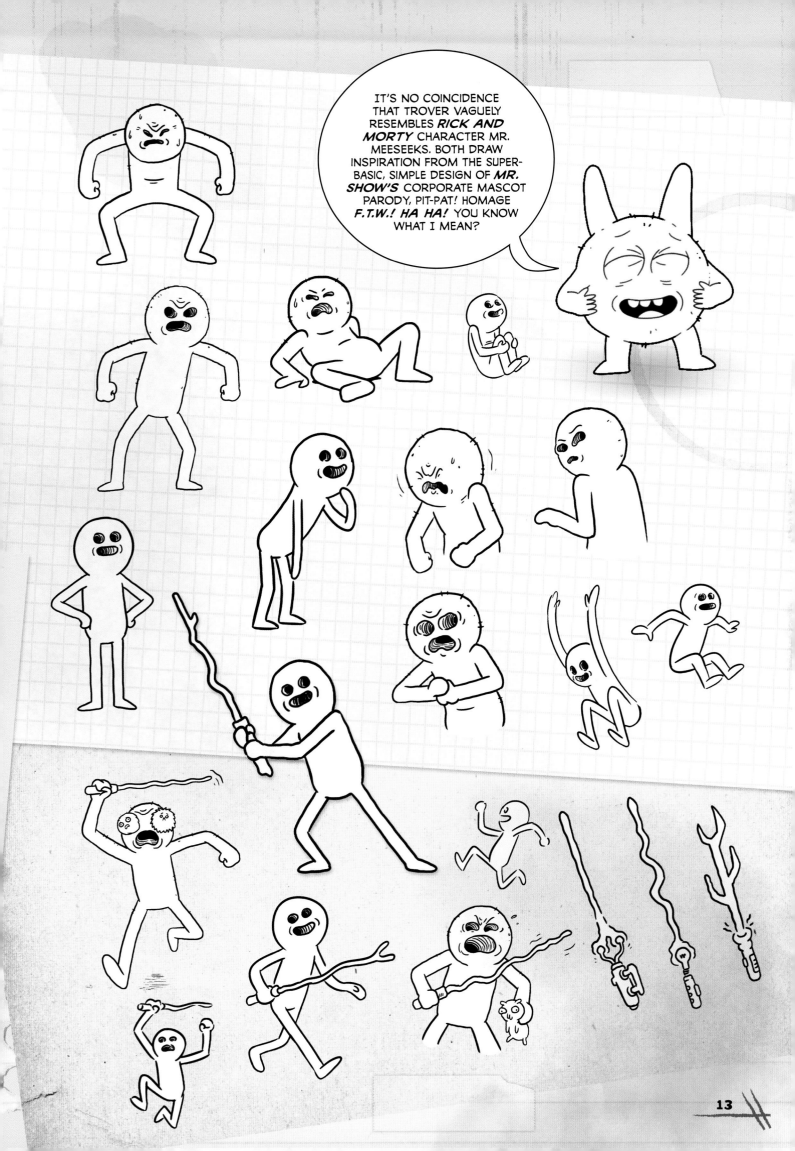

13

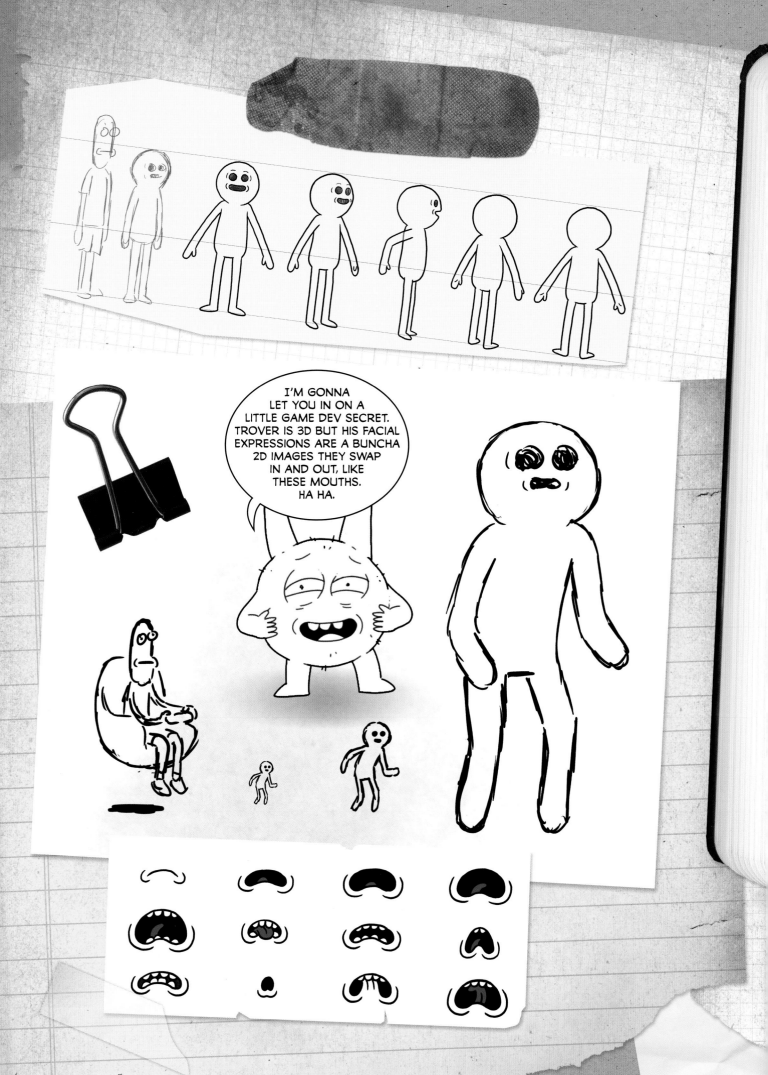

Cavity Holes

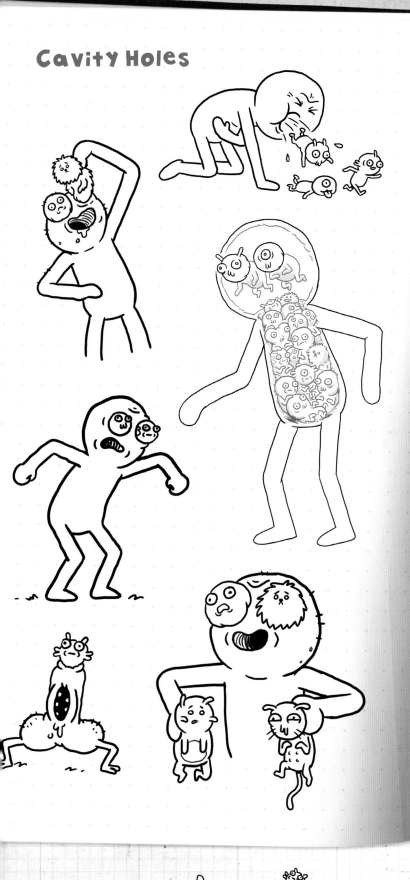

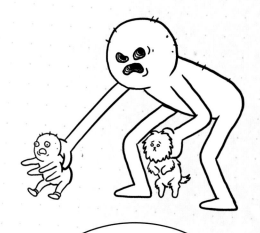

HERE'S WHERE TROVER CRAMS THOSE RED POWER BABIES. AT ONE POINT THEY TESTED OUT A COLOR-CHANGING TROVER THAT DISPLAYED YOUR CURRENT H.P. BY FILLING UP WITH BABIES, GRADUALLY TURNING RED FROM HIS TOES TO HIS HEAD. CRIMSON TROVER: THAT WOULDA BEEN WEIRD, HUH? ALL BLOODY LOOKING.

NO WAY, JOSE! WAIT...IS IT OKAY TO SAY THAT? I DIDN'T MEAN OFFENSE. GONNA HAVE TO LOOK UP THE ETYMOLOGY ON THAT OLD PHRASE AND MAKE SURE IT DOESN'T COME FROM IMPURE ORIGINS. I'LL LET YOU KNOW WHAT I FIND OUT. LET'S KEEP GOING.

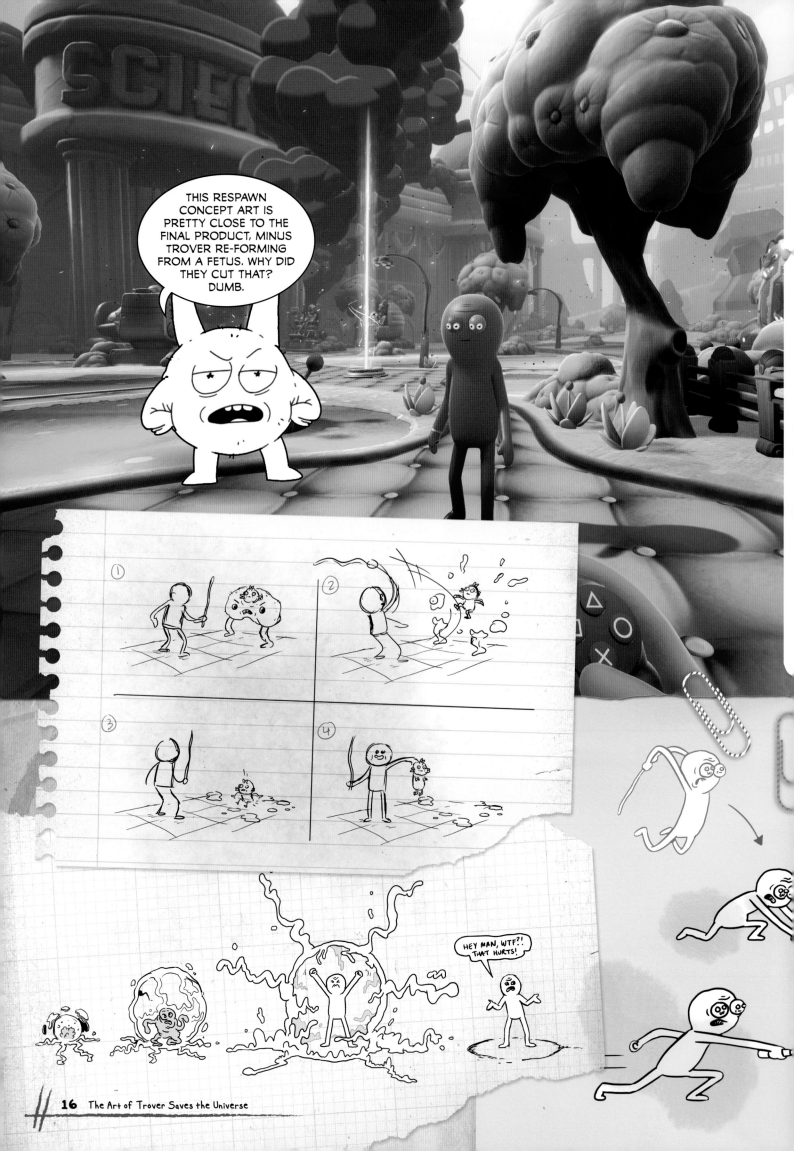

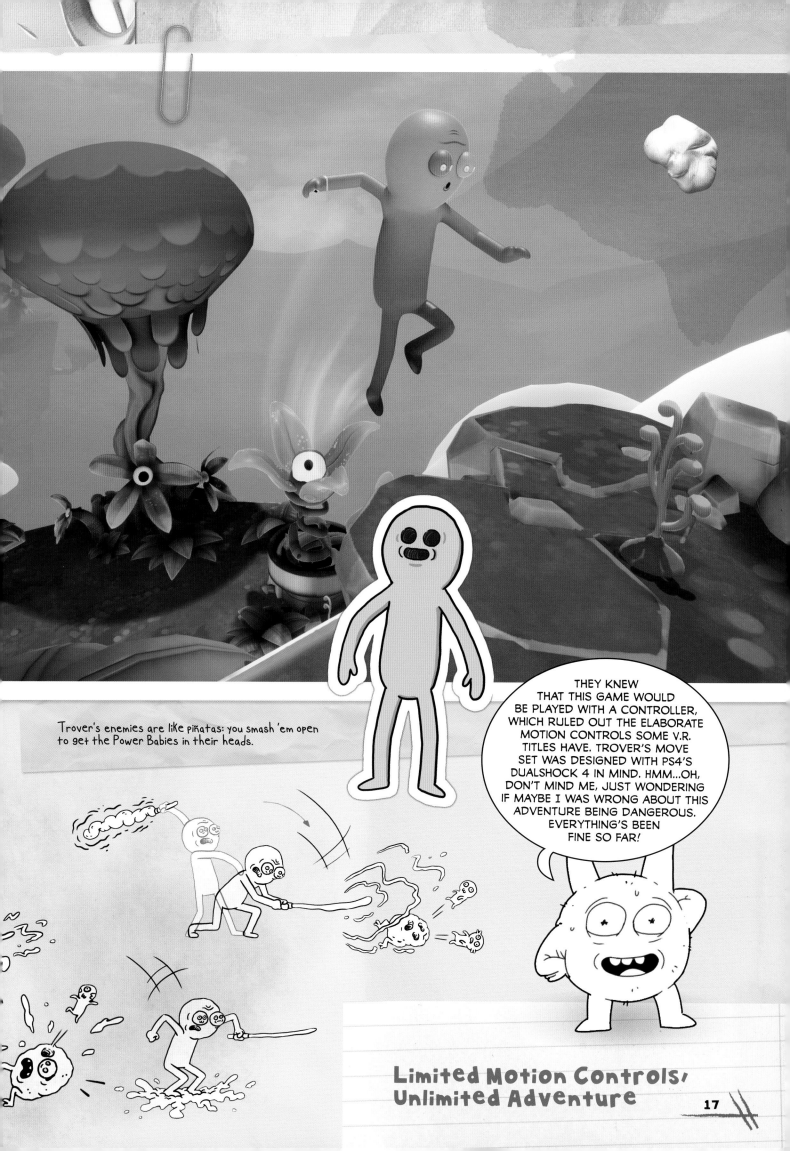

Trover's enemies are like piñatas: you smash 'em open to get the Power Babies in their heads.

THEY KNEW THAT THIS GAME WOULD BE PLAYED WITH A CONTROLLER, WHICH RULED OUT THE ELABORATE MOTION CONTROLS SOME V.R. TITLES HAVE. TROVER'S MOVE SET WAS DESIGNED WITH PS4'S DUALSHOCK 4 IN MIND. HMM...OH, DON'T MIND ME, JUST WONDERING IF MAYBE I WAS WRONG ABOUT THIS ADVENTURE BEING DANGEROUS. EVERYTHING'S BEEN FINE SO FAR!

Limited Motion Controls, Unlimited Adventure

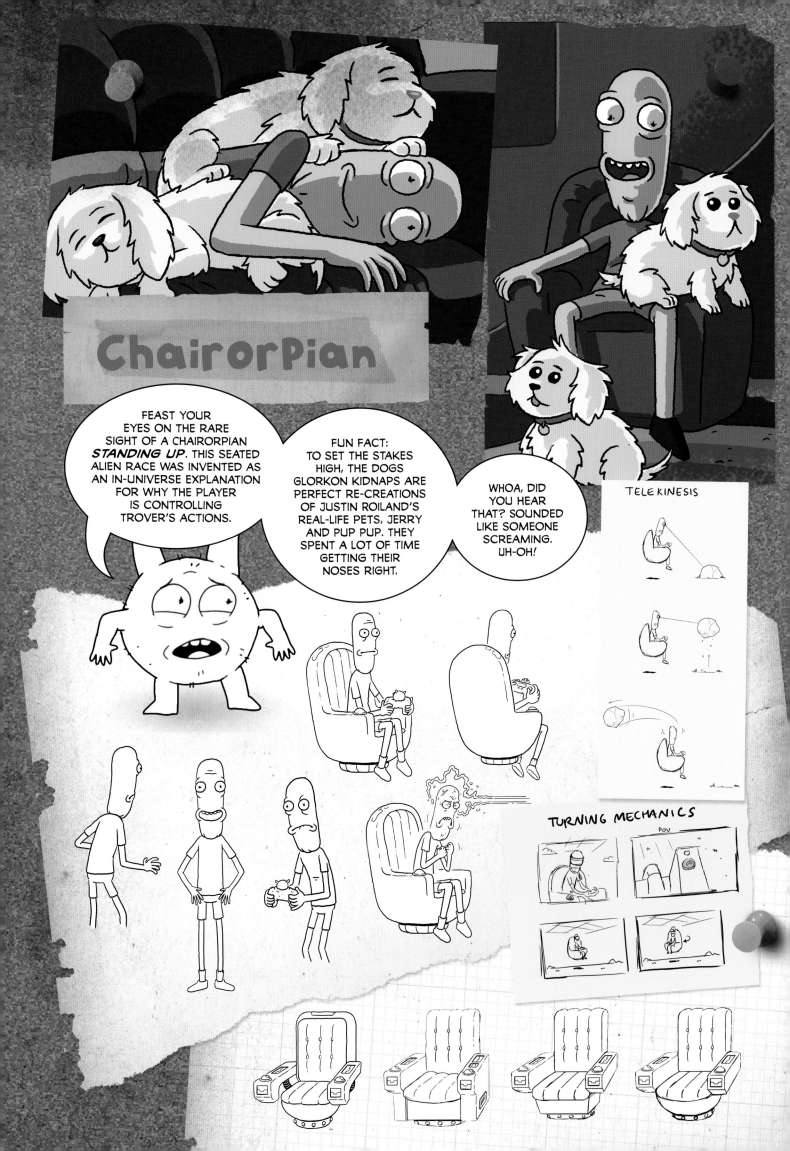

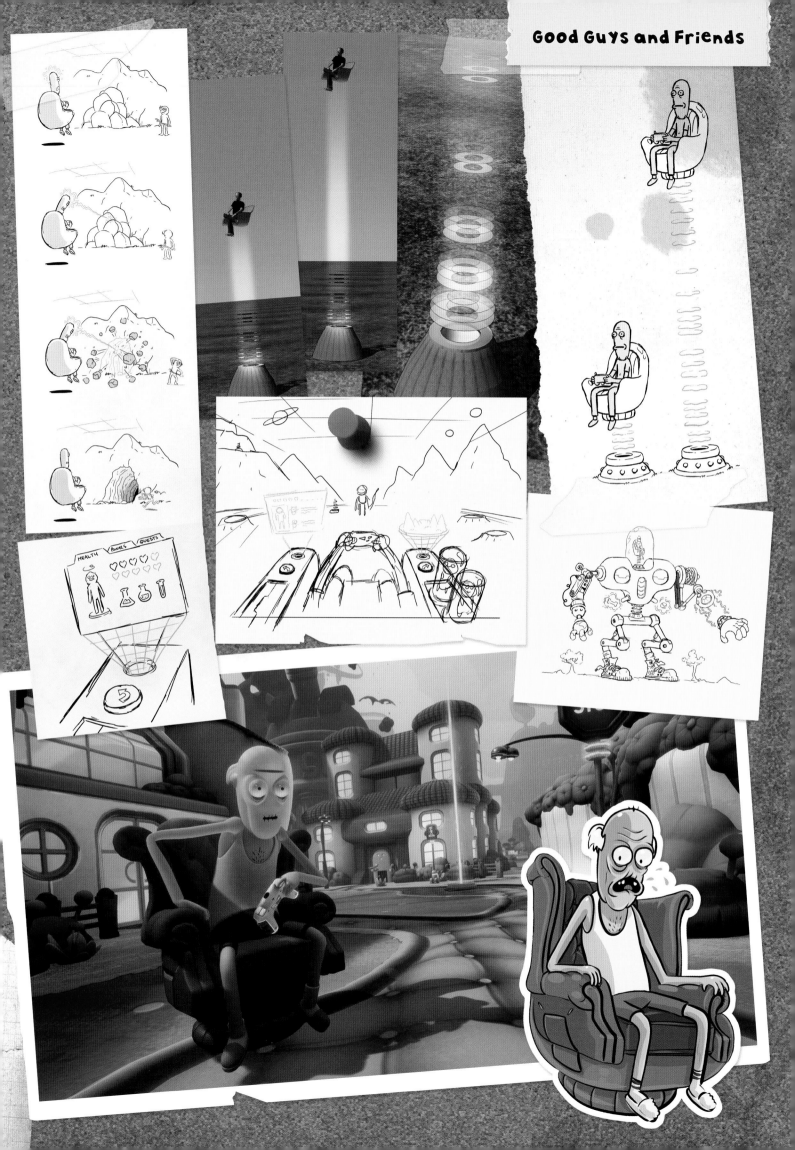

Quest Givers

AH GEEZ, IT'S THOSE ASSHOLES THAT KEEP TELLING YOU WHAT TO DO. SQUANCH'S GUIDING PHILOSOPHY FOR DESIGNING QUEST GIVERS WAS THAT THEY'RE ALL FULL OF SHIT. THEY'RE UNRELIABLE, DISHONEST, OR BOTH.

THEY WANTED PLAYERS TO DECIDE WHETHER OR NOT TO TRUST THESE UNTRUSTWORTHY JAGOFFS. SOMETIMES IT'S TEMPTING TO BLOW OFF THEIR QUESTS OR EVEN MURDER THEM. YOU HAVE TO LIVE WITH THE GUILT, THOUGH. THIS UNIBROWED DUDE IS MR. STIFFY, A CUT QUEST GIVER. HIS WHOLE SHTICK WAS THAT HE DIDN'T MOVE (HENCE THE NAME) AND BLOCKED YOUR PATH UNTIL YOU PAID HIM TO GET PAST. ALTHOUGH THE QUEST IS GONE, SHARP-EYED PLAYERS CAN STILL FIND MR. STIFFY IN-GAME AS AN EASTER EGG.

LISTEN, I GOTTA TELL YOU. LOTS OF CREEPY NOISES GOING ON JUST OFF THE PAGES IN HERE. IT'S NOT SOUNDING TOO SAFE.

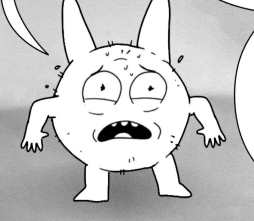

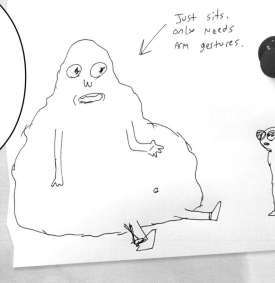

Quest giver for prototype Rough shitty concept.

Just sits. only needs arm gestures.

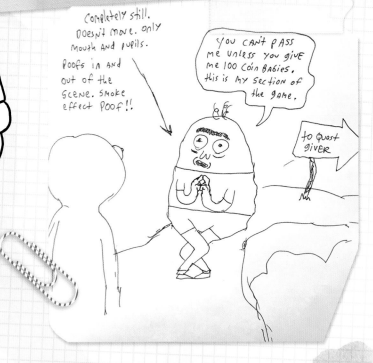

Completely still. Doesn't move. Only mouth and pupils.

Poofs in and out of the scene. smoke effect POOF!!

You can't PASS me unless you give me 100 coin babies. this is my section of the game.

to Quest Giver

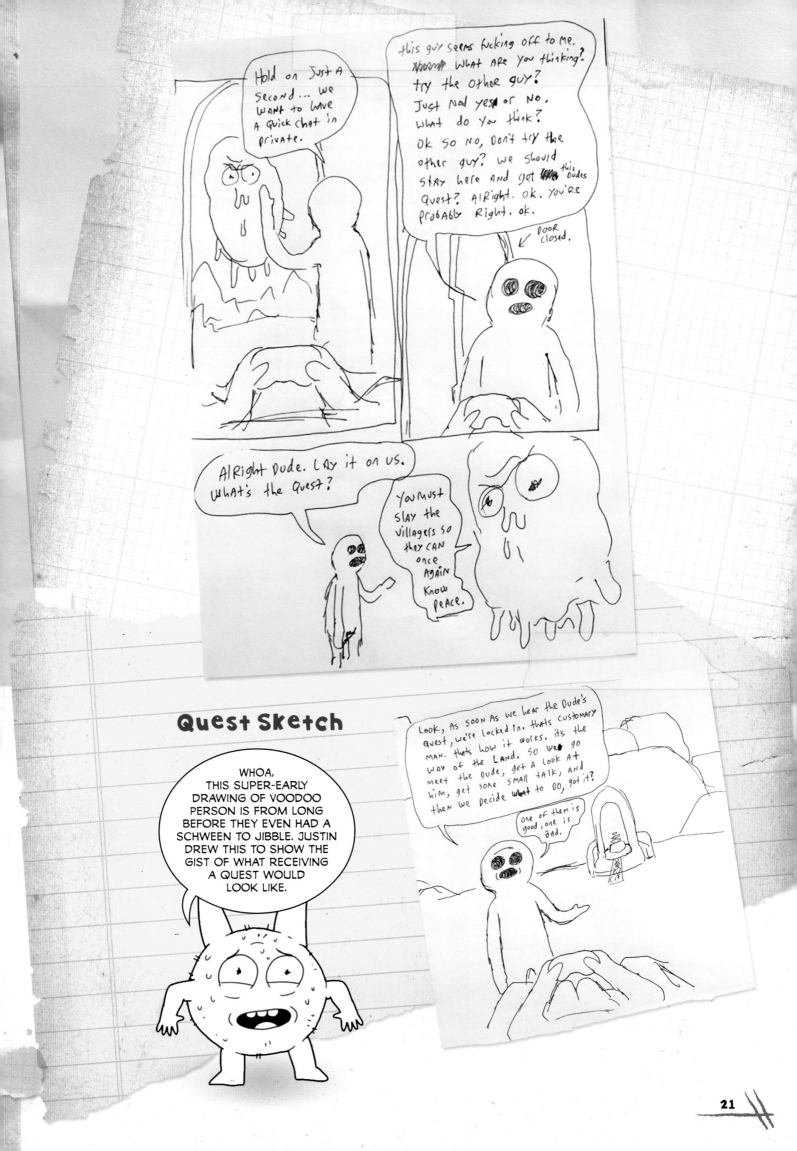

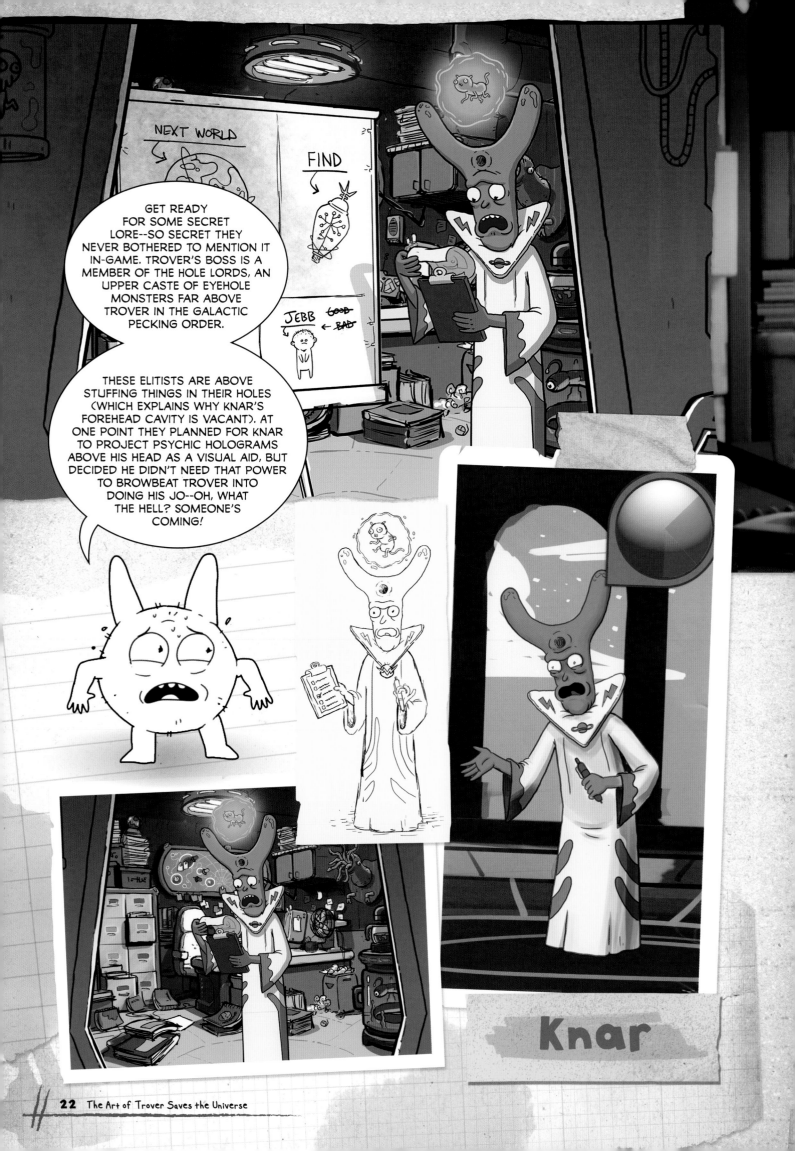

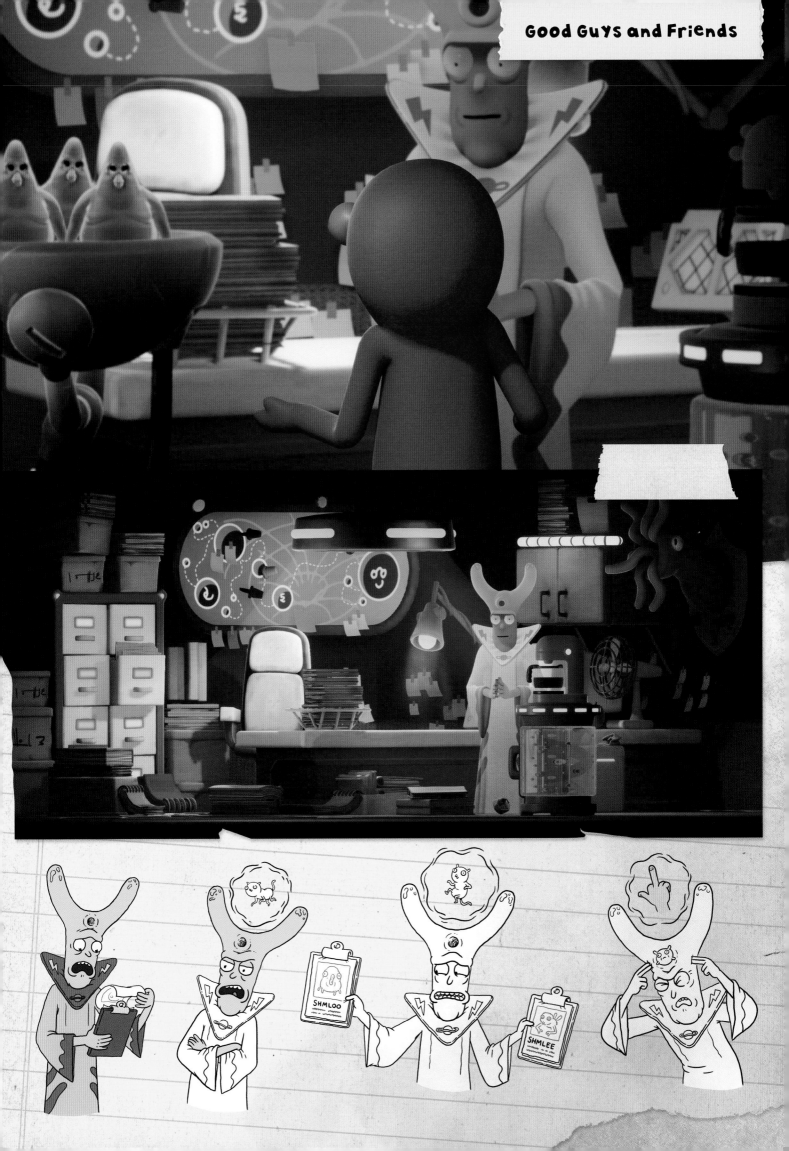

BREAKING NEWS!
GREEN MONSTER STEALS C.S.C. CLONING EQUIPMENT! **LIVE**
IS BREAKDANCING LINKED TO THE DECLINE IN BEE POPULATION? SHOCKING STUDY INDICATES THAT NO, IT IS NOT.

WHO THE HELL ARE YOU?

WHAT? I'M IN THE MIDDLE OF DOING AN ART BOOK.

...UH... OKAY, YEAH, SURE. WHATEVER YOU NEED, ZUPPET. JUST PROMISE TO BE QUIET WHILE I DO ALL THIS.

ALL RIGHT. BACK TO IT: TO CREATE *AS THE CHAIR TURNS*, JUSTIN FIRST RECORDED HIMSELF AS BOTH BICKERING SPOUSES TO LOCK DOWN THE TONE AND DIALOGUE.

I'M ZUPPET THE ZEPTOID. PLEASE JUST LET ME STAY. IT'S NOT SAFE OUT THERE.

PLEASE. I'M *BEGGING* YOU.

OKAY, OKAY, OF COURSE. THANK YOU.

THEN, SAMANTHA'S LINES WERE REPLACED BY VOICE ACTOR CASSIE STEELE, WHO ALSO STARRED AS HALF OF ANOTHER CONTENTIOUS COUPLE: BIRD PERSON'S GIRLFRIEND TAMMY ON *RICK AND MORTY*.

BREAKING NEWS!
GREEN MONSTER STEALS C.S.C. CLONING EQUIPMENT!

CHAIR NEWS

LIVE

IS BREAKDANCING LINKED TO THE DECLINE IN BEE POPULATION? SHOCKING STUDY INDICATES THAT NO, IT IS NOT.

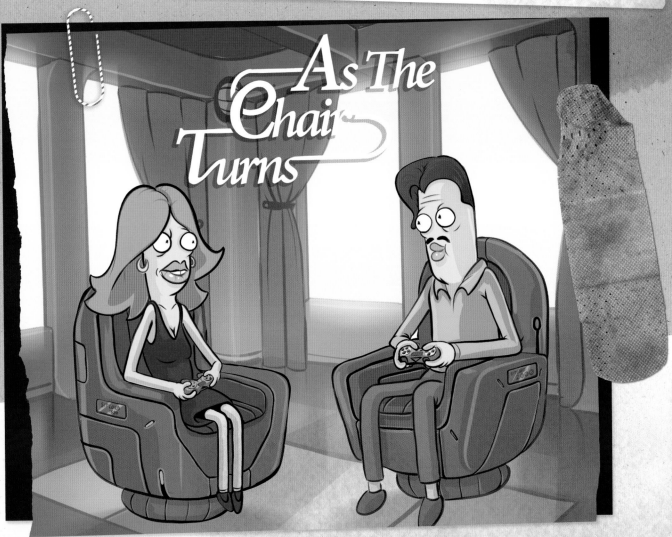

As The Chair Turns

Mr. PoPuP

POPPING YOUR CHAIR UP AND DOWN IS AN ESSENTIAL SKILL, BUT PLAYTESTERS WERE HAVING TROUBLE GRASPING HOW TO USE IT. SQUANCH'S SOLUTION WAS TO ADD THIS TUTORIAL CHARACTER TO SHOUT THE LESSON IN YOUR FACE.

THEY ALSO MADE MR. POPUP ANNOYING AS HELL, SO THE PLAYER WOULD HAVE A REASON TO KILL HIM AT THE END OF THE LEVEL.

SERVES THAT PRICK RIGHT FOR WITHHOLDING THE CRYSTAL OF ITHACLES!

OH, UH. YEAH, I GUESS SO. HEY, I REALLY DO NEED YOU TO STAY QUIET IF YOU WANT TO STAY ON THE PAGE WITH ME.

SORRY. YEAH, GOT IT. SO SORRY.

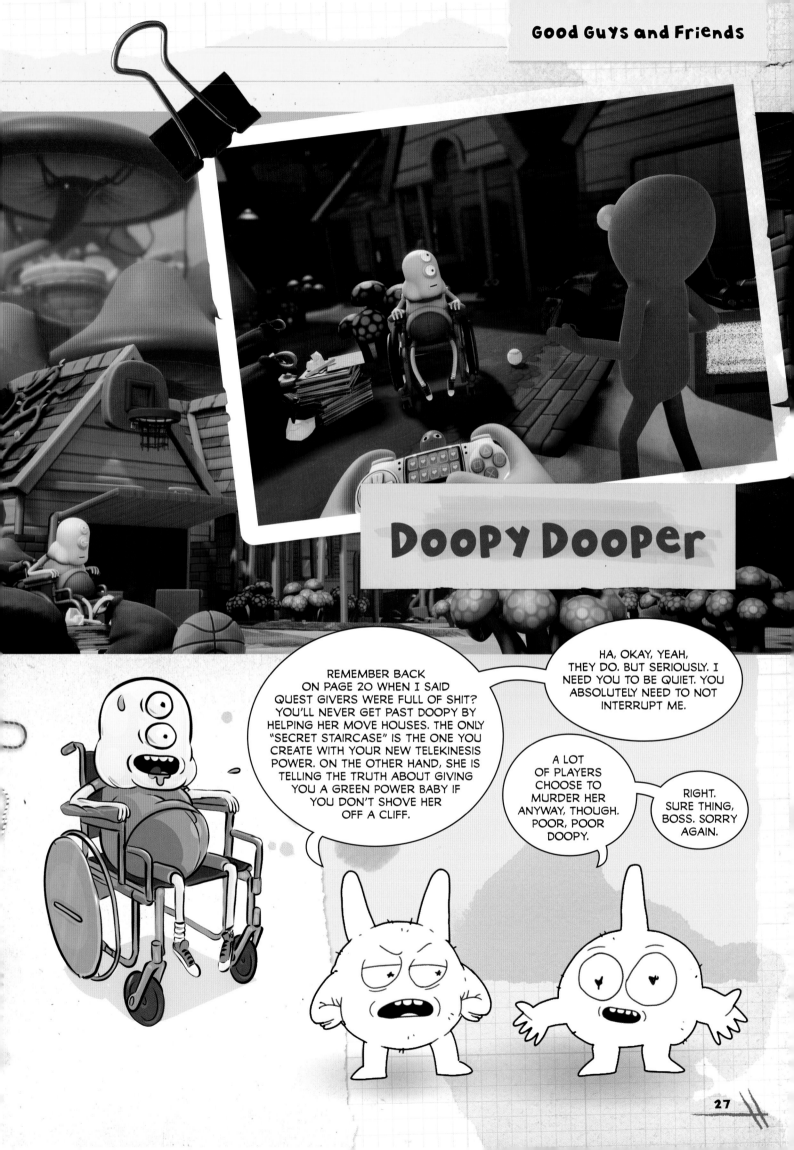

Doopy Dooper

REMEMBER BACK ON PAGE 20 WHEN I SAID QUEST GIVERS WERE FULL OF SHIT? YOU'LL NEVER GET PAST DOOPY BY HELPING HER MOVE HOUSES. THE ONLY "SECRET STAIRCASE" IS THE ONE YOU CREATE WITH YOUR NEW TELEKINESIS POWER. ON THE OTHER HAND, SHE IS TELLING THE TRUTH ABOUT GIVING YOU A GREEN POWER BABY IF YOU DON'T SHOVE HER OFF A CLIFF.

HA, OKAY, YEAH, THEY DO. BUT SERIOUSLY. I NEED YOU TO BE QUIET. YOU ABSOLUTELY NEED TO NOT INTERRUPT ME.

A LOT OF PLAYERS CHOOSE TO MURDER HER ANYWAY, THOUGH. POOR, POOR DOOPY.

RIGHT. SURE THING, BOSS. SORRY AGAIN.

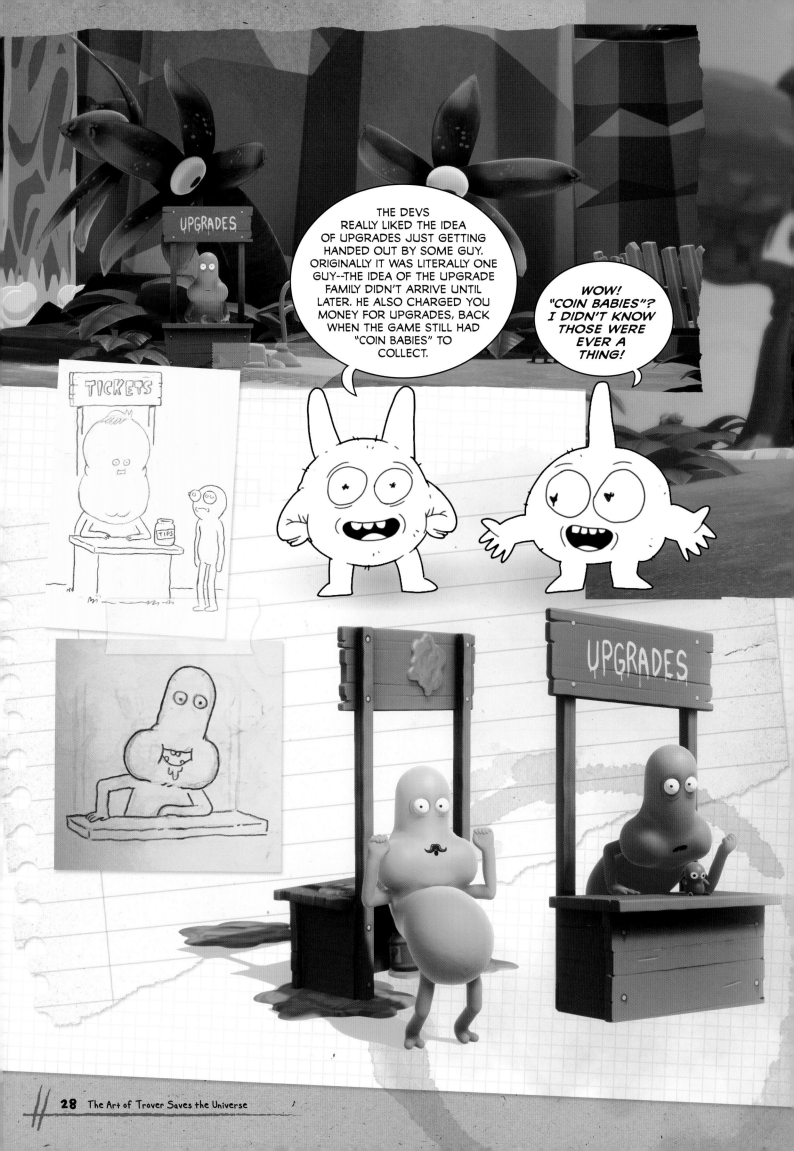

Upgrades

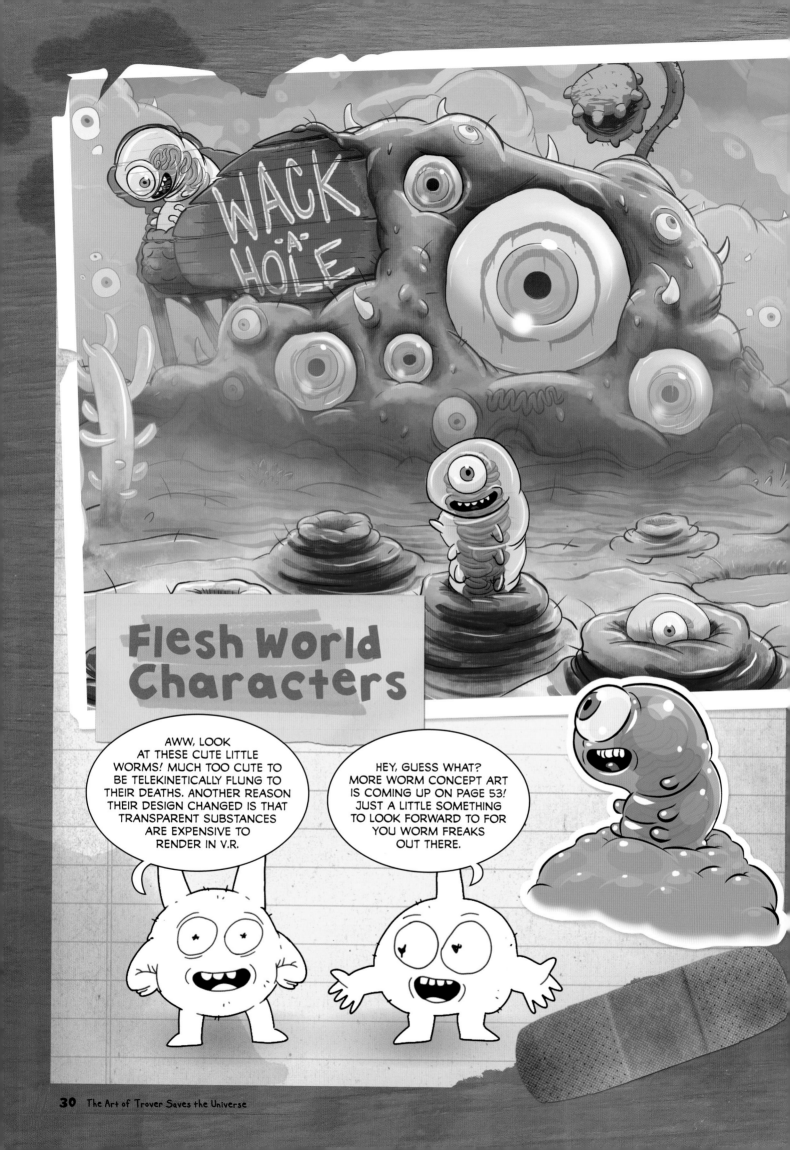

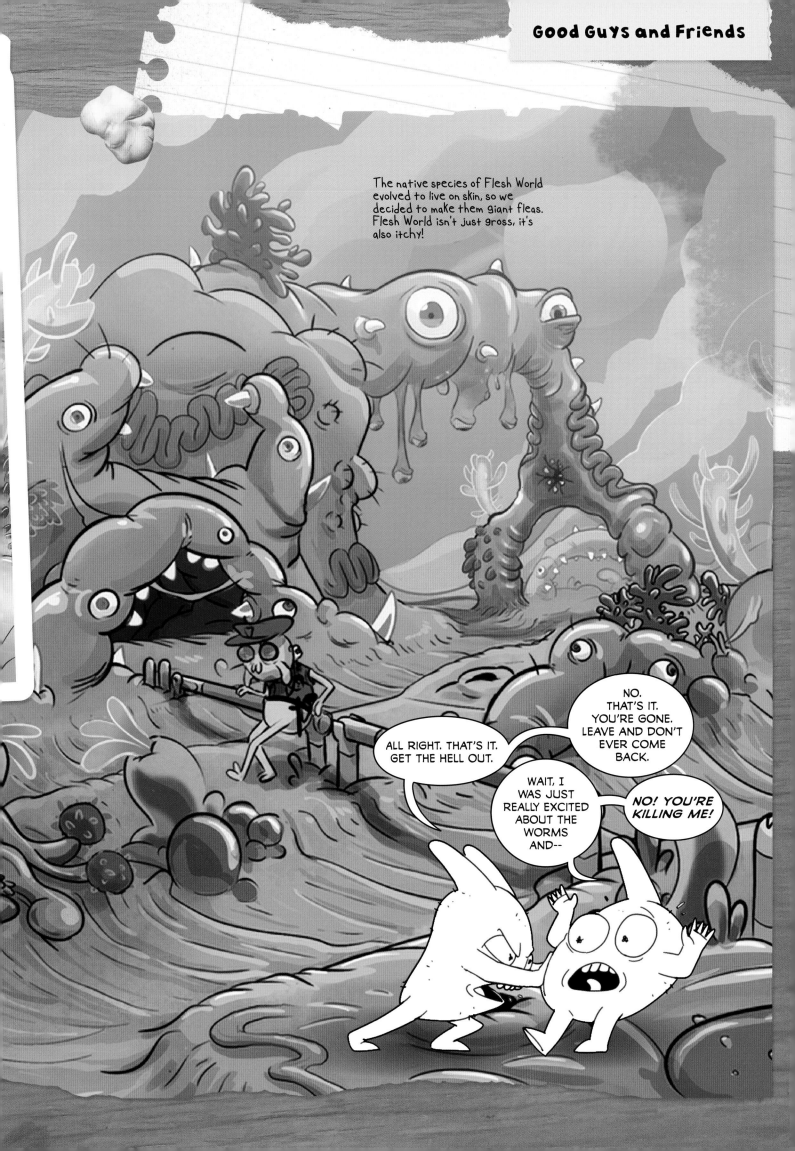

Fat Little Jerk

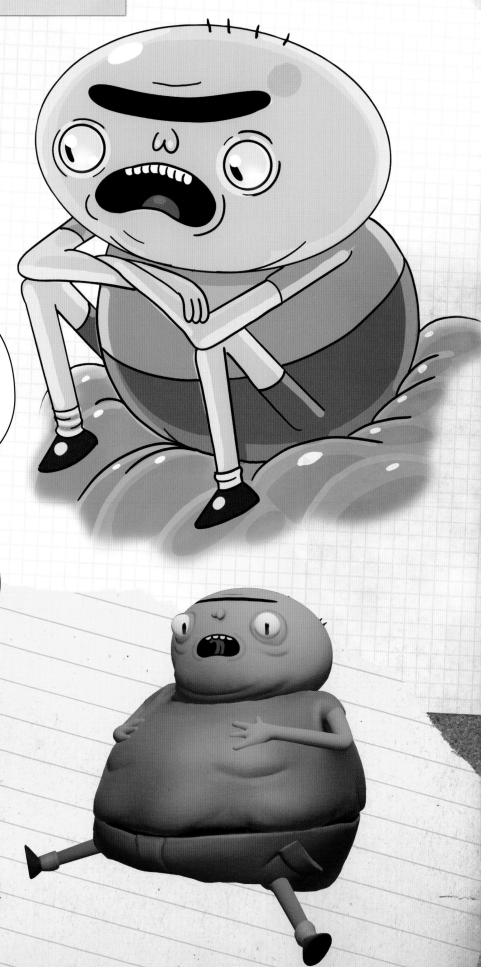

BEFORE THIS GUY WAS A GUY, THEY ORIGINALLY ENVISIONED HIM AS SOME KIND OF ANIMAL YOU OVERFEED TO DEATH. THAT'S FROM WHEN FLESH WORLD WAS ACTUALLY A ZOO, NOT A PRISON DISGUISED AS A ZOO. MAN, THAT LEVEL SURE GOT CHANGED UP A LOT. GOOD THING FAT LITTLE JERK CAN TALK, SO HE CAN SCREAM WHICH COLOR NUMMY NUM-NUMS HE WANTS IN HIS TUM-TUM.

GEEZ, YOU DIDN'T HEAR THAT SCREAM, DID YOU? I'M SURE IT WASN'T ZUPPET. ZUPPET IS FINE. BESIDES, WHAT WAS I SUPPOSED TO DO? HE WOULDN'T SHUT UP! I HAVE A JOB TO DO! IT'S ZUPPET'S OWN DAMN FAULT IF HE GOT HURT. BUT HE DEFINITELY DIDN'T.

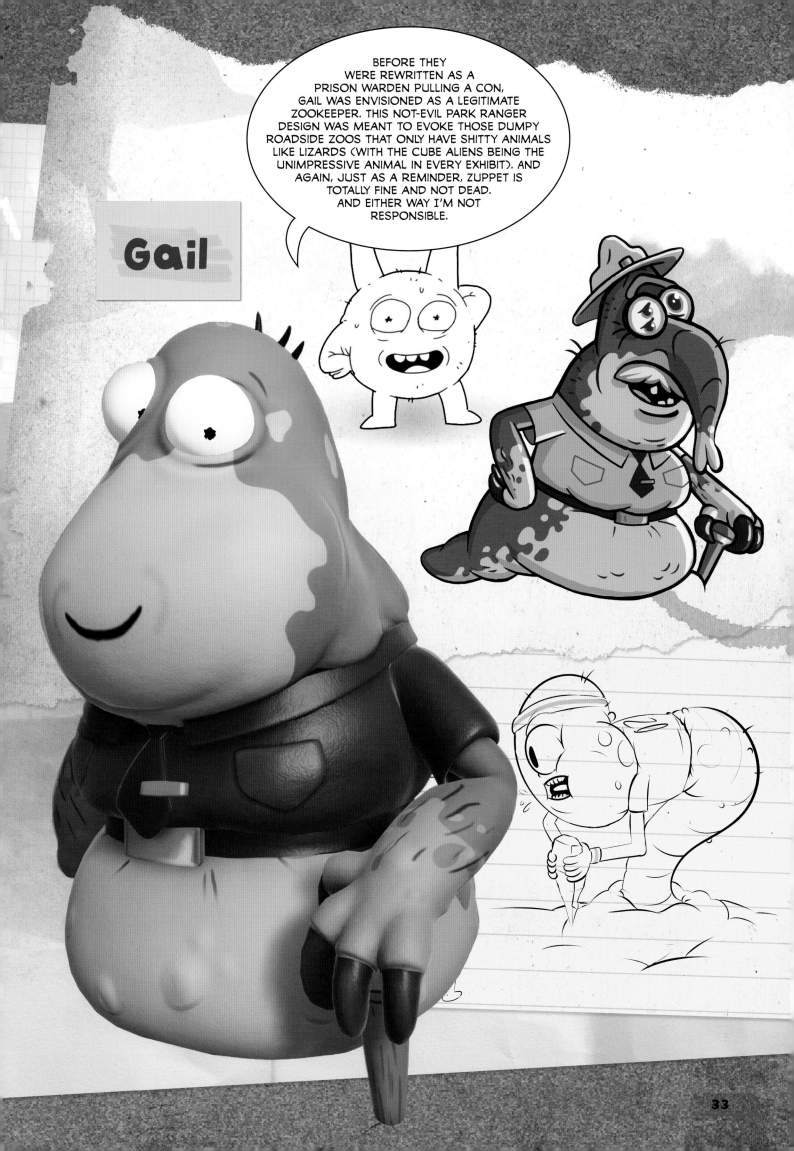

Bad Guys and Jerks

OKAY, SO THE "GOOD GUYS AND FRIENDS" THING FROM BEFORE MAKES MORE SENSE WHEN YOU COMPARE THOSE GUYS TO THESE GUYS. FOR YOU TO UNDERSTAND THE ENEMY DESIGN, THE ORIGINAL PURPOSE OF EYEHOLE CREATURES MUST BE REVEALED--WHERE THE WHOLE IDEA FOR HOLES CAME FROM. PREPARE YOURSELF FOR SOME TOP-SECRET KNOWLEDGE: THIS GAME WAS ORIGINALLY THOUGHT UP AS A FIRST-PERSON V.R. SHOOTER. INSTEAD OF A SWORD, TROVER HAD A GUN AND HE'D BLAST THE POWER BABIES OUT OF BAD GUYS' HEADS.

A REAL TEST OF MARKSMANSHIP TO HIT THOSE EYE SOCKETS. THAT VERSION OF THE GAME NEVER EVEN GOT PROTOTYPED, BUT THEY LOVED THE LOOK OF THE EYEHOLE CREATURES AND REPURPOSED THEM AFTER THE CHANGE TO THIRD-PERSON COMBAT. HEY. I SEE YOU LOOKING AT ME LIKE THAT. IT'S NOT MY FAULT IF ZUPPET DIED. GOD...I HOPE HE'S OKAY, THOUGH... WHAT IF HE *IS* DEAD? OH, NO...DID I GET HIM KILLED? WHAT IF HE DIED AND IT'S MY FAULT?

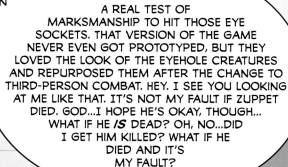

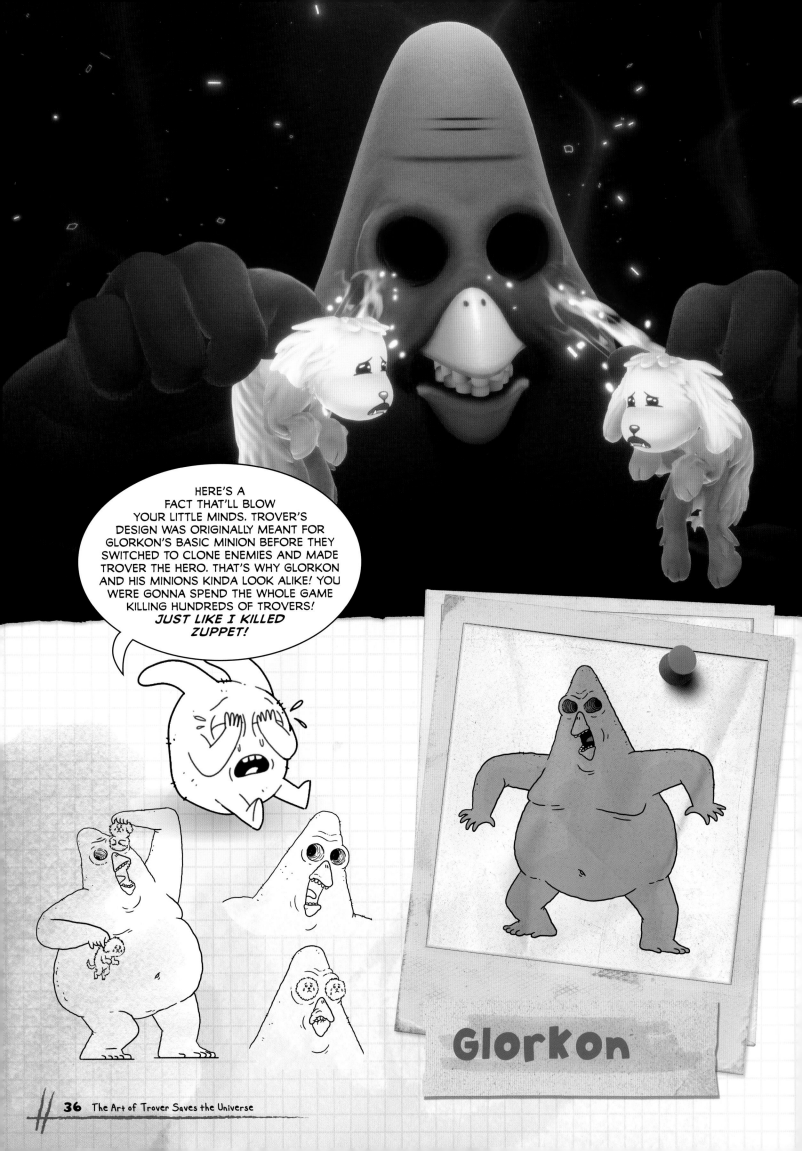

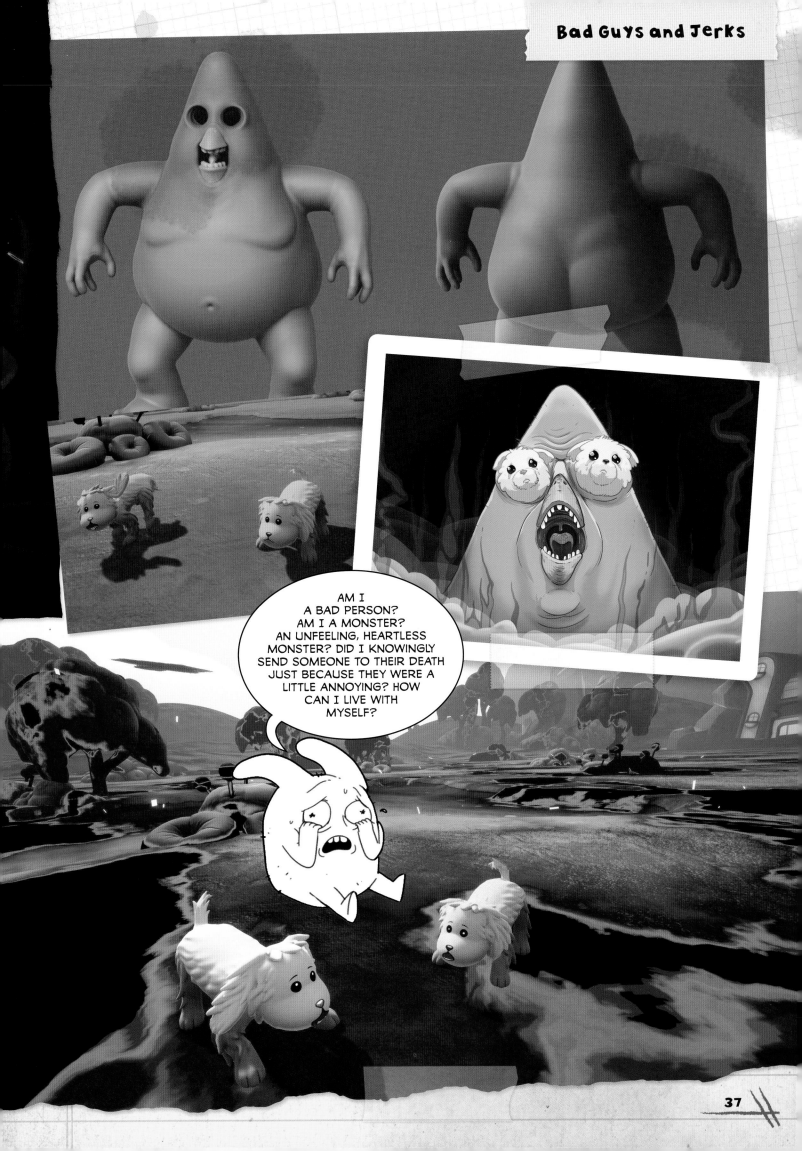

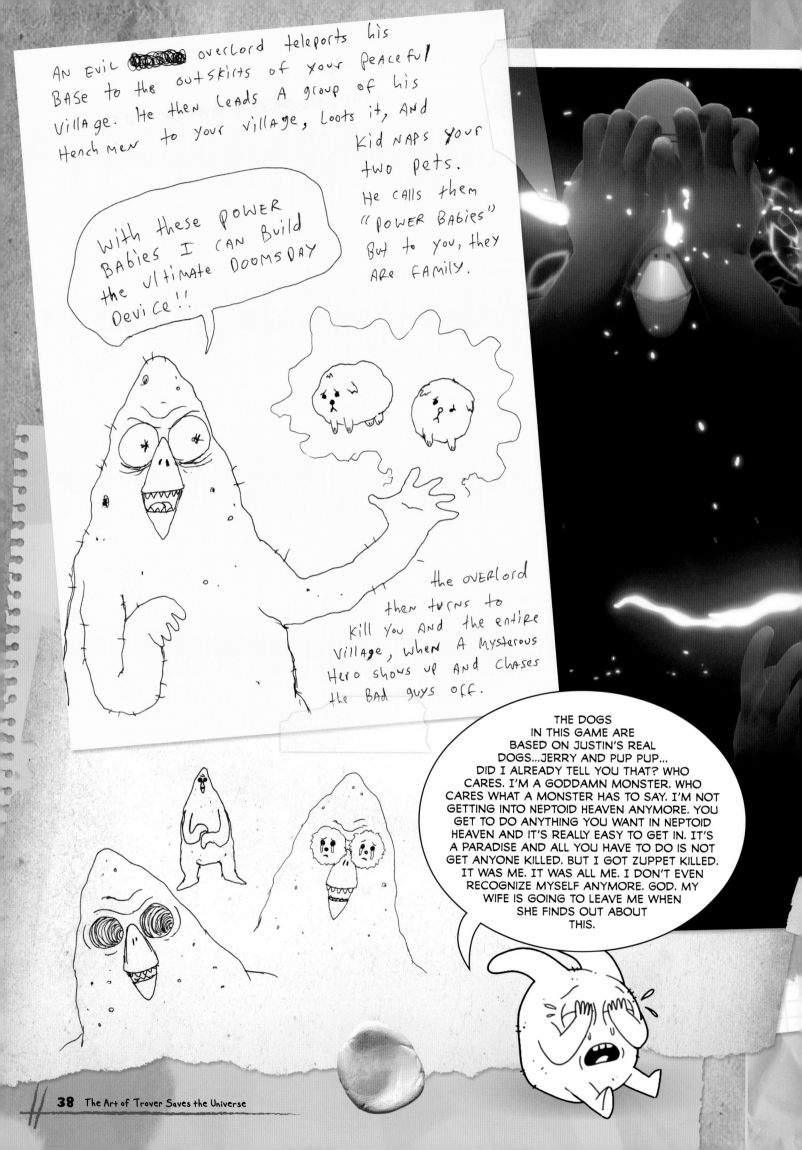

An Evil ▓▓▓ overlord teleports his BASE to the outskirts of your Peaceful villAge. He then leAds A group of his Hench men to your villAge, Loots it, And kid NAPs your two Pets. He cAlls them "POWER BAbies" But to you, they ARe FAMily.

With these POWER BAbies I CAN Build the ultimAte DOOMSDAY Device!!

the overlord then turns to Kill You And the entire villAge, when A Mysterous Hero shows up And chases the BAd guys off.

THE DOGS IN THIS GAME ARE BASED ON JUSTIN'S REAL DOGS...JERRY AND PUP PUP... DID I ALREADY TELL YOU THAT? WHO CARES. I'M A GODDAMN MONSTER. WHO CARES WHAT A MONSTER HAS TO SAY. I'M NOT GETTING INTO NEPTOID HEAVEN ANYMORE. YOU GET TO DO ANYTHING YOU WANT IN NEPTOID HEAVEN AND IT'S REALLY EASY TO GET IN. IT'S A PARADISE AND ALL YOU HAVE TO DO IS NOT GET ANYONE KILLED. BUT I GOT ZUPPET KILLED. IT WAS ME. IT WAS ALL ME. I DON'T EVEN RECOGNIZE MYSELF ANYMORE. GOD. MY WIFE IS GOING TO LEAVE ME WHEN SHE FINDS OUT ABOUT THIS.

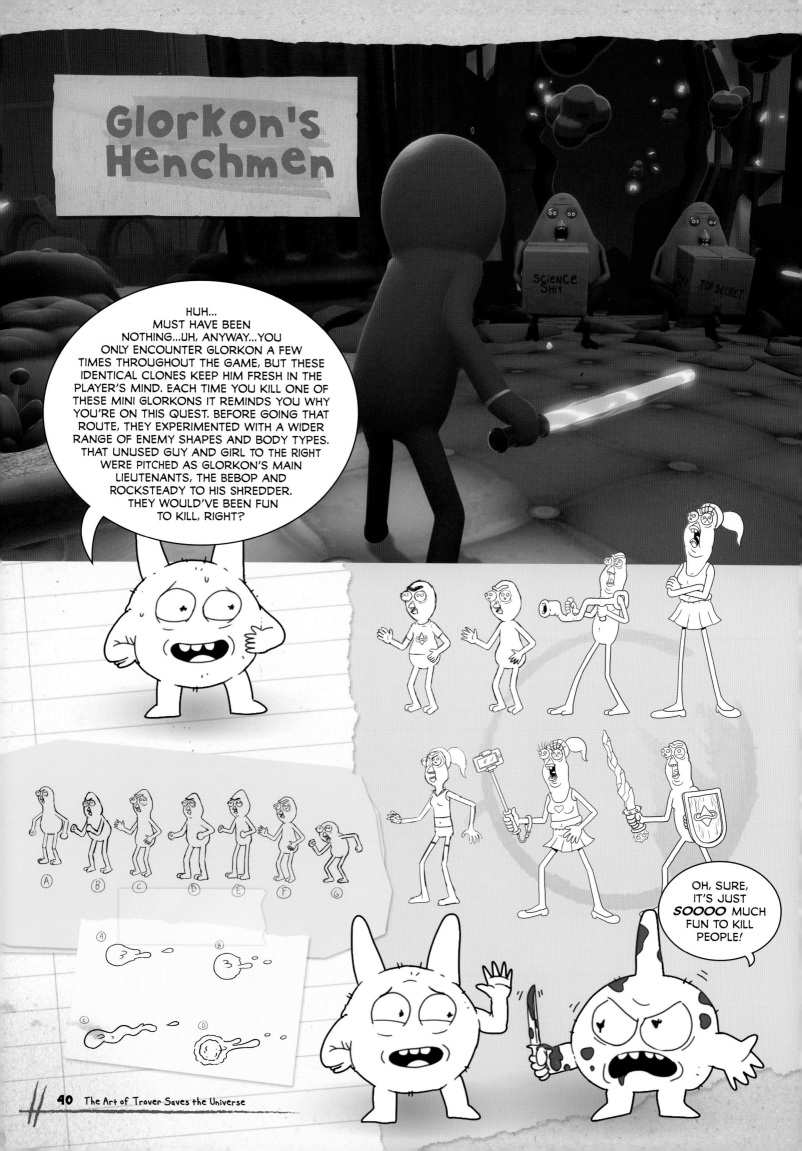

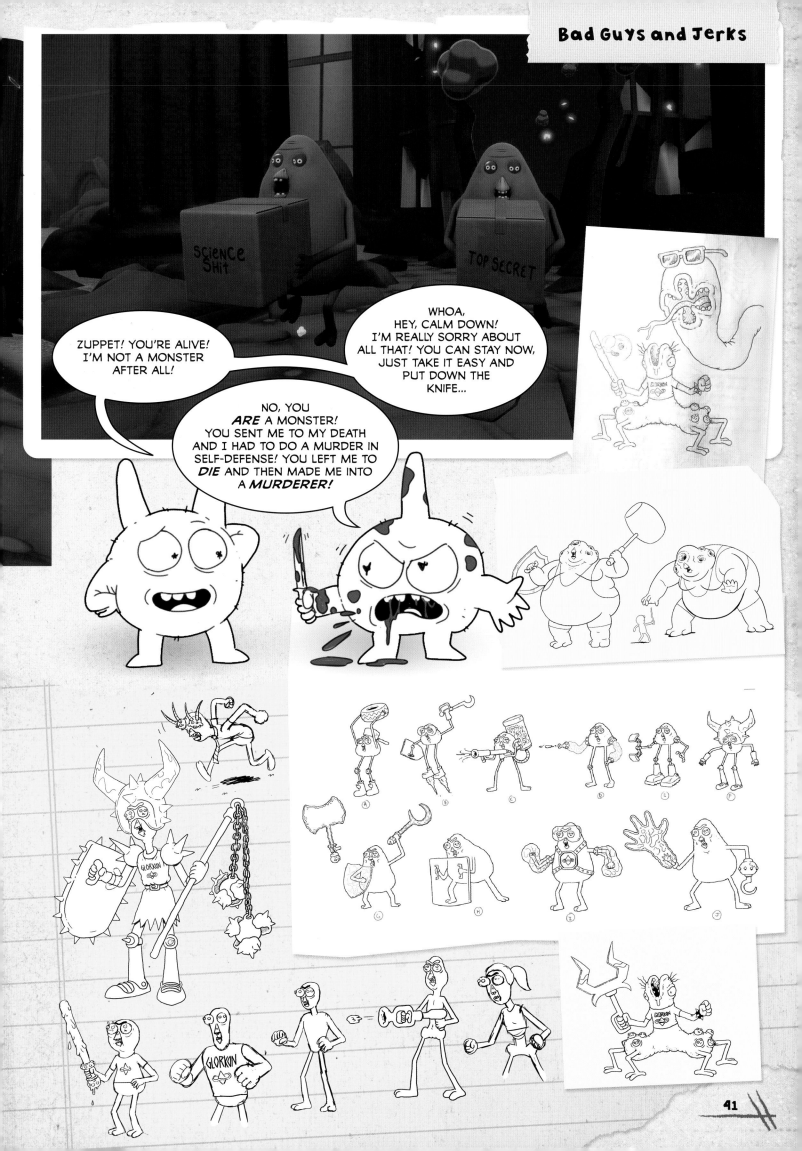

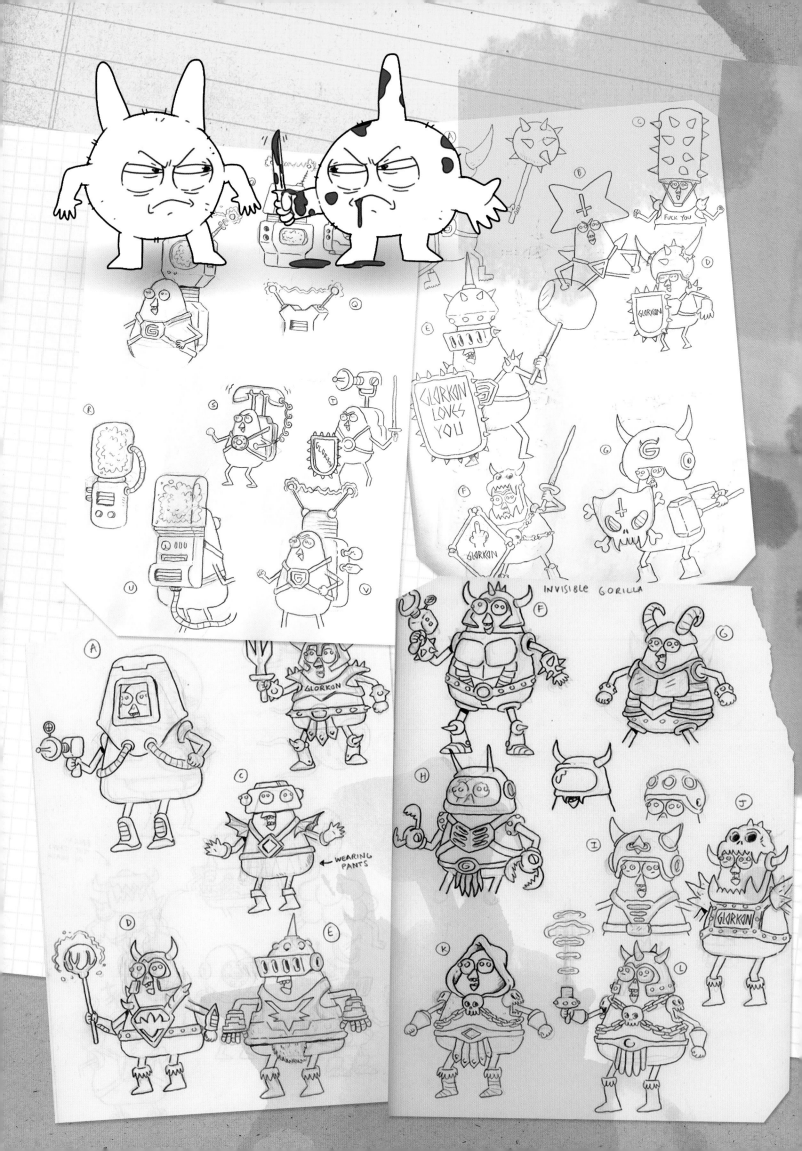

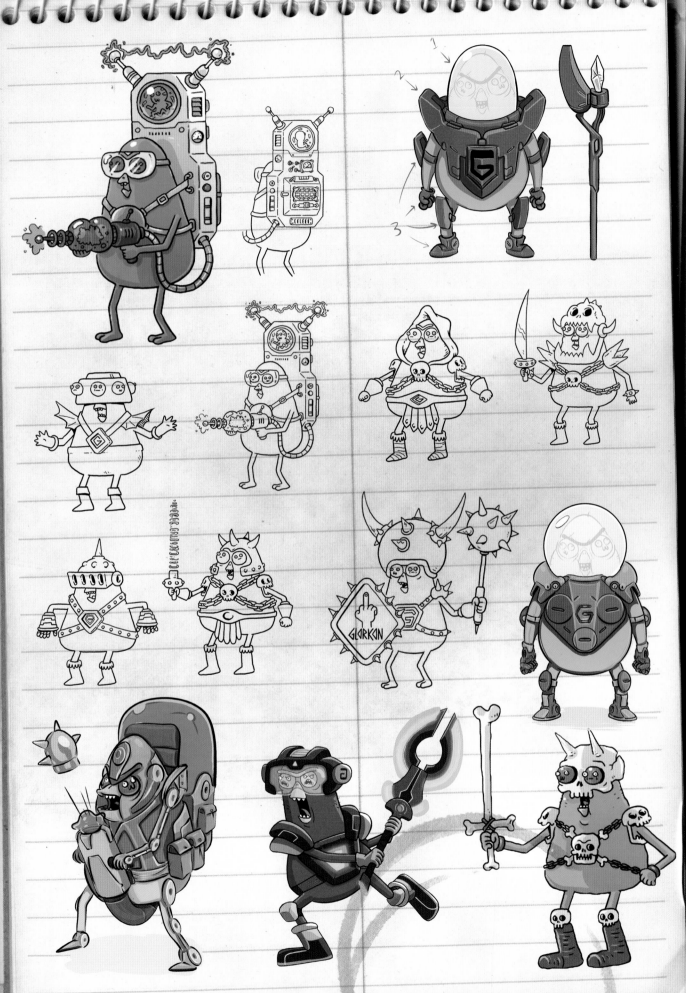

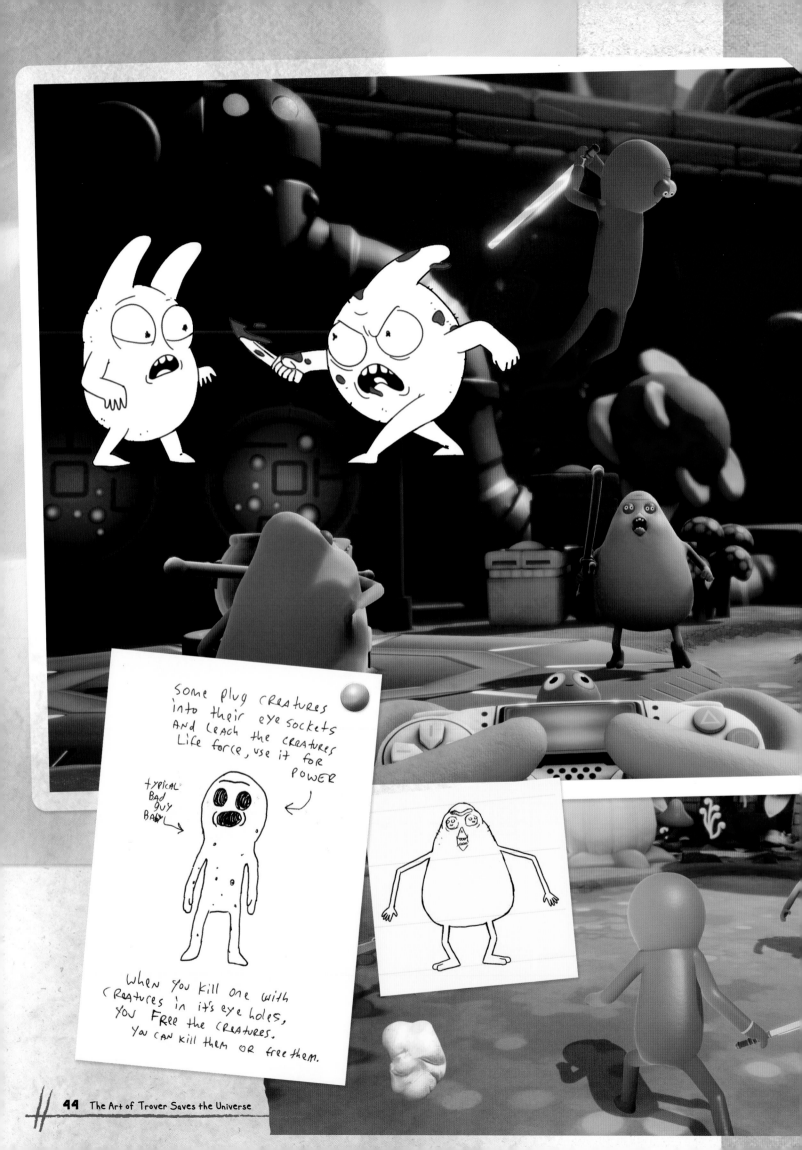

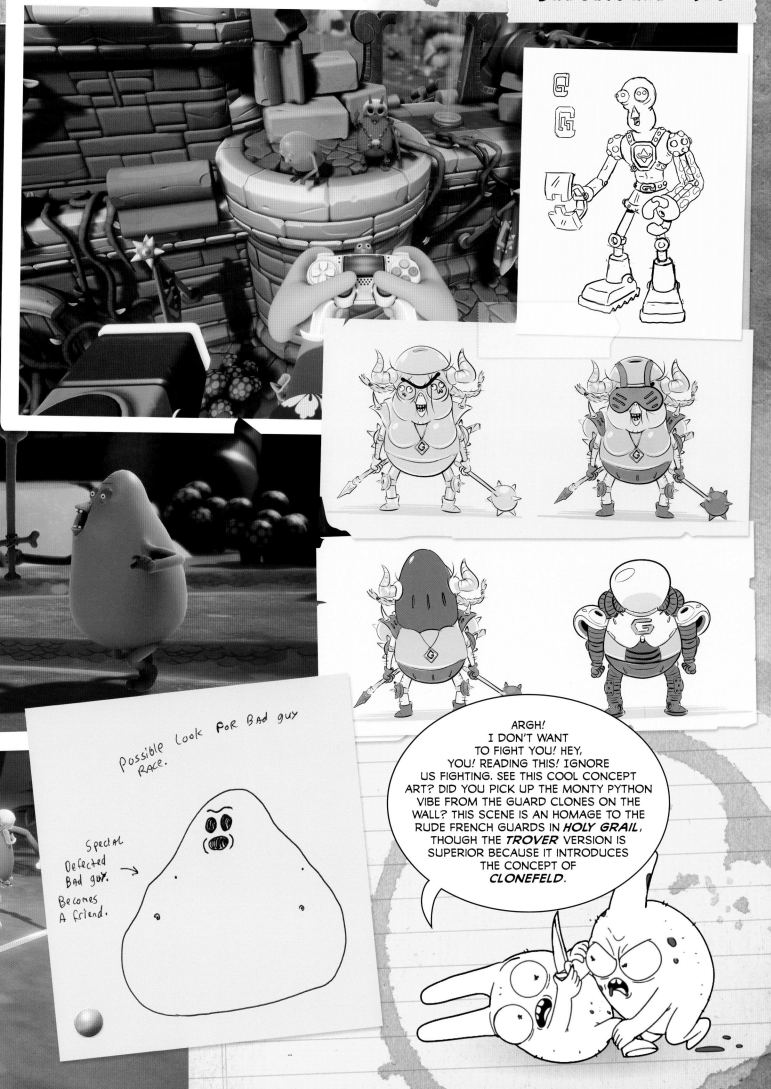

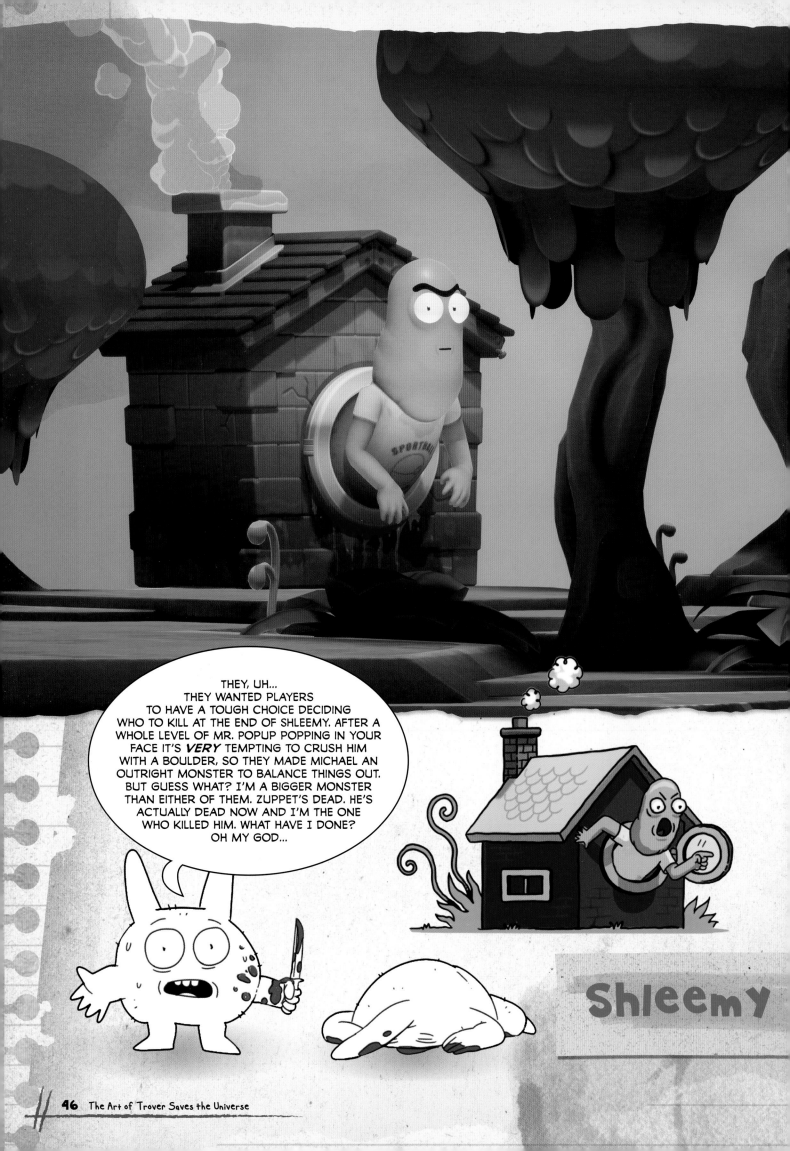

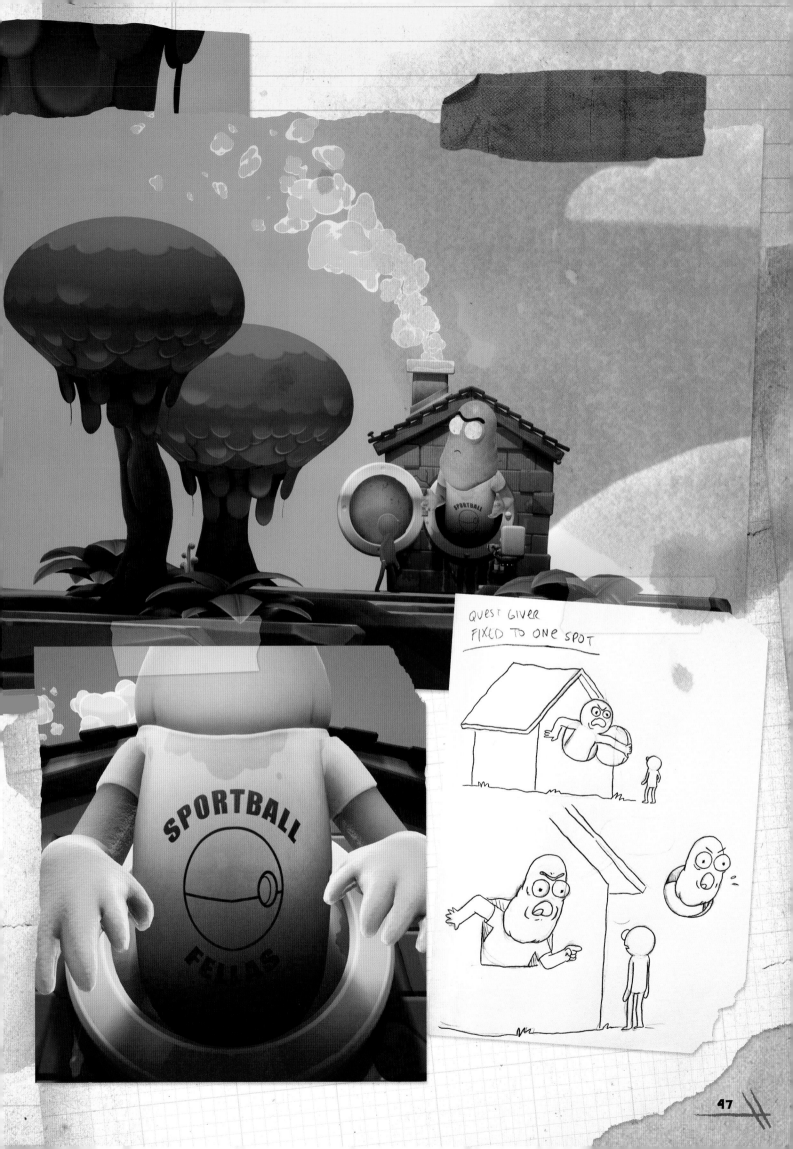

QUEST GIVER
FIXED TO ONE SPOT

47

Early Enemy Concepts

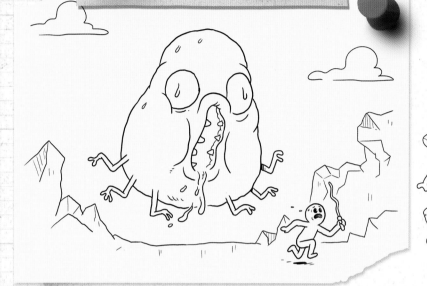

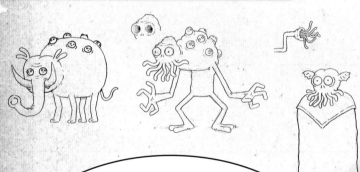

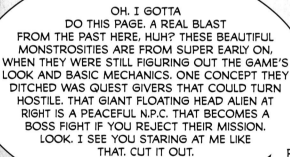

OH. I GOTTA DO THIS PAGE. A REAL BLAST FROM THE PAST HERE, HUH? THESE BEAUTIFUL MONSTROSITIES ARE FROM SUPER EARLY ON, WHEN THEY WERE STILL FIGURING OUT THE GAME'S LOOK AND BASIC MECHANICS. ONE CONCEPT THEY DITCHED WAS QUEST GIVERS THAT COULD TURN HOSTILE. THAT GIANT FLOATING HEAD ALIEN AT RIGHT IS A PEACEFUL N.P.C. THAT BECOMES A BOSS FIGHT IF YOU REJECT THEIR MISSION. LOOK. I SEE YOU STARING AT ME LIKE THAT. CUT IT OUT.

YOU KNOW IT WAS HIM OR ME, RIGHT? YOU GET THAT, DON'T YOU? IF I DIDN'T KILL ZUPPET, HE WOULD HAVE KILLED *ME*. SELF-DEFENSE. SO DON'T GET ALL JUDGY.

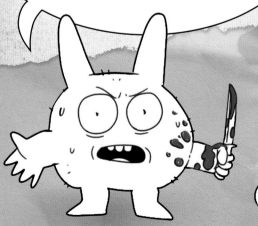

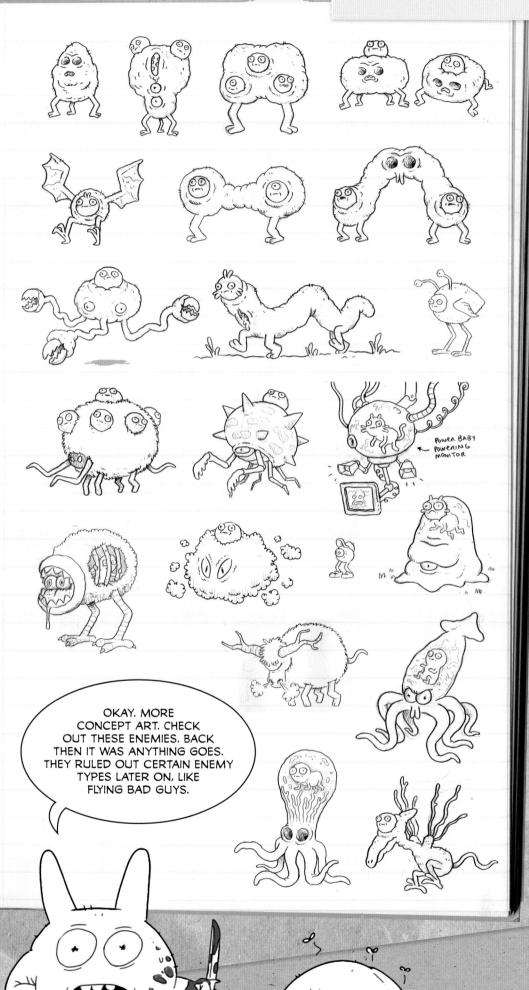

OKAY. MORE CONCEPT ART. CHECK OUT THESE ENEMIES. BACK THEN IT WAS ANYTHING GOES. THEY RULED OUT CERTAIN ENEMY TYPES LATER ON, LIKE FLYING BAD GUYS.

POWER BABY POWERING MONITOR

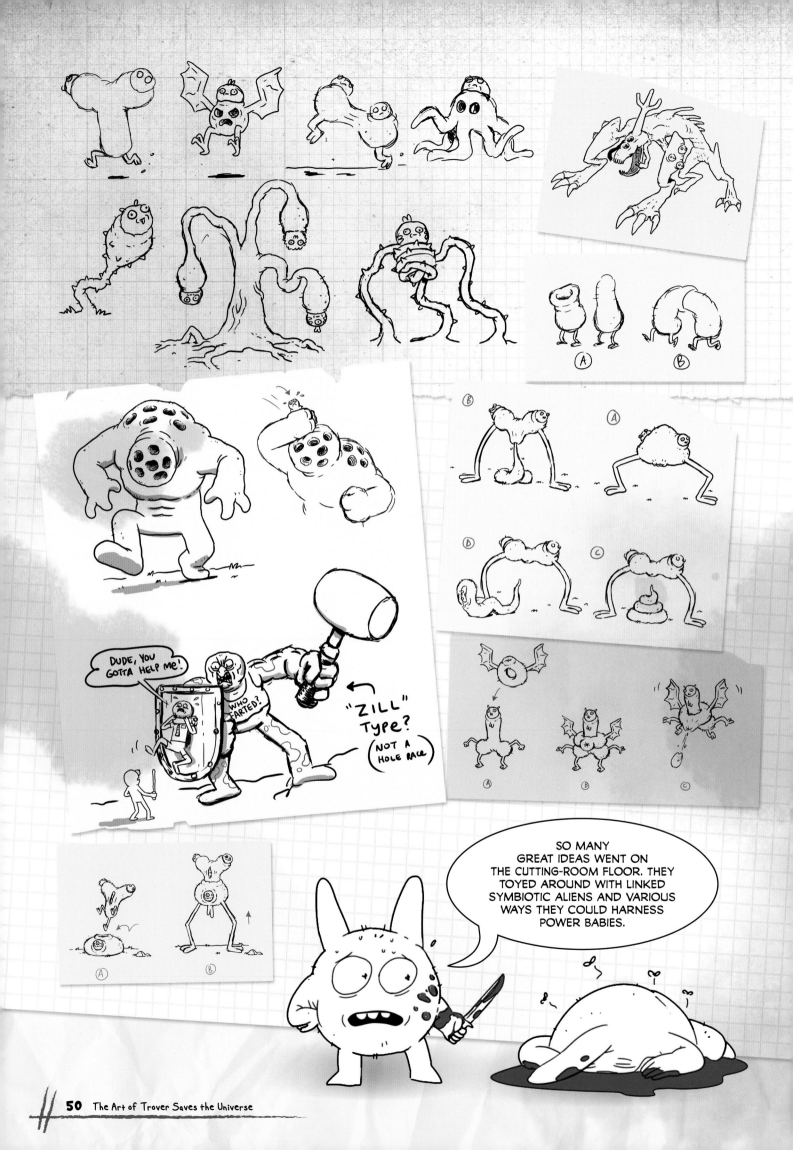

SO MANY GREAT IDEAS WENT ON THE CUTTING-ROOM FLOOR. THEY TOYED AROUND WITH LINKED SYMBIOTIC ALIENS AND VARIOUS WAYS THEY COULD HARNESS POWER BABIES.

DUDE, YOU GOTTA HELP ME!

WHO FARTED?

"ZILL" TYPE?
(NOT A HOLE RACE)

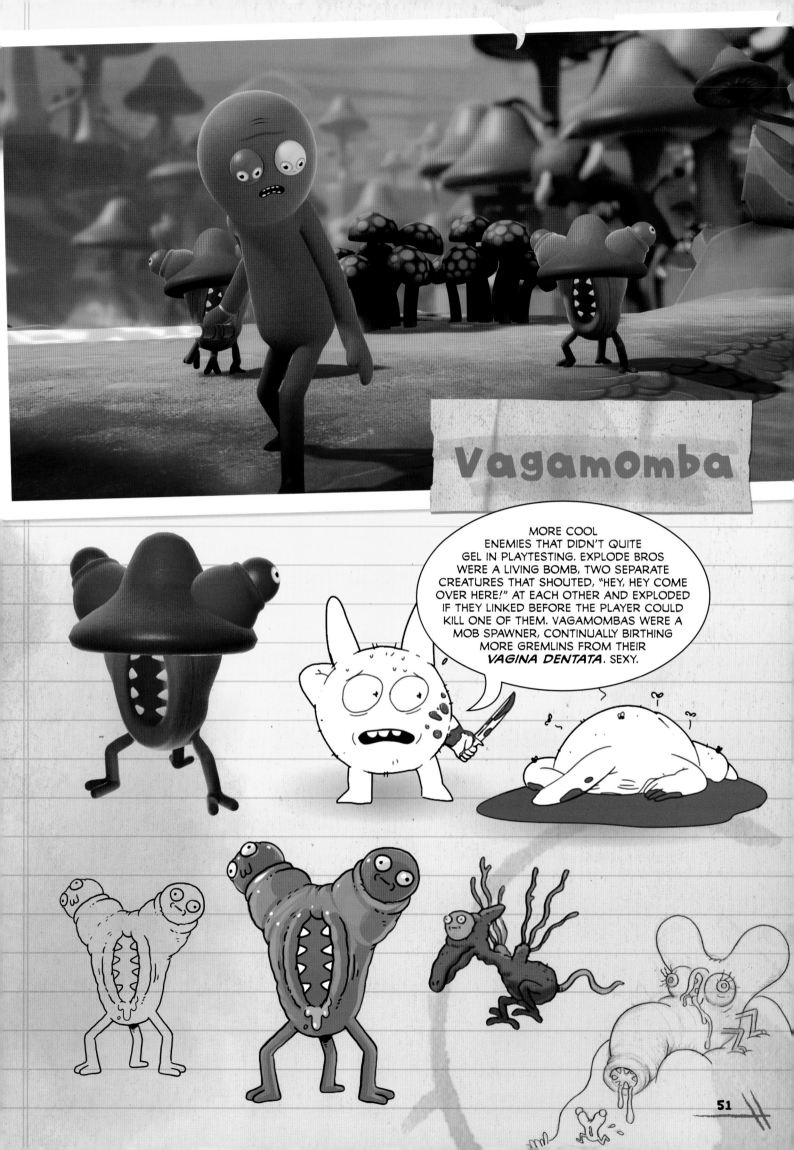

Vagamomba

MORE COOL ENEMIES THAT DIDN'T QUITE GEL IN PLAYTESTING. EXPLODE BROS WERE A LIVING BOMB, TWO SEPARATE CREATURES THAT SHOUTED, "HEY, HEY COME OVER HERE!" AT EACH OTHER AND EXPLODED IF THEY LINKED BEFORE THE PLAYER COULD KILL ONE OF THEM. VAGAMOMBAS WERE A MOB SPAWNER, CONTINUALLY BIRTHING MORE GREMLINS FROM THEIR *VAGINA DENTATA*. SEXY.

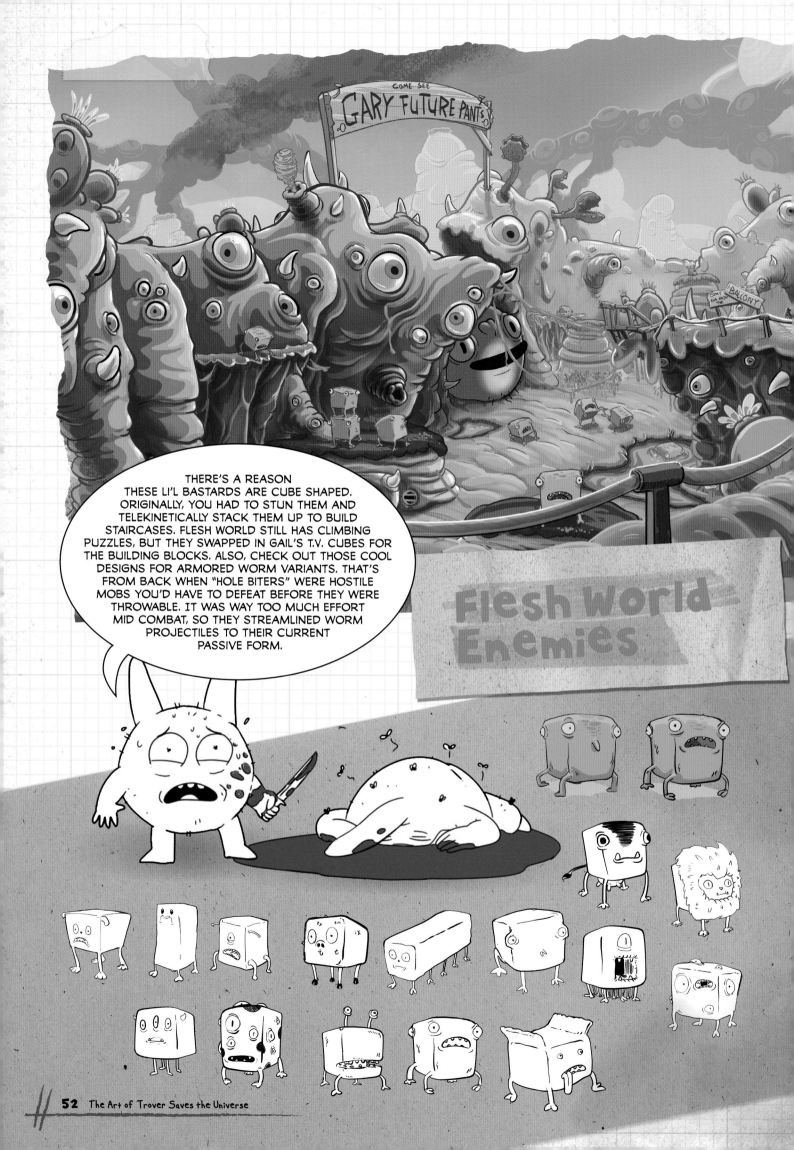

THERE'S A REASON THESE LI'L BASTARDS ARE CUBE SHAPED. ORIGINALLY, YOU HAD TO STUN THEM AND TELEKINETICALLY STACK THEM UP TO BUILD STAIRCASES. FLESH WORLD STILL HAS CLIMBING PUZZLES, BUT THEY SWAPPED IN GAIL'S T.V. CUBES FOR THE BUILDING BLOCKS. ALSO, CHECK OUT THOSE COOL DESIGNS FOR ARMORED WORM VARIANTS. THAT'S FROM BACK WHEN "HOLE BITERS" WERE HOSTILE MOBS YOU'D HAVE TO DEFEAT BEFORE THEY WERE THROWABLE. IT WAS WAY TOO MUCH EFFORT MID COMBAT, SO THEY STREAMLINED WORM PROJECTILES TO THEIR CURRENT PASSIVE FORM.

Flesh World Enemies

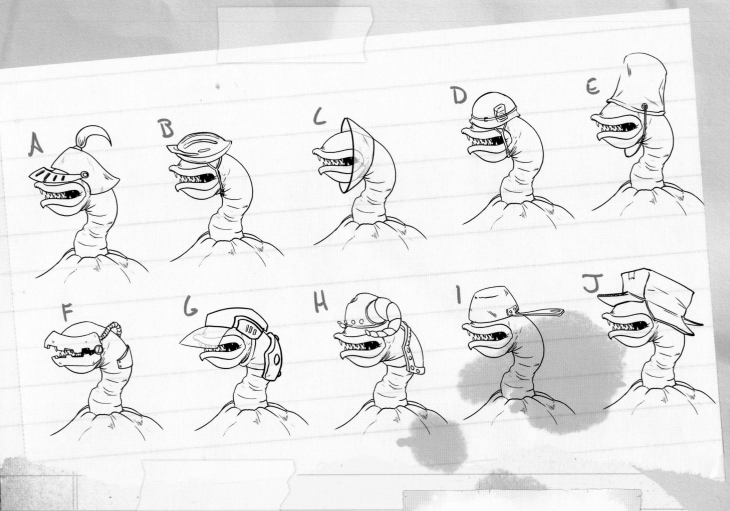

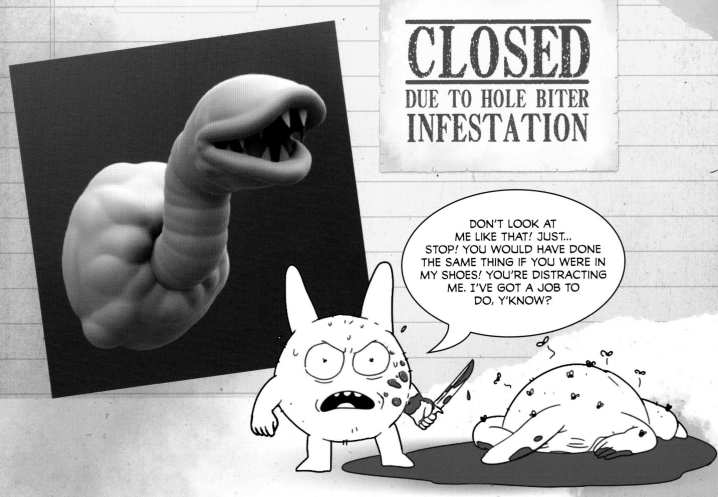

GiZmOS

Controller

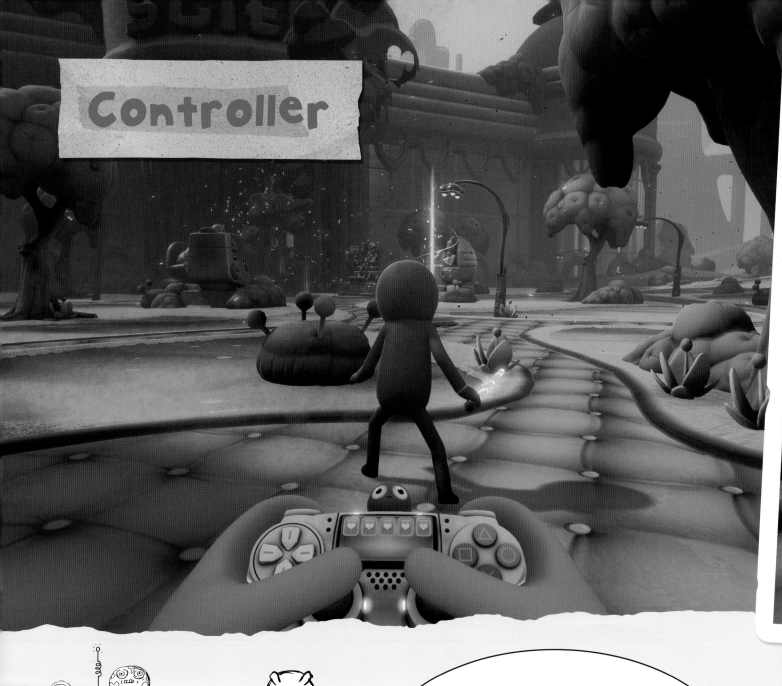

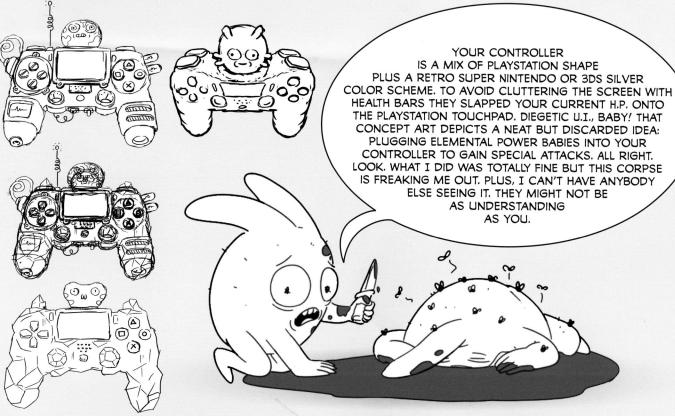

YOUR CONTROLLER IS A MIX OF PLAYSTATION SHAPE PLUS A RETRO SUPER NINTENDO OR 3DS SILVER COLOR SCHEME. TO AVOID CLUTTERING THE SCREEN WITH HEALTH BARS THEY SLAPPED YOUR CURRENT H.P. ONTO THE PLAYSTATION TOUCHPAD. DIEGETIC U.I., BABY! THAT CONCEPT ART DEPICTS A NEAT BUT DISCARDED IDEA: PLUGGING ELEMENTAL POWER BABIES INTO YOUR CONTROLLER TO GAIN SPECIAL ATTACKS. ALL RIGHT. LOOK. WHAT I DID WAS TOTALLY FINE BUT THIS CORPSE IS FREAKING ME OUT. PLUS, I CAN'T HAVE ANYBODY ELSE SEEING IT. THEY MIGHT NOT BE AS UNDERSTANDING AS YOU.

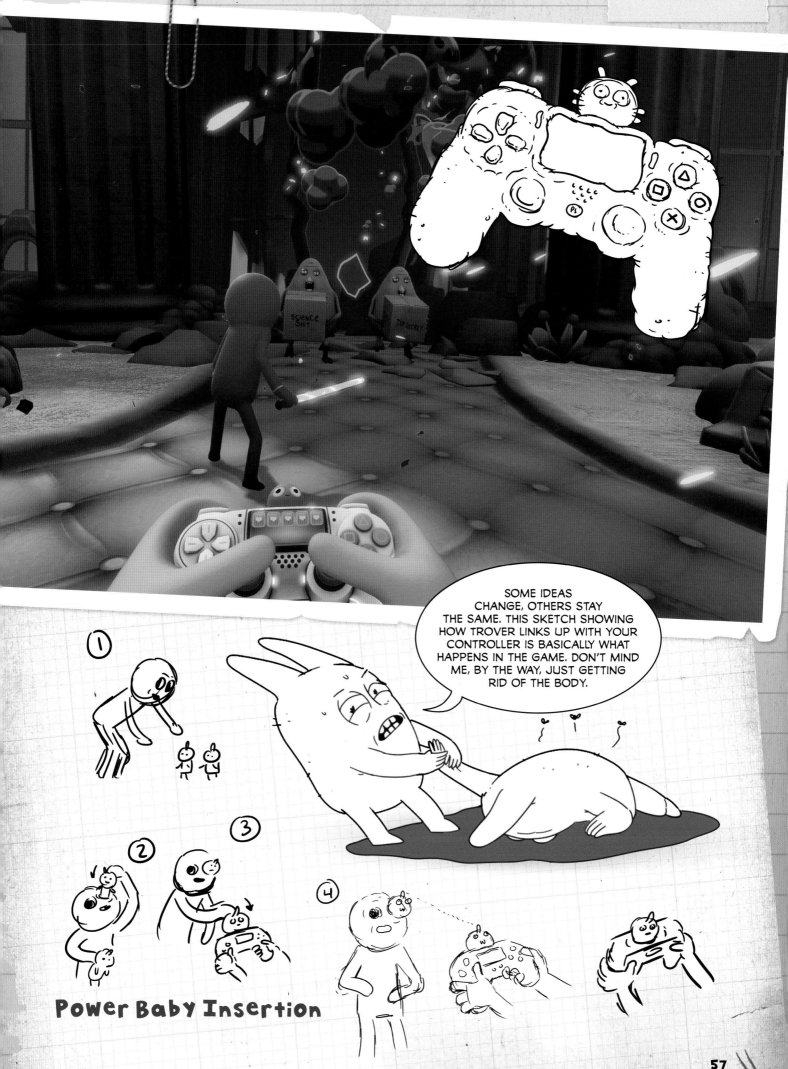

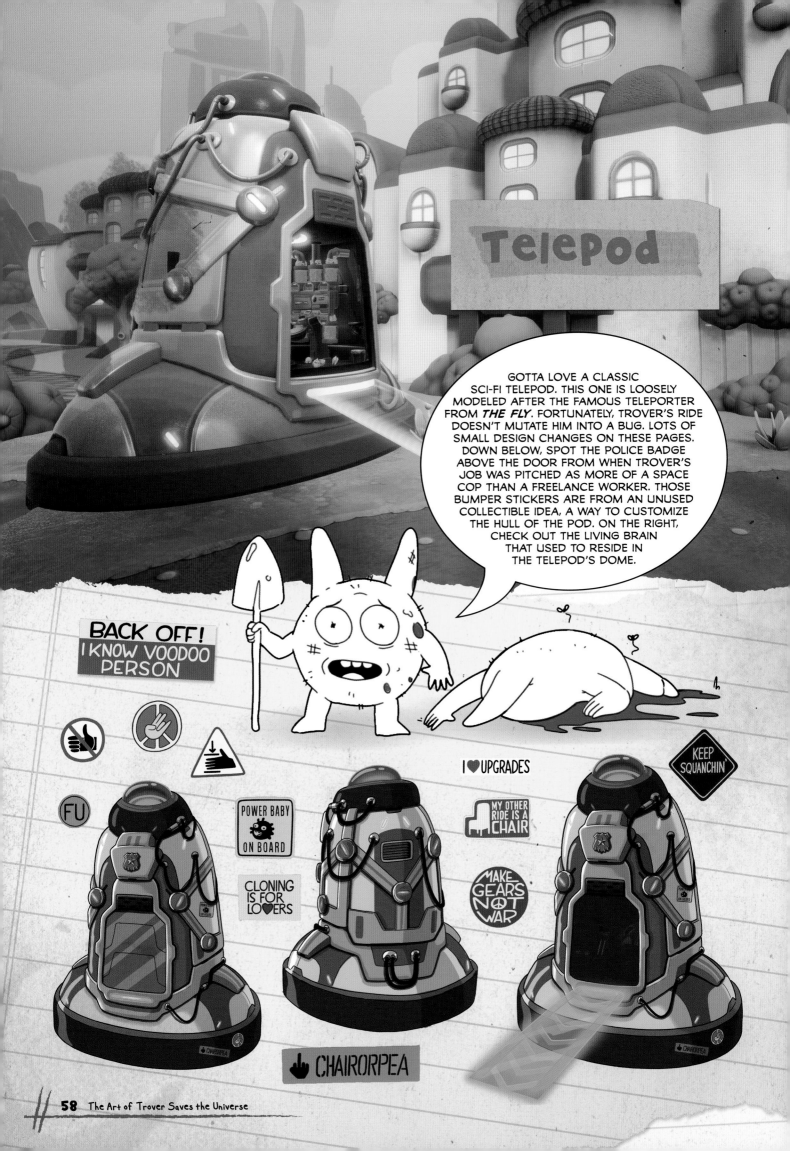

Telepod

GOTTA LOVE A CLASSIC SCI-FI TELEPOD. THIS ONE IS LOOSELY MODELED AFTER THE FAMOUS TELEPORTER FROM *THE FLY*. FORTUNATELY, TROVER'S RIDE DOESN'T MUTATE HIM INTO A BUG. LOTS OF SMALL DESIGN CHANGES ON THESE PAGES. DOWN BELOW, SPOT THE POLICE BADGE ABOVE THE DOOR FROM WHEN TROVER'S JOB WAS PITCHED AS MORE OF A SPACE COP THAN A FREELANCE WORKER. THOSE BUMPER STICKERS ARE FROM AN UNUSED COLLECTIBLE IDEA, A WAY TO CUSTOMIZE THE HULL OF THE POD. ON THE RIGHT, CHECK OUT THE LIVING BRAIN THAT USED TO RESIDE IN THE TELEPOD'S DOME.

BACK OFF! I KNOW VOODOO PERSON

I ♥ UPGRADES

KEEP SQUANCHIN'

FU

POWER BABY ON BOARD

MY OTHER RIDE IS A CHAIR

CLONING IS FOR LOVERS

MAKE GEARS NOT WAR

CHAIRORPEA

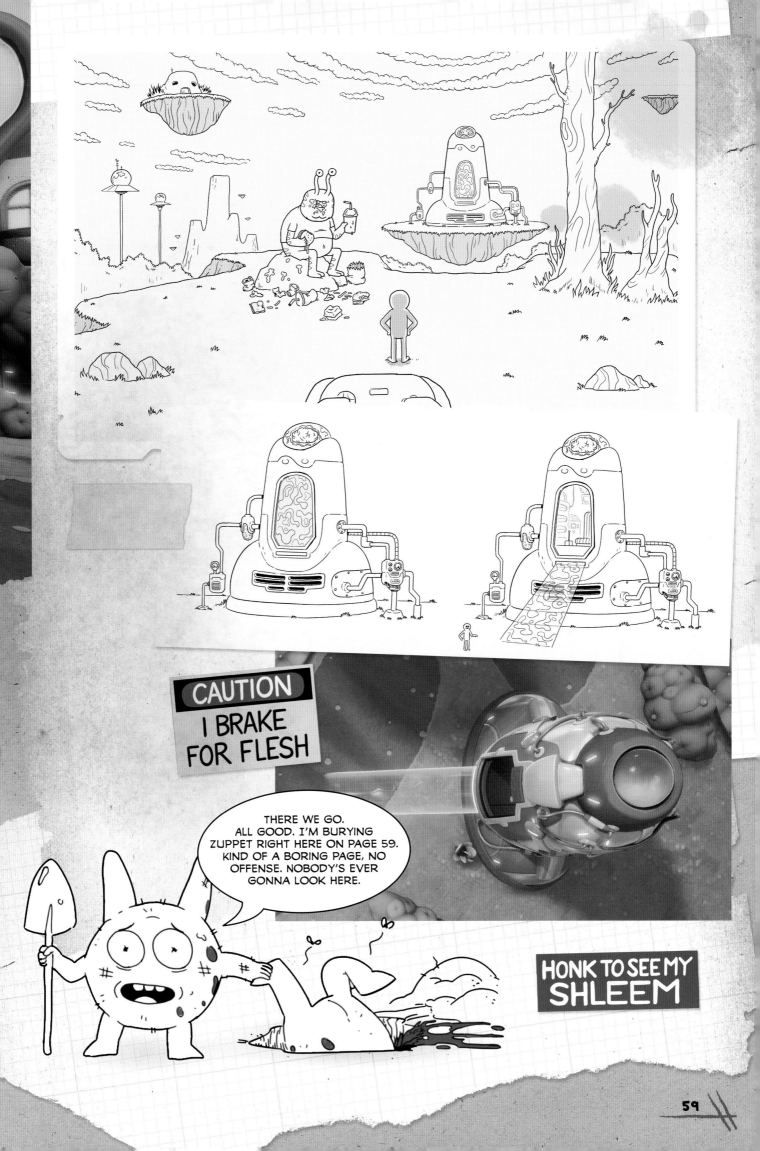

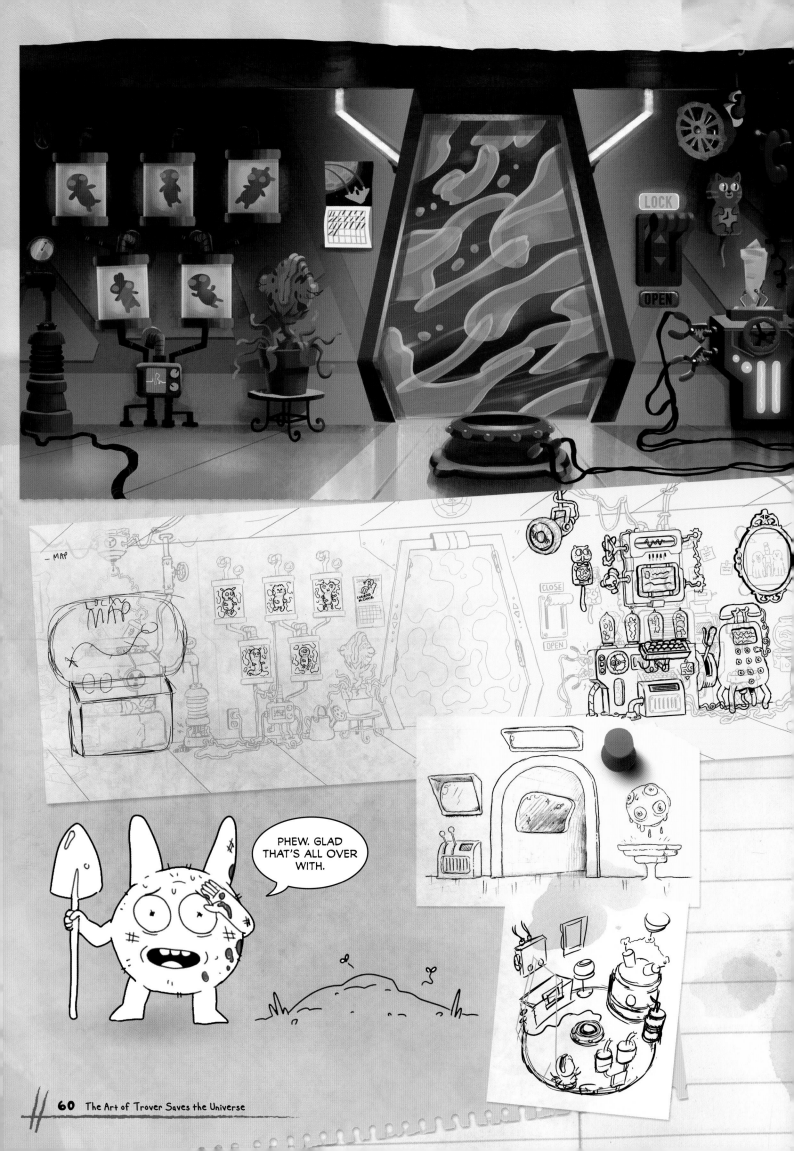

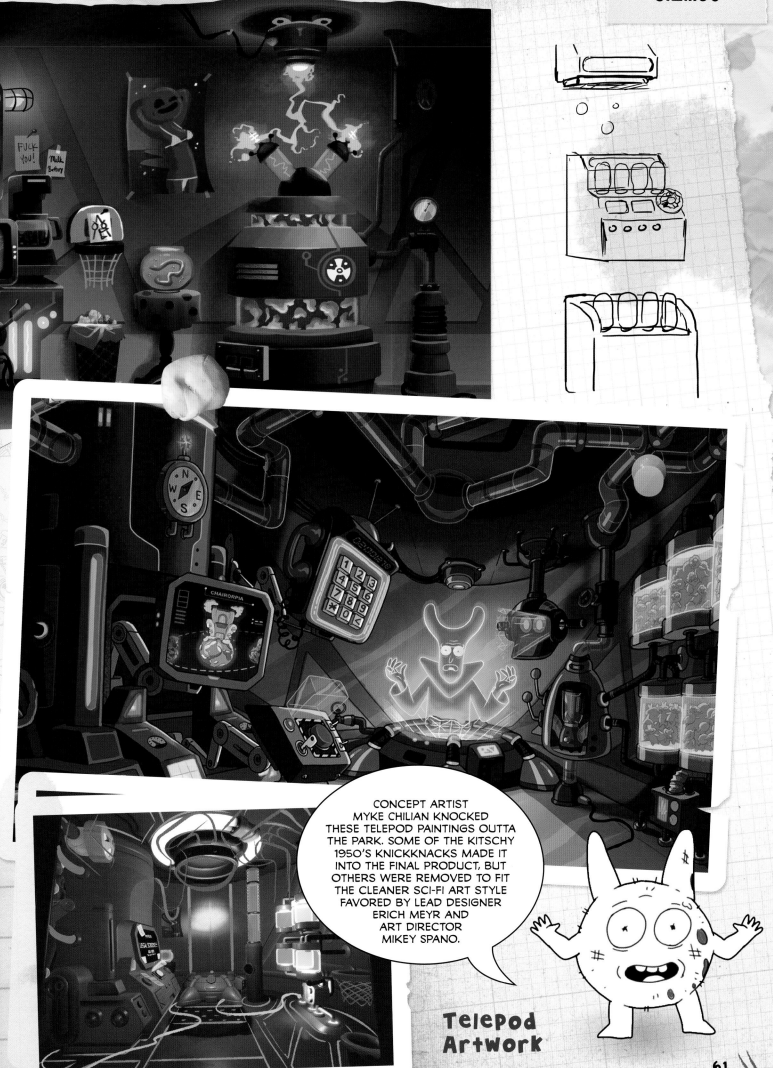

CONCEPT ARTIST MYKE CHILIAN KNOCKED THESE TELEPOD PAINTINGS OUTTA THE PARK. SOME OF THE KITSCHY 1950'S KNICKKNACKS MADE IT INTO THE FINAL PRODUCT, BUT OTHERS WERE REMOVED TO FIT THE CLEANER SCI-FI ART STYLE FAVORED BY LEAD DESIGNER ERICH MEYR AND ART DIRECTOR MIKEY SPANO.

Telepod Artwork

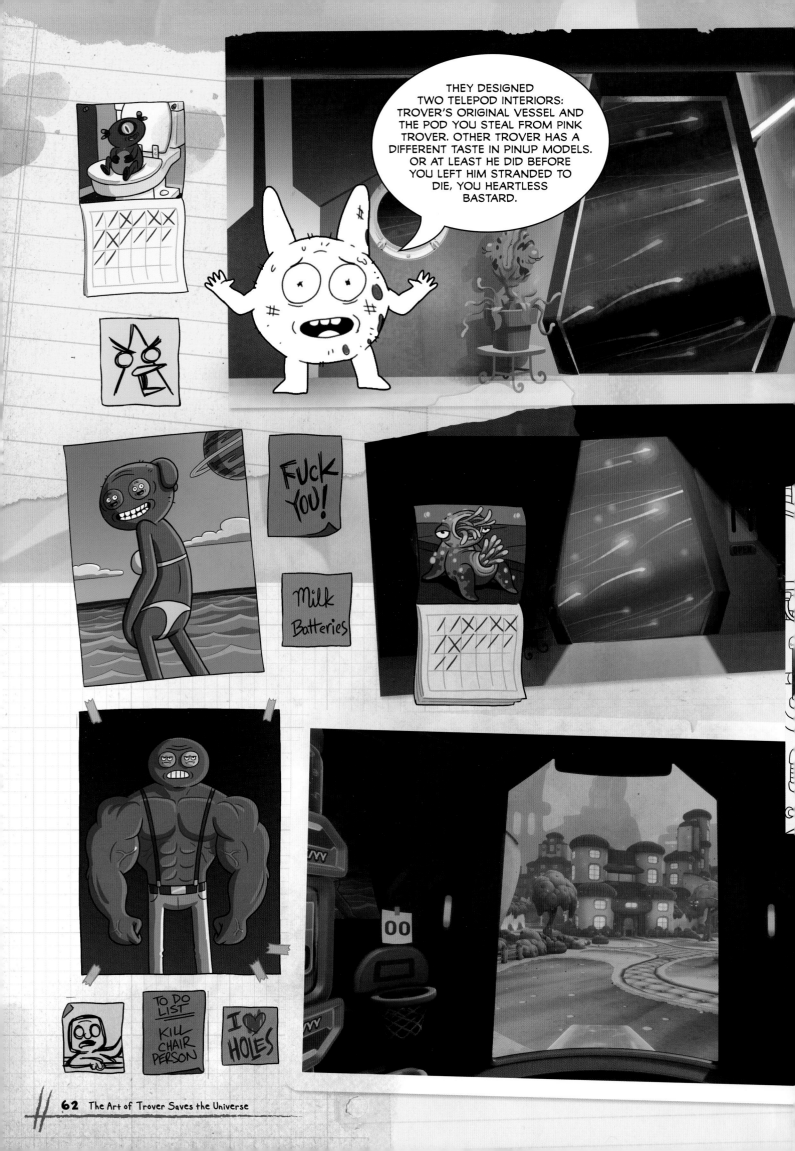

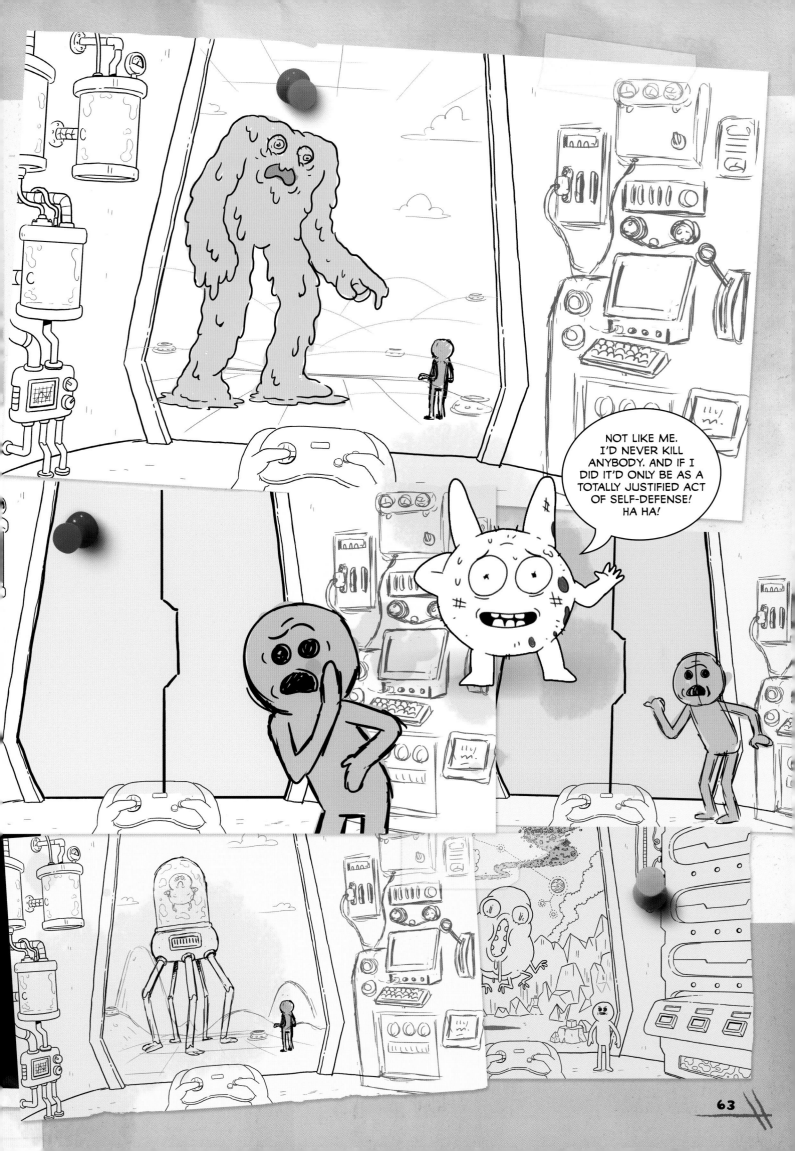

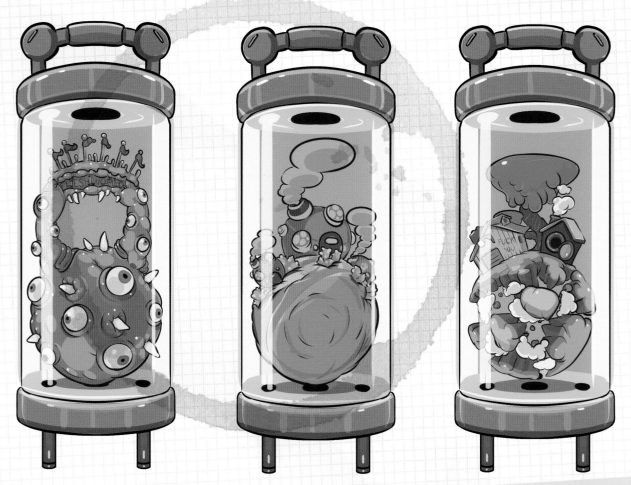

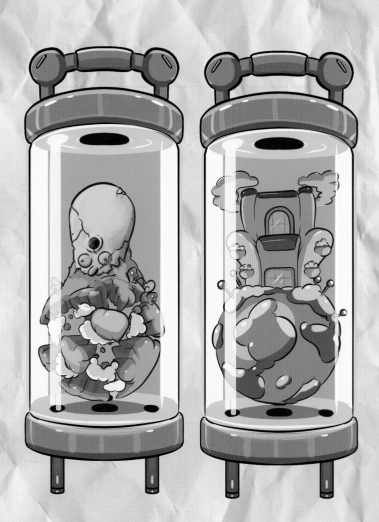

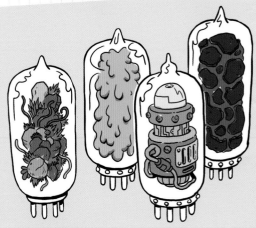

THESE NAVIGATION BULBS LOOK AWESOME, BUT MAN, THEY WOULDA BEEN A HASSLE. WARPING TO A PLANET WOULD HAVE REQUIRED FIRST INSTALLING THE CORRECT BULB, MANUALLY SCREWING IT INTO YOUR TELEPOD IN GLORIOUS V.R. THEY DITCHED THAT FOR A SIMPLE BUTTON PRESS. GOD, IS IT HOT IN HERE OR IS IT JUST ME? IT'S GETTING REALLY HARD TO DO ALL THIS NARRATION ALL OF A SUDDEN...

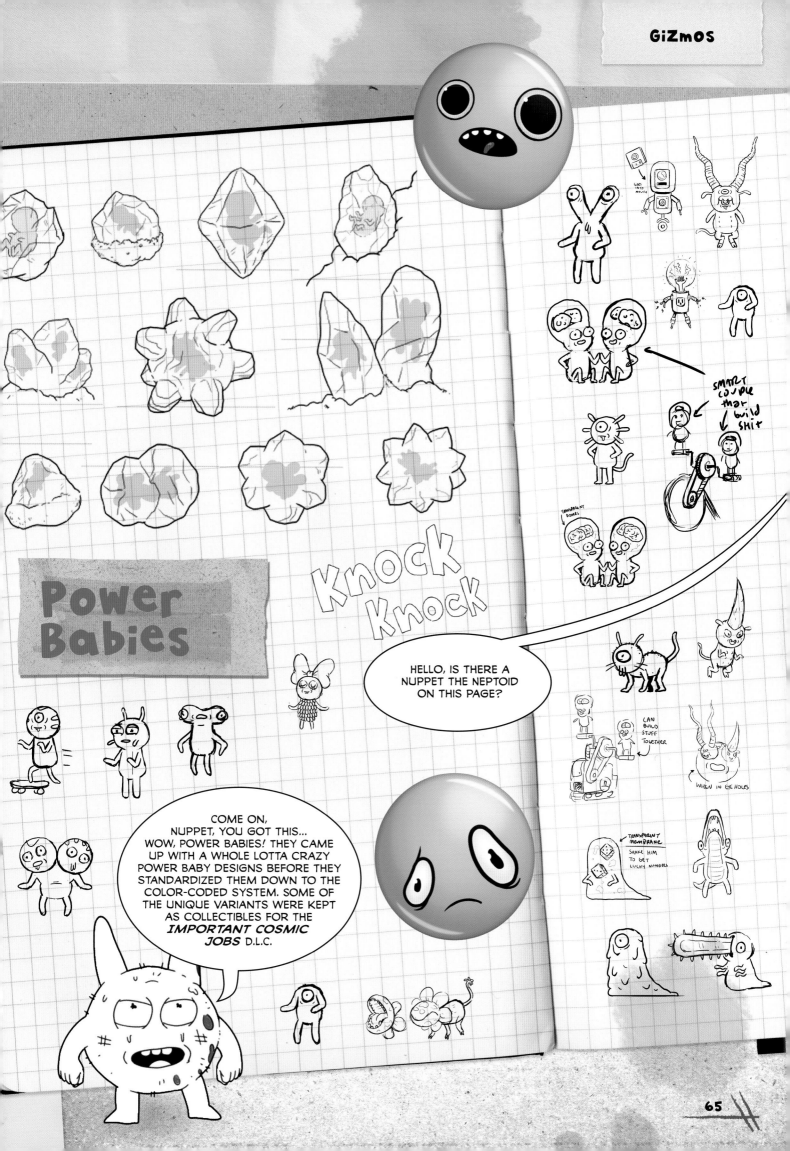

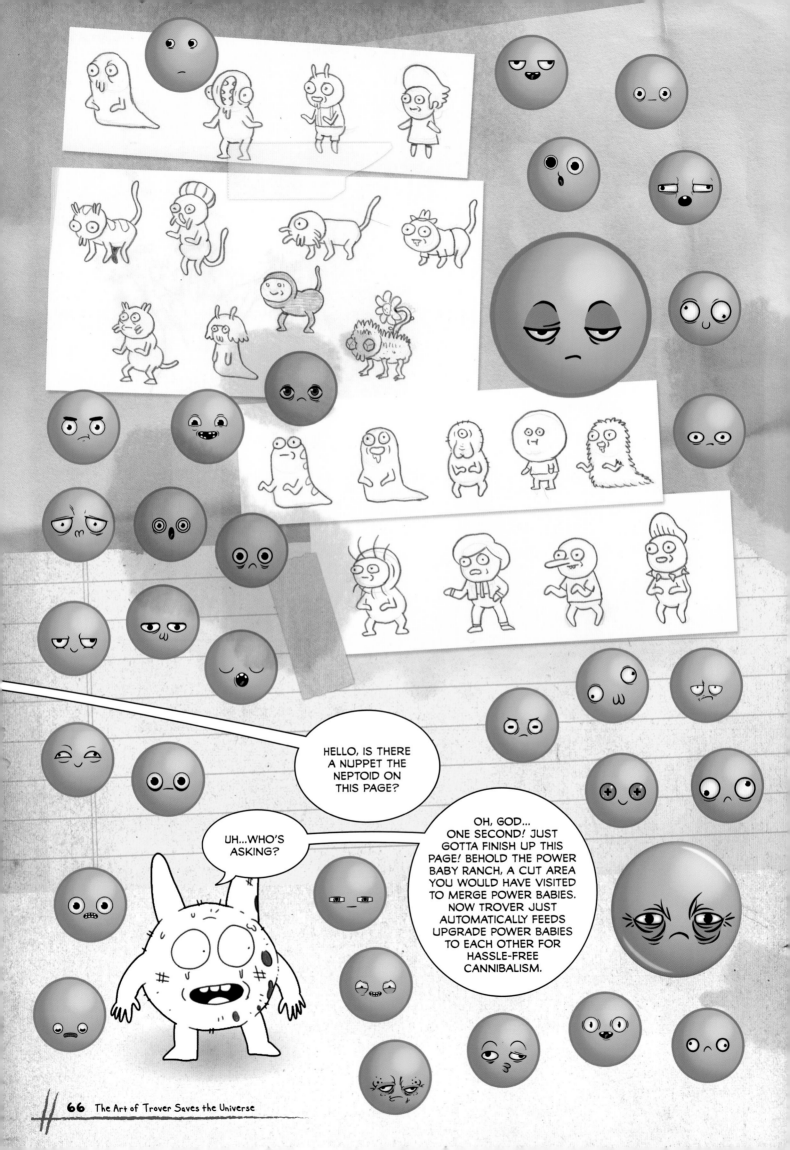

HELLO, IS THERE A NUPPET THE NEPTOID ON THIS PAGE?

UH...WHO'S ASKING?

OH, GOD... ONE SECOND! JUST GOTTA FINISH UP THIS PAGE! BEHOLD THE POWER BABY RANCH, A CUT AREA YOU WOULD HAVE VISITED TO MERGE POWER BABIES. NOW TROVER JUST AUTOMATICALLY FEEDS UPGRADE POWER BABIES TO EACH OTHER FOR HASSLE-FREE CANNIBALISM.

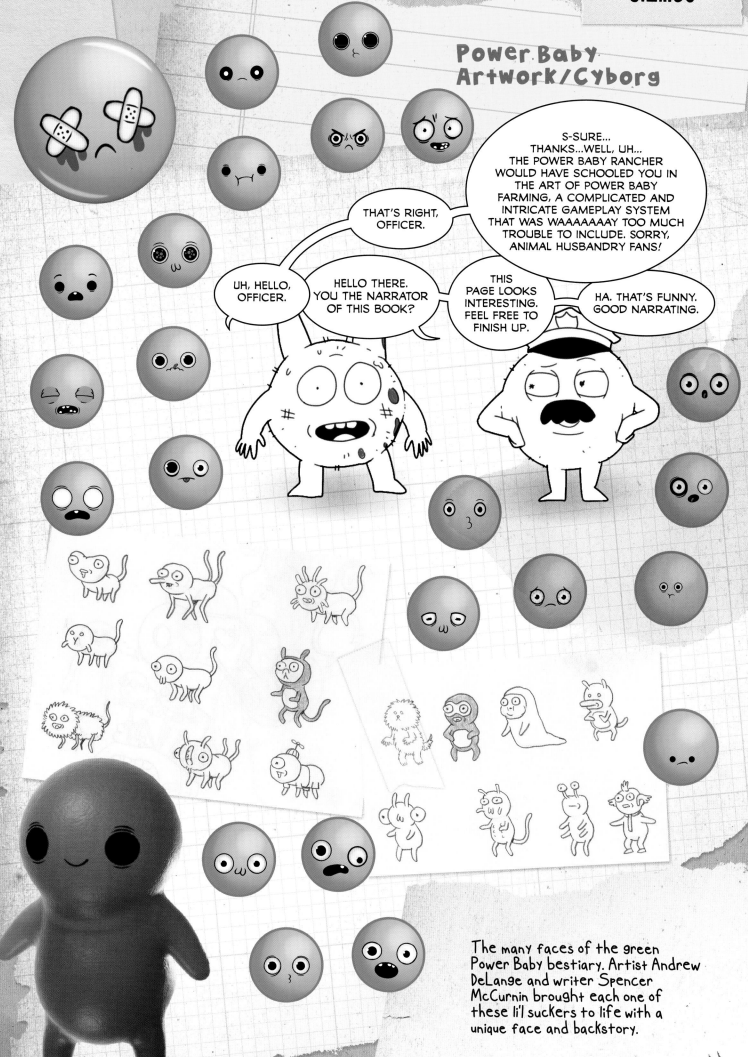

Power Baby
Artwork/Cyborg

S-SURE... THANKS...WELL, UH... THE POWER BABY RANCHER WOULD HAVE SCHOOLED YOU IN THE ART OF POWER BABY FARMING, A COMPLICATED AND INTRICATE GAMEPLAY SYSTEM THAT WAS WAAAAAAAY TOO MUCH TROUBLE TO INCLUDE. SORRY, ANIMAL HUSBANDRY FANS!

THAT'S RIGHT, OFFICER.

UH, HELLO, OFFICER.

HELLO THERE. YOU THE NARRATOR OF THIS BOOK?

THIS PAGE LOOKS INTERESTING. FEEL FREE TO FINISH UP.

HA. THAT'S FUNNY. GOOD NARRATING.

The many faces of the green Power Baby bestiary. Artist Andrew DeLange and writer Spencer McCurnin brought each one of these li'l suckers to life with a unique face and backstory.

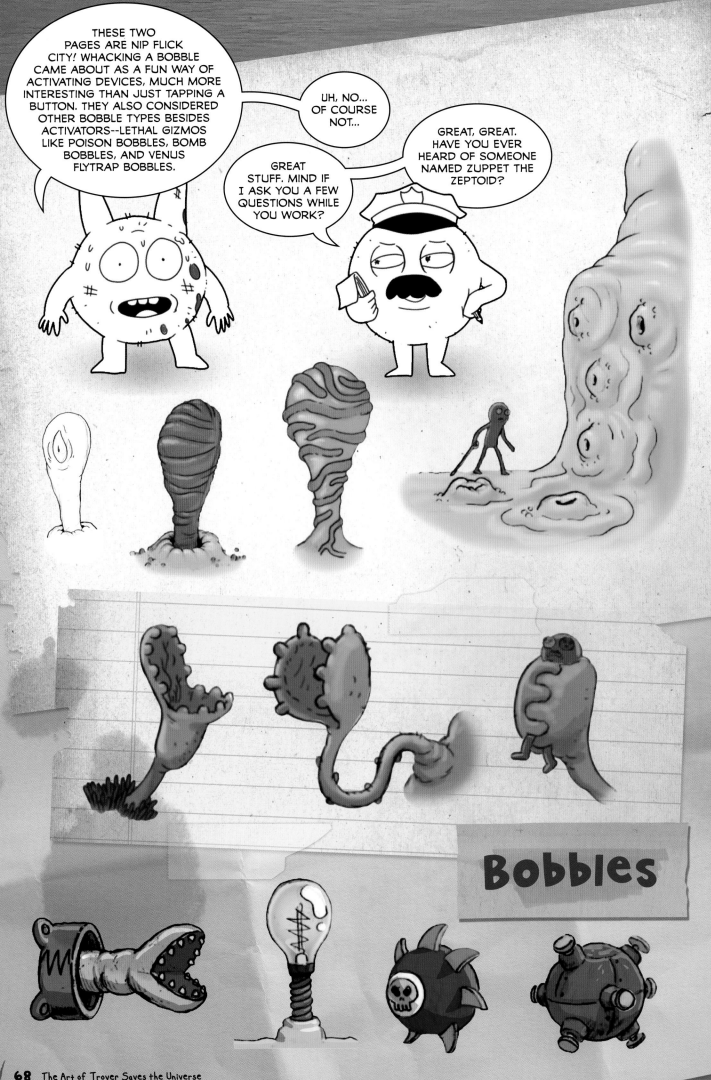

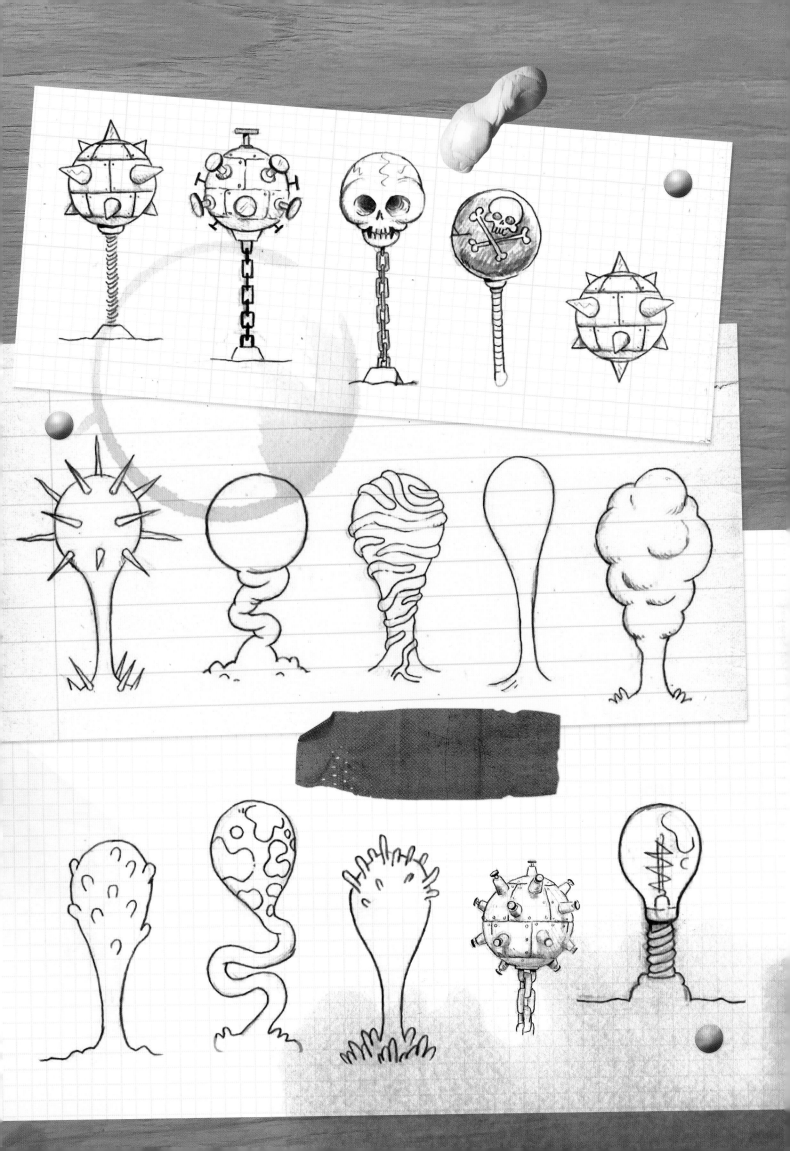

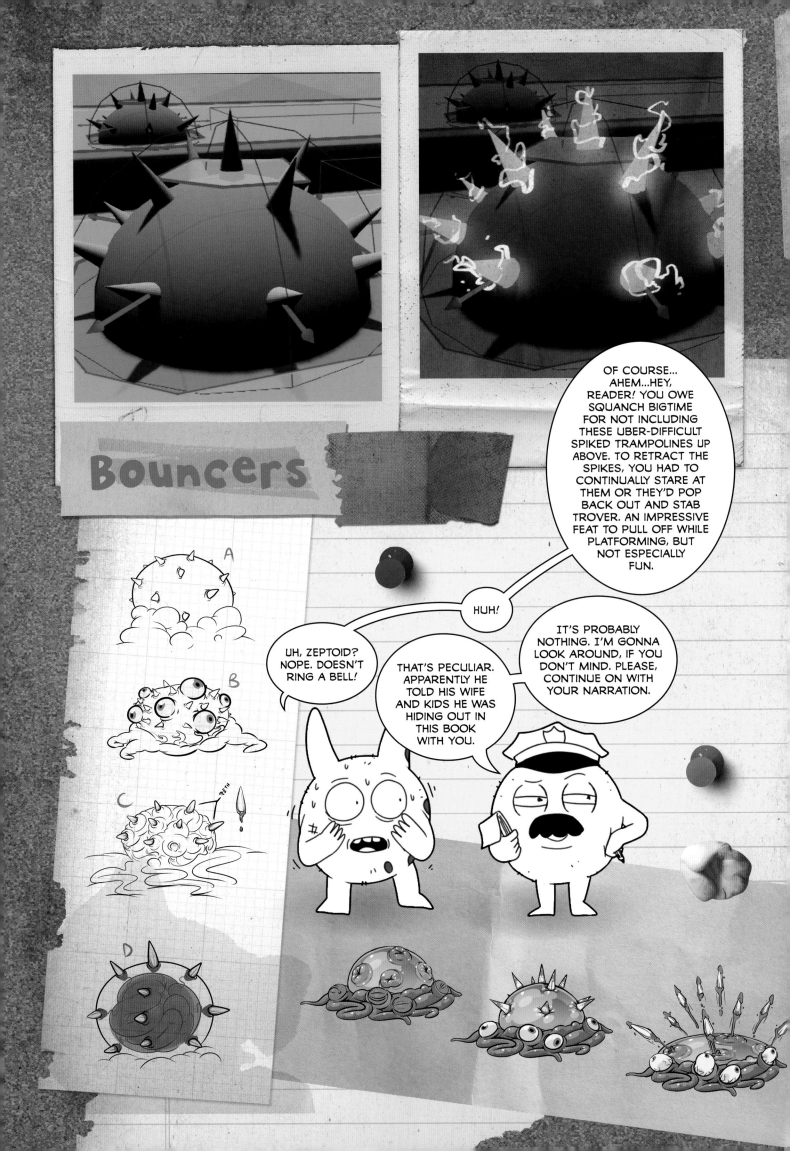

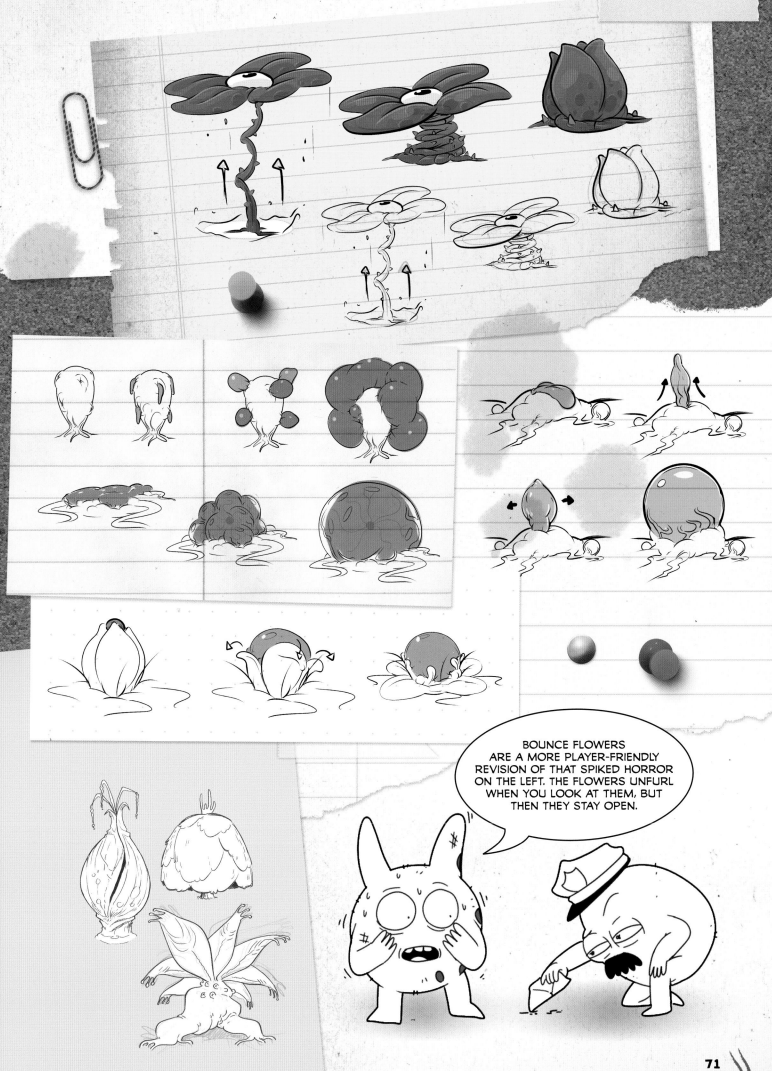

BOUNCE FLOWERS ARE A MORE PLAYER-FRIENDLY REVISION OF THAT SPIKED HORROR ON THE LEFT. THE FLOWERS UNFURL WHEN YOU LOOK AT THEM, BUT THEN THEY STAY OPEN.

The World Merger and Other Equipment

A BIG GRAB BAG OF STUFF OVER HERE. DOWN BELOW, CHECK OUT THOSE ALTERNATE OPTIONS FOR THE WORLD MERGER. ON THE RIGHT SIDE WE HAVE CONCEPT ART FOR THE FLESH WORLD PADLOCKS, THE CAULDRON YOU BRING TO VOODOO PERSON, AND THE BOMB GLORKON THROWS IN YOUR TELEPOD.

THE RED-AND-BLACK THING IS AN UNUSED DESIGN FOR A MINEFIELD EXPLOSIVE. THE BUTTONS ON THE BOMB-DEFUSAL PANEL CHANGED INTO A GRID LATER ON, WHEN THEY MADE THIS JOKE A CALLBACK TO THE IMPOSSIBLE PUZZLE ON SHLEEMY WORLD.

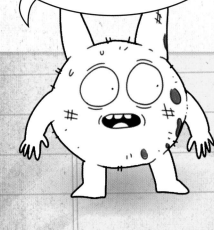

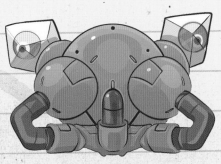

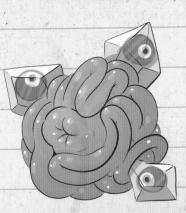

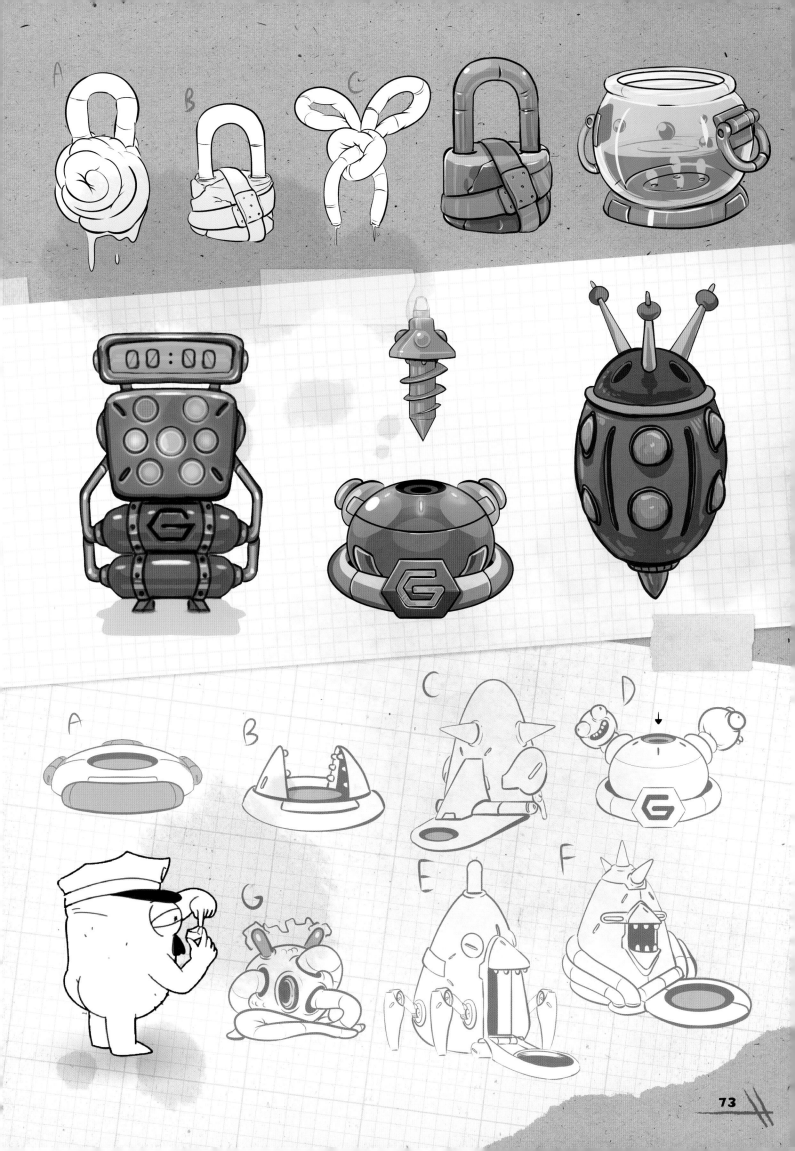

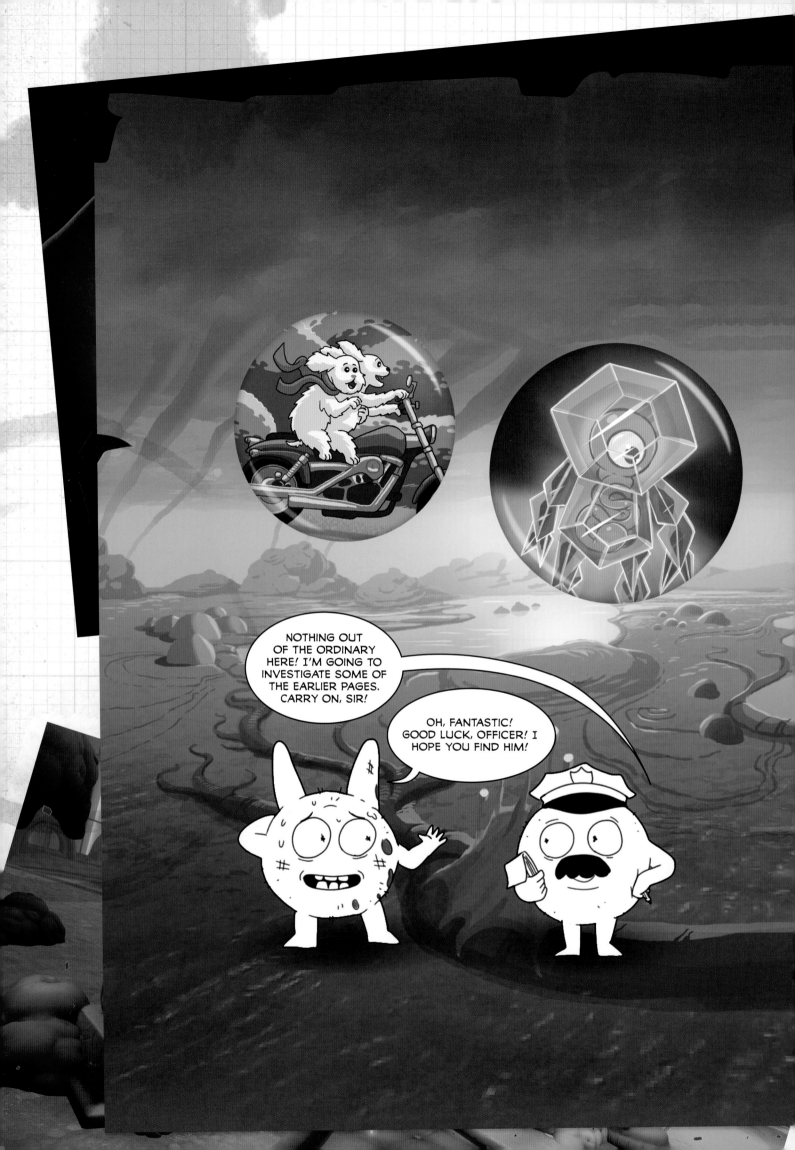

The Universe

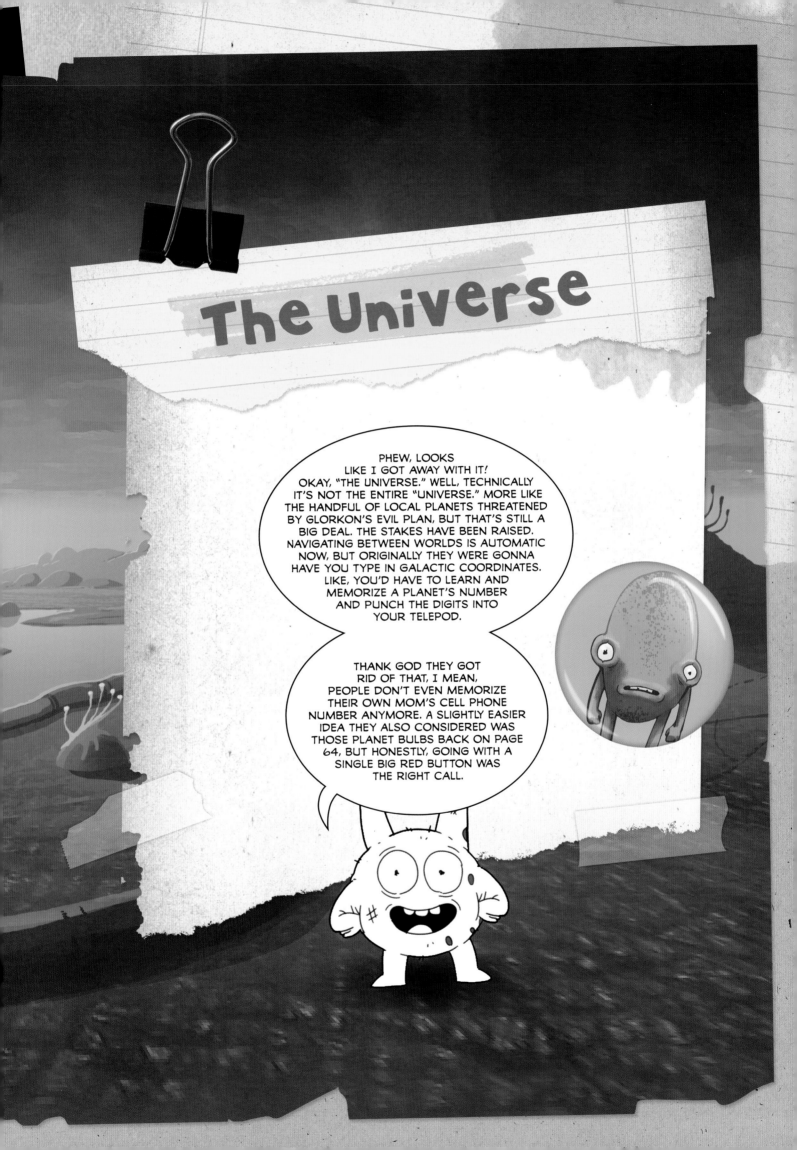

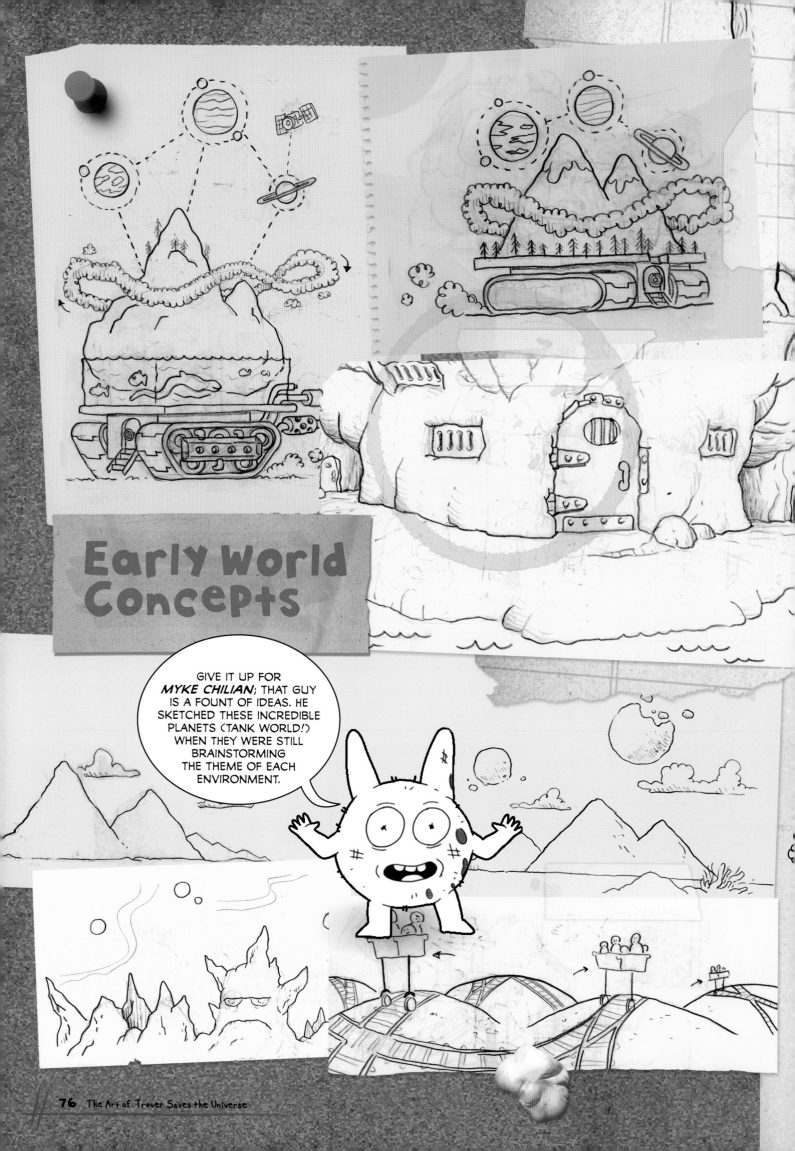

Early World Concepts

GIVE IT UP FOR **MYKE CHILIAN**; THAT GUY IS A FOUNT OF IDEAS. HE SKETCHED THESE INCREDIBLE PLANETS (TANK WORLD!) WHEN THEY WERE STILL BRAINSTORMING THE THEME OF EACH ENVIRONMENT.

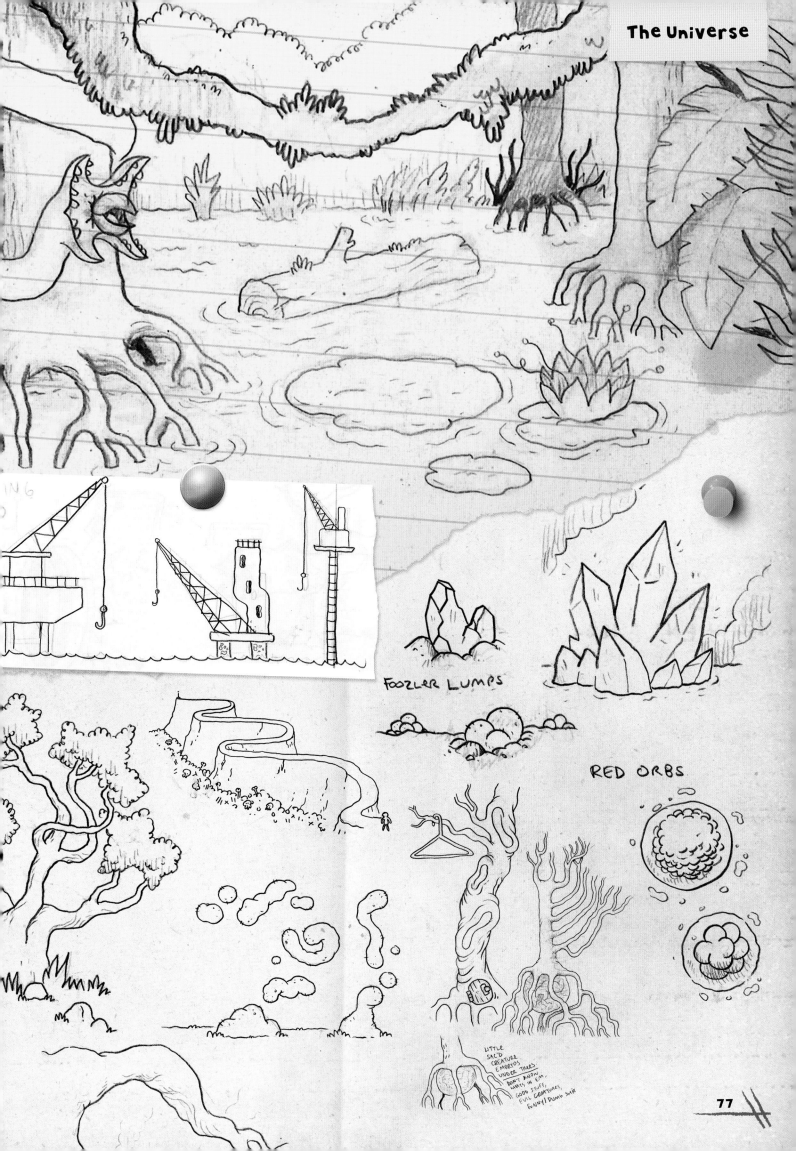

FOOZLER LUMPS

RED ORBS

LITTLE SAC'D CREATURE EMBRYOS UNDER TREES. DON'T KNOW WHATS IN EM. GOOD STUFF, EVIL CREATURES, FUNNY/ DUMB SHIT

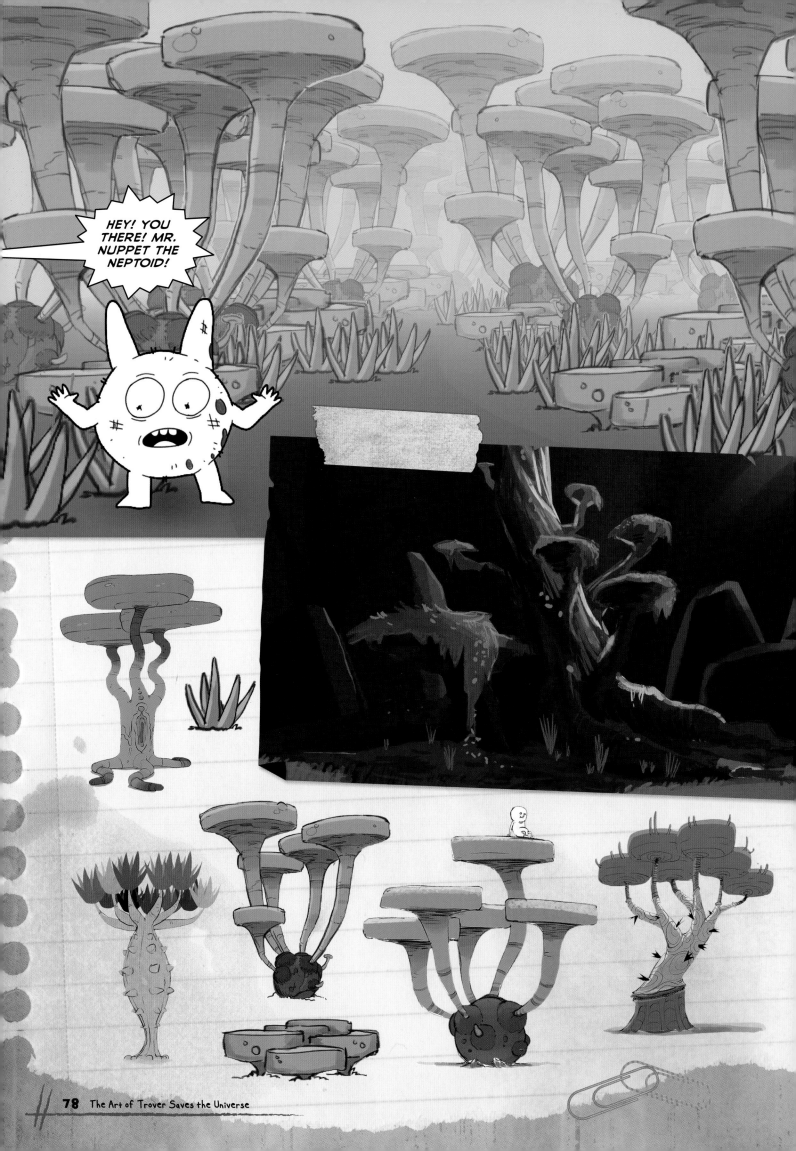

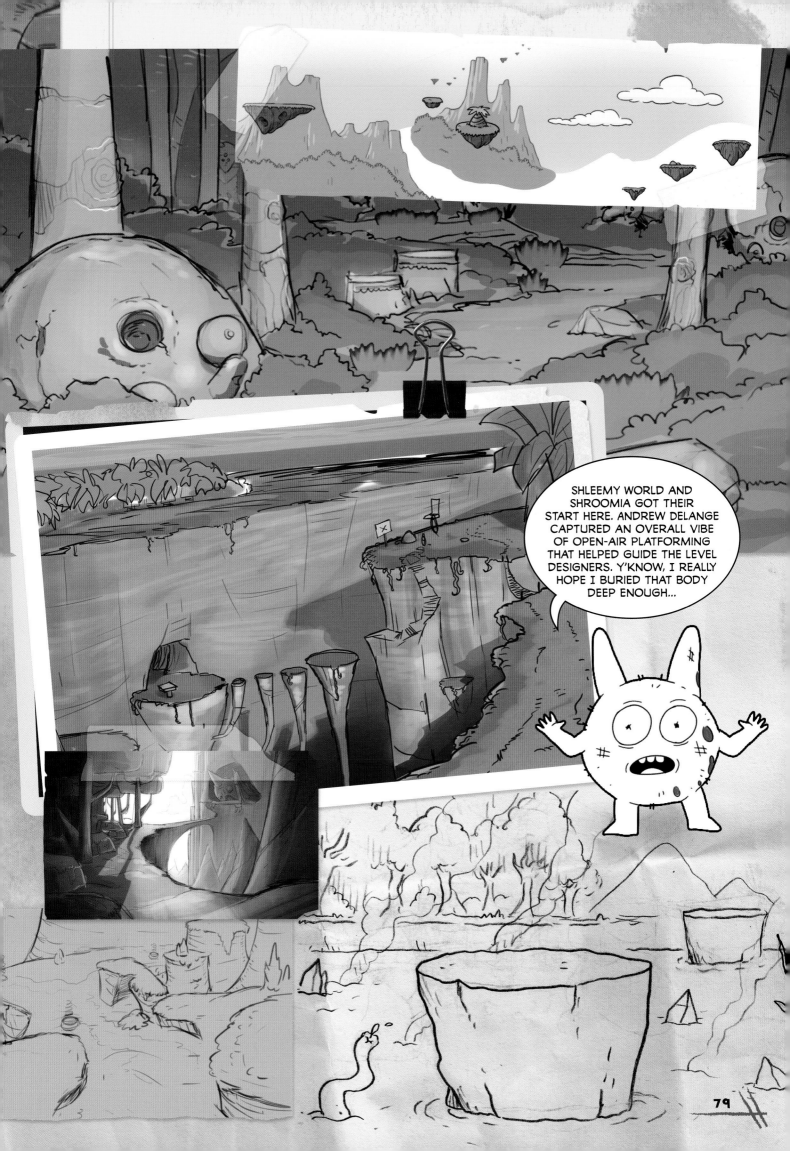

SHLEEMY WORLD AND SHROOMIA GOT THEIR START HERE. ANDREW DELANGE CAPTURED AN OVERALL VIBE OF OPEN-AIR PLATFORMING THAT HELPED GUIDE THE LEVEL DESIGNERS. Y'KNOW, I REALLY HOPE I BURIED THAT BODY DEEP ENOUGH...

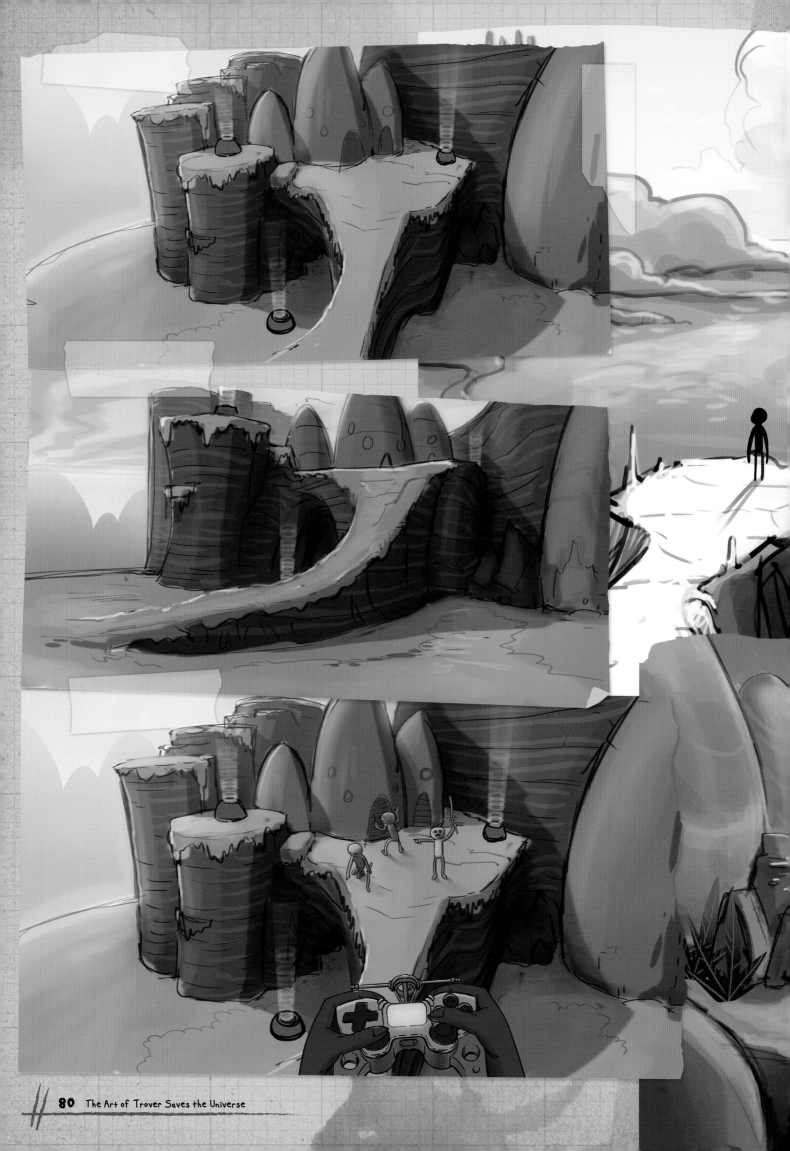

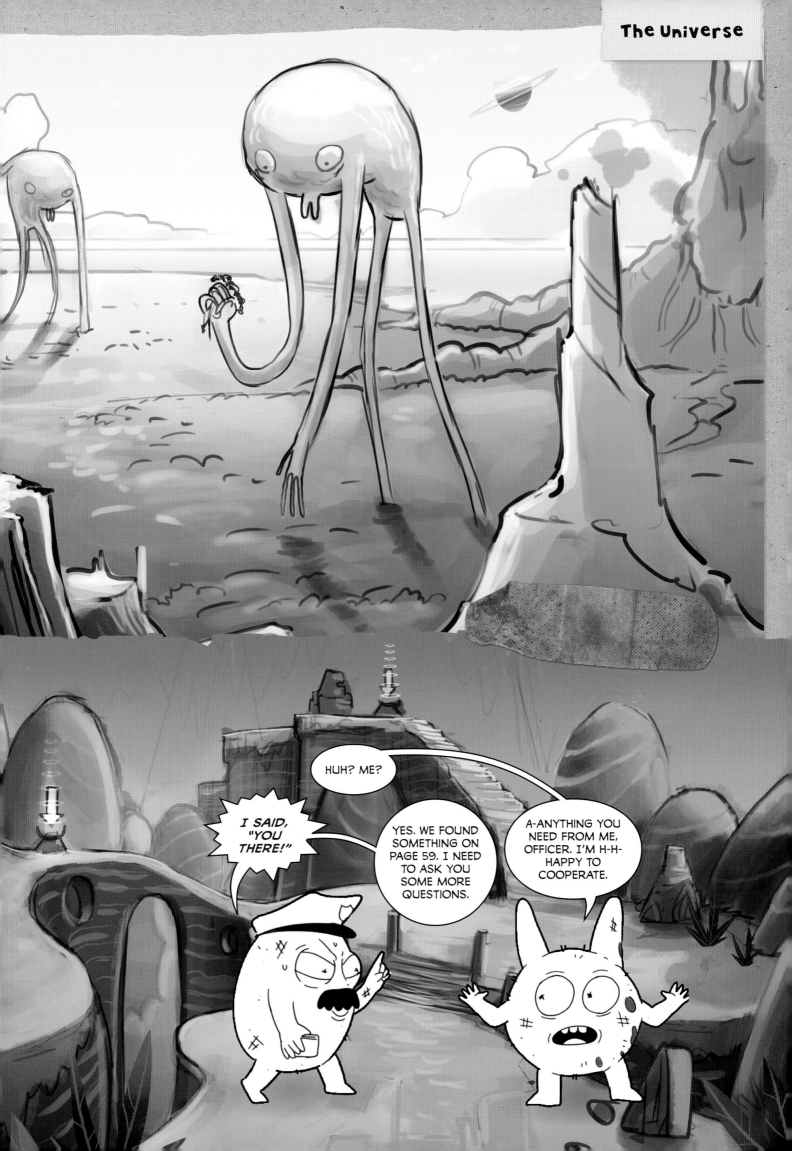

ChairorPia

THE TUTORIAL LEVEL STARTS WITH A BIT OF TRICKERY. MANY V.R. GAMES ARE SET IN A CONFINED SPACE FULL OF LITTLE GADGETS TO PLAY WITH. YOUR HOME IS MODELED AFTER THAT NORM, TO LULL THE PLAYER INTO THINKING THEY'RE IN ANOTHER ROOM-WITH-STUFF-TO-POKE-AT SIMULATOR. THEN TROVER ARRIVES, THE DOOR OPENS, AND *SURPRISE!* YOU'RE THROWN OUTDOORS INTO CHAIRORPIA AND A VERY DIFFERENT GAME.

CUT THAT OUT. IT'S NOT THE TIME FOR NARRATION. WE FOUND ZUPPET'S DEAD BODY BURIED A COUPLE DOZEN PAGES BACK.

OH MY GOD, ZUPPET'S DEAD?

DON'T PLAY *DUMB* WITH ME. YOU MUST'VE PASSED THROUGH THERE. YOU'RE TELLING ME YOU DIDN'T SEE ANYTHING SUSPICIOUS?

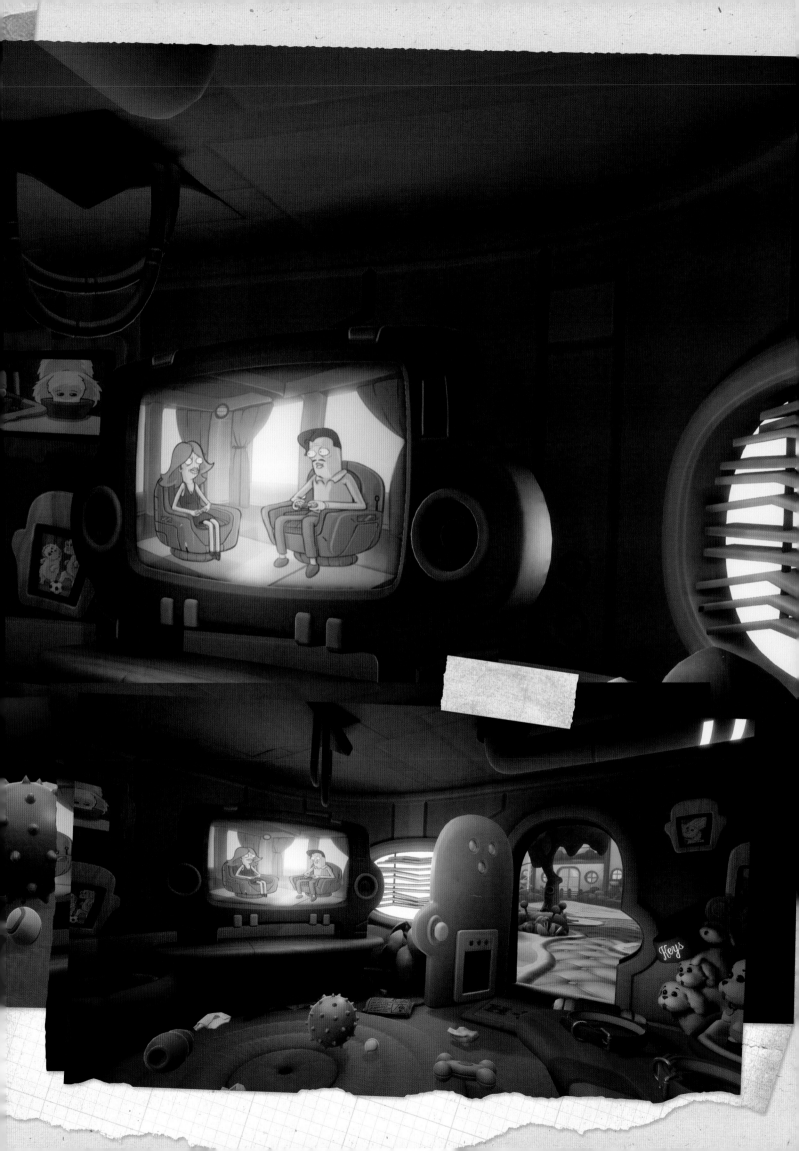

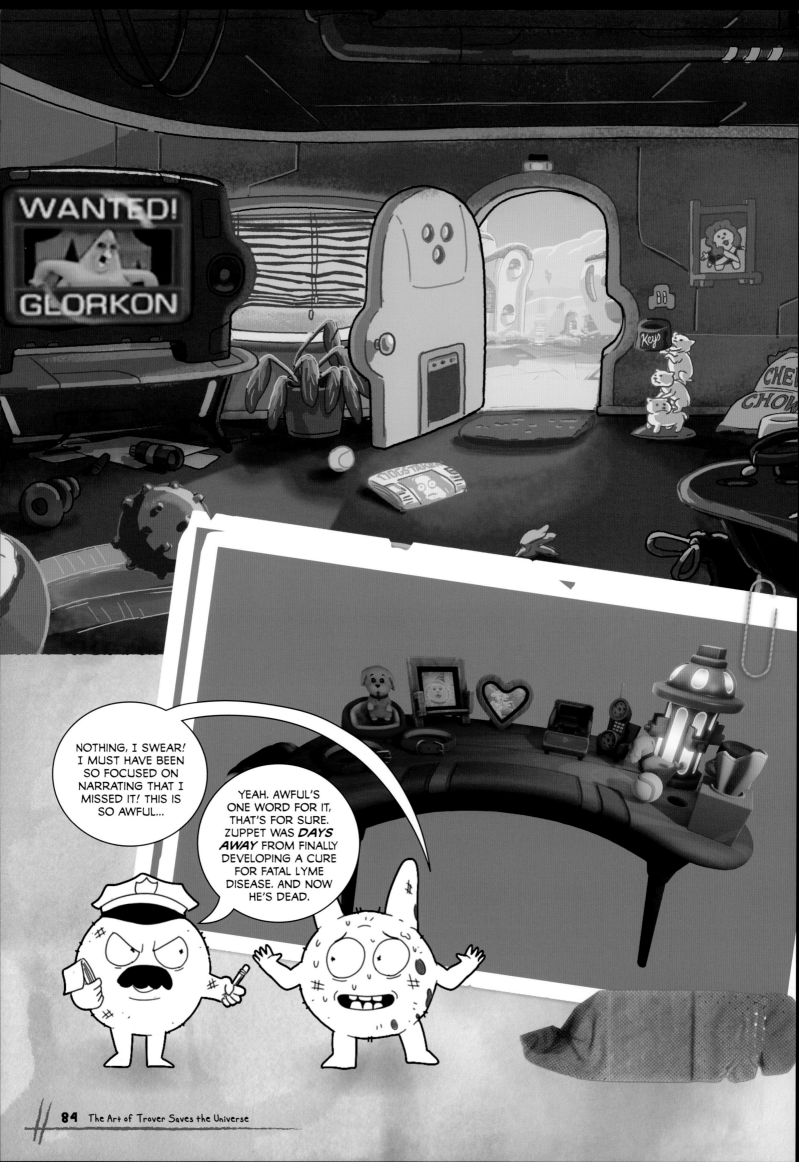

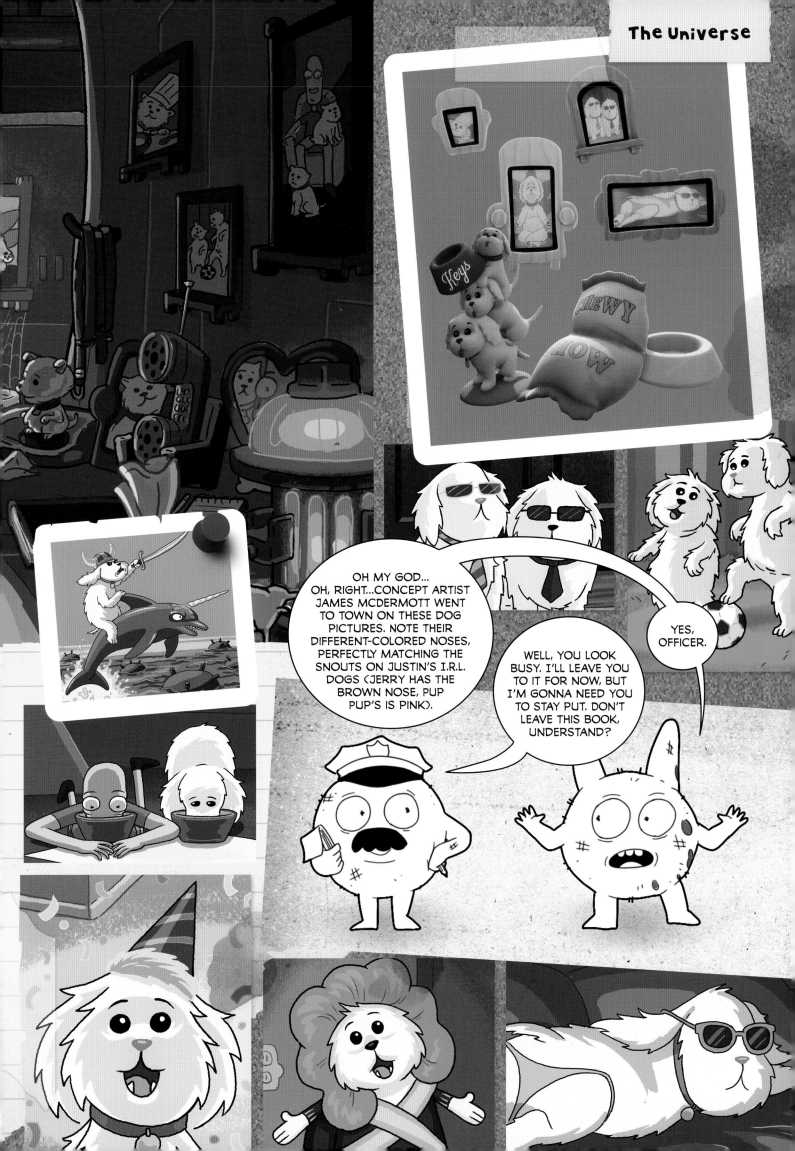

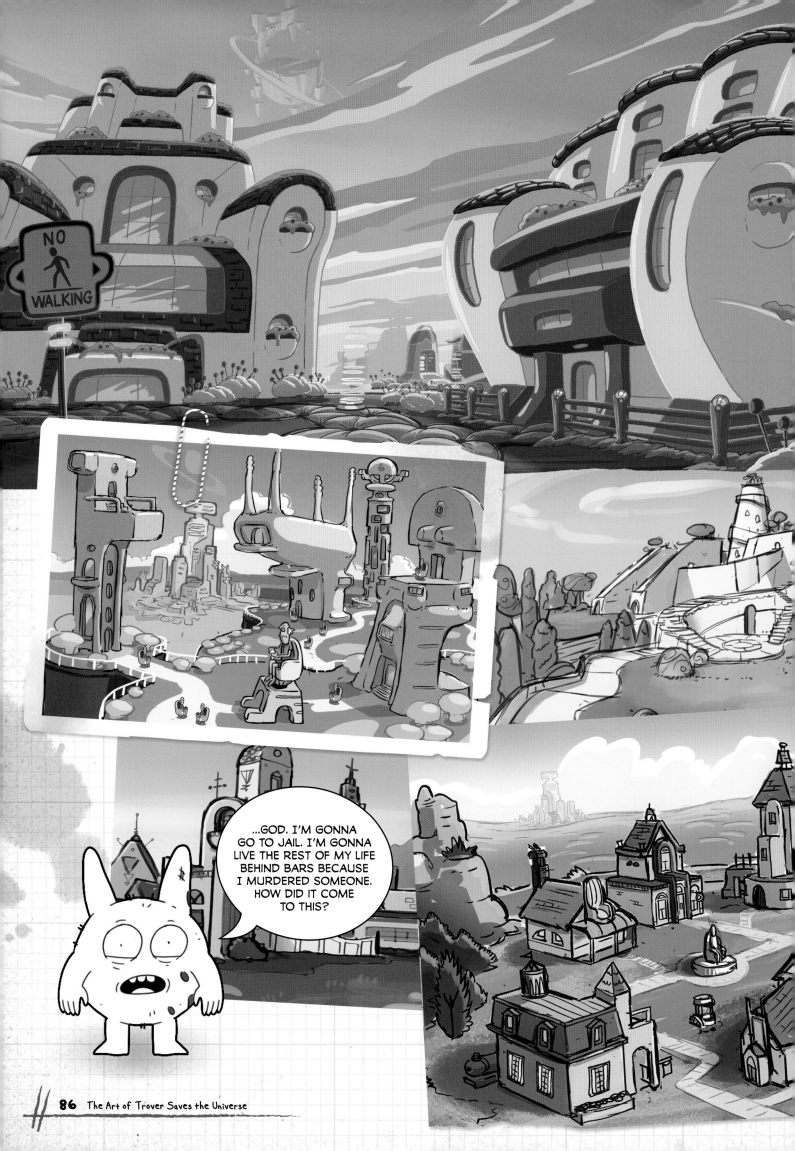

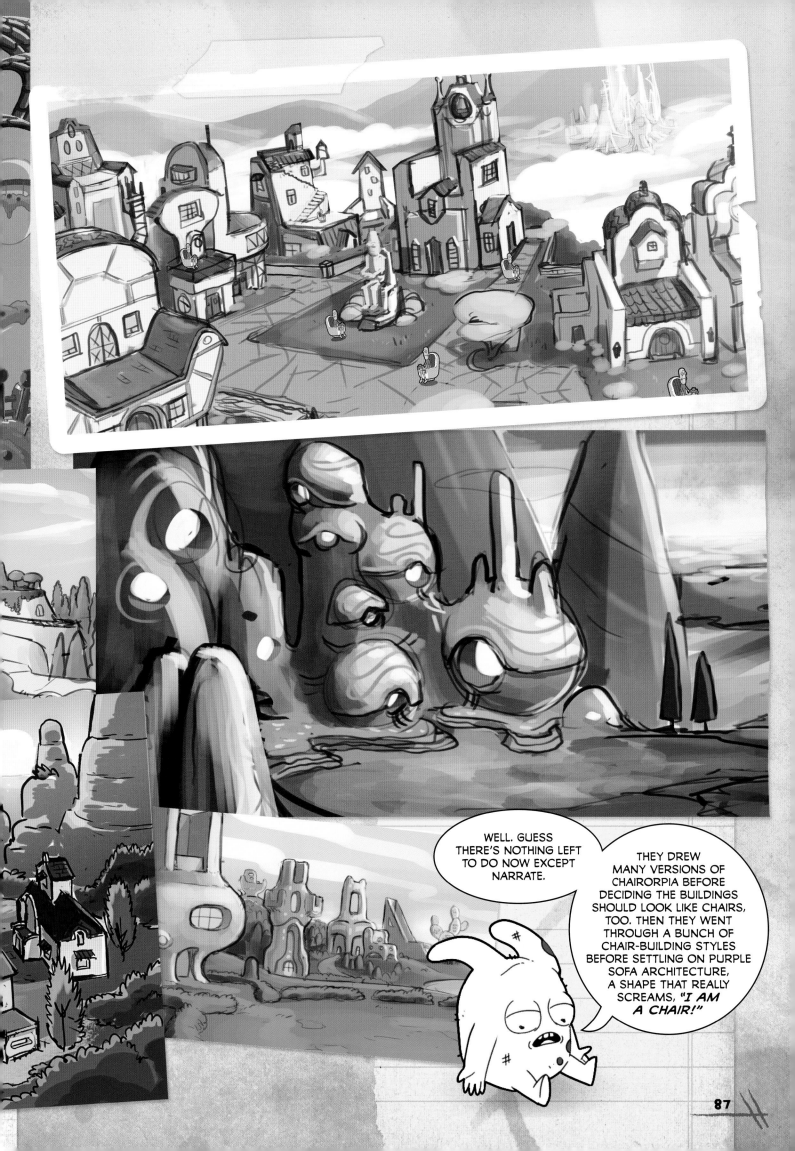

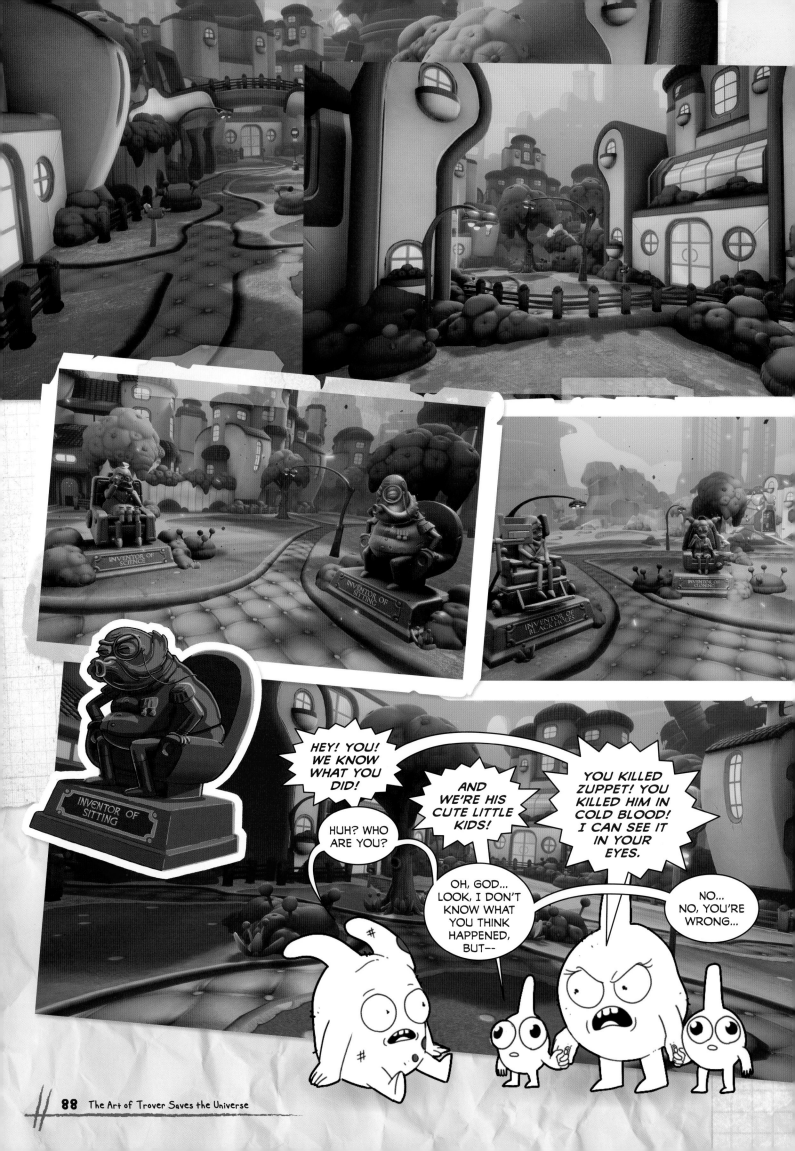

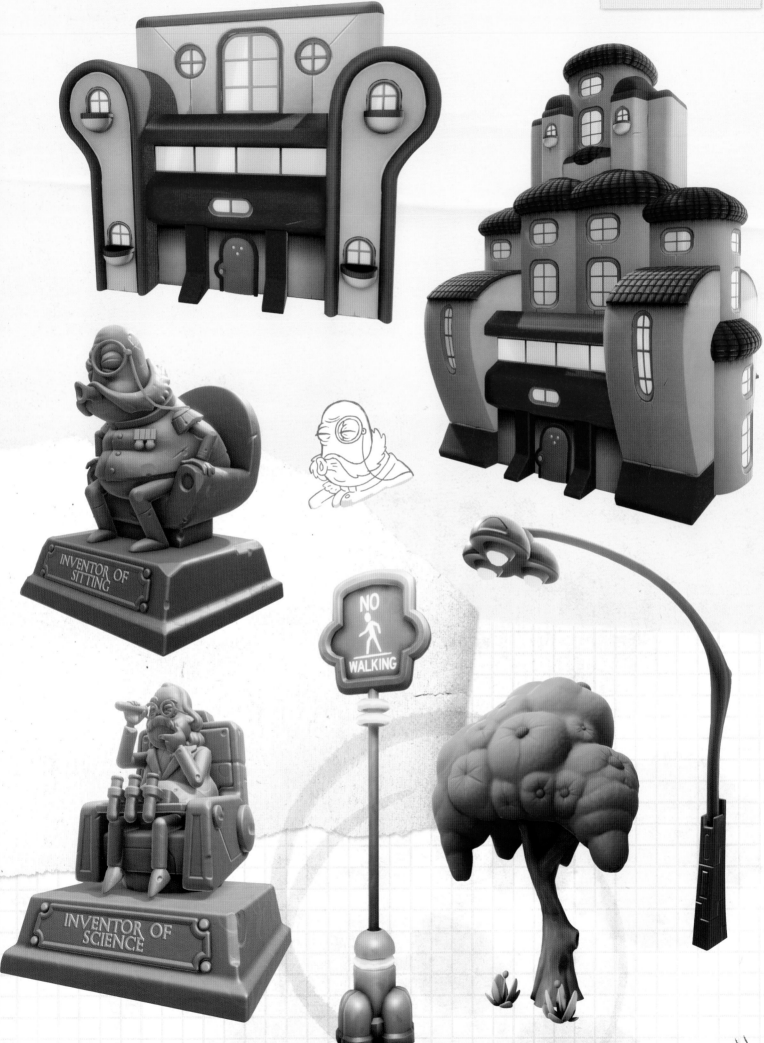

INVENTOR OF
SITTING

INVENTOR OF
SCIENCE

NO
WALKING

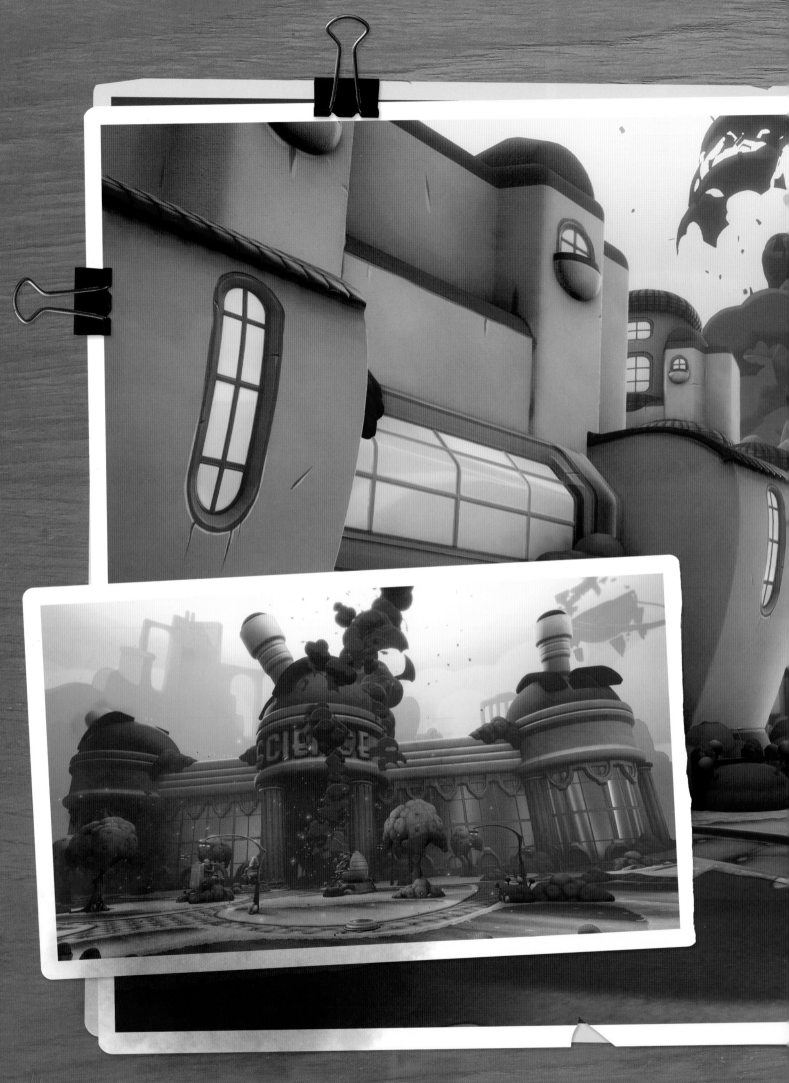

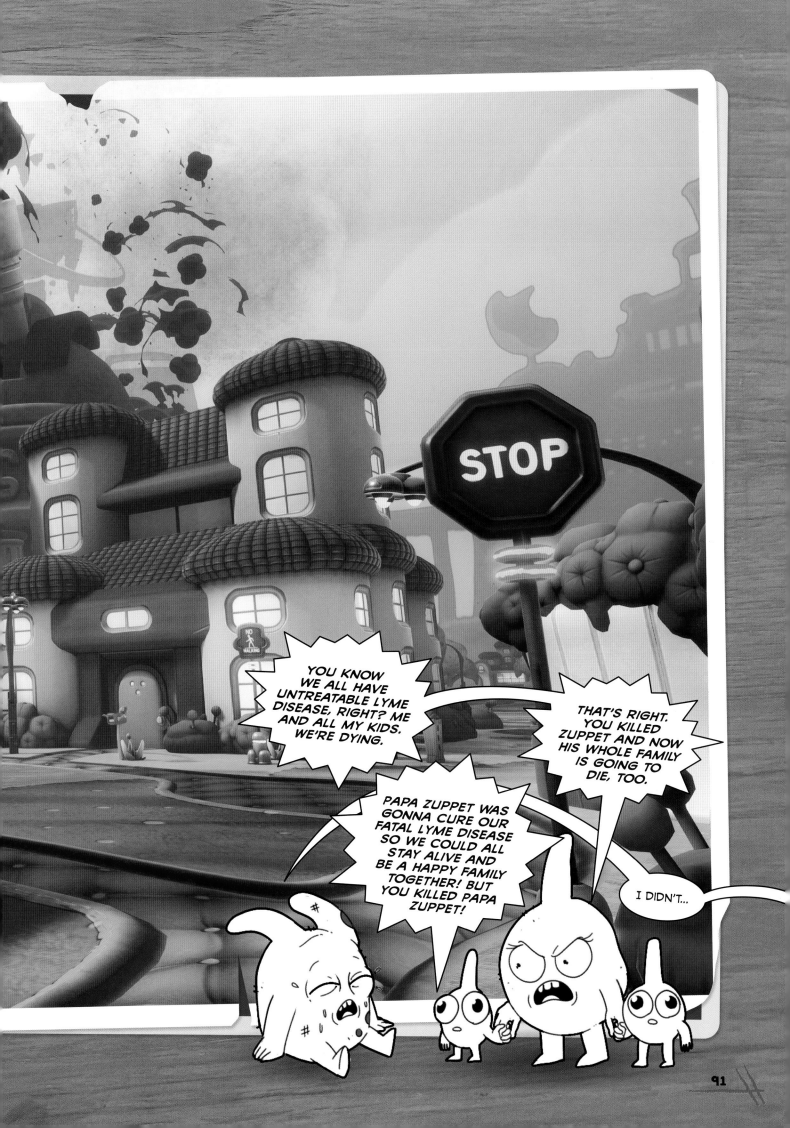

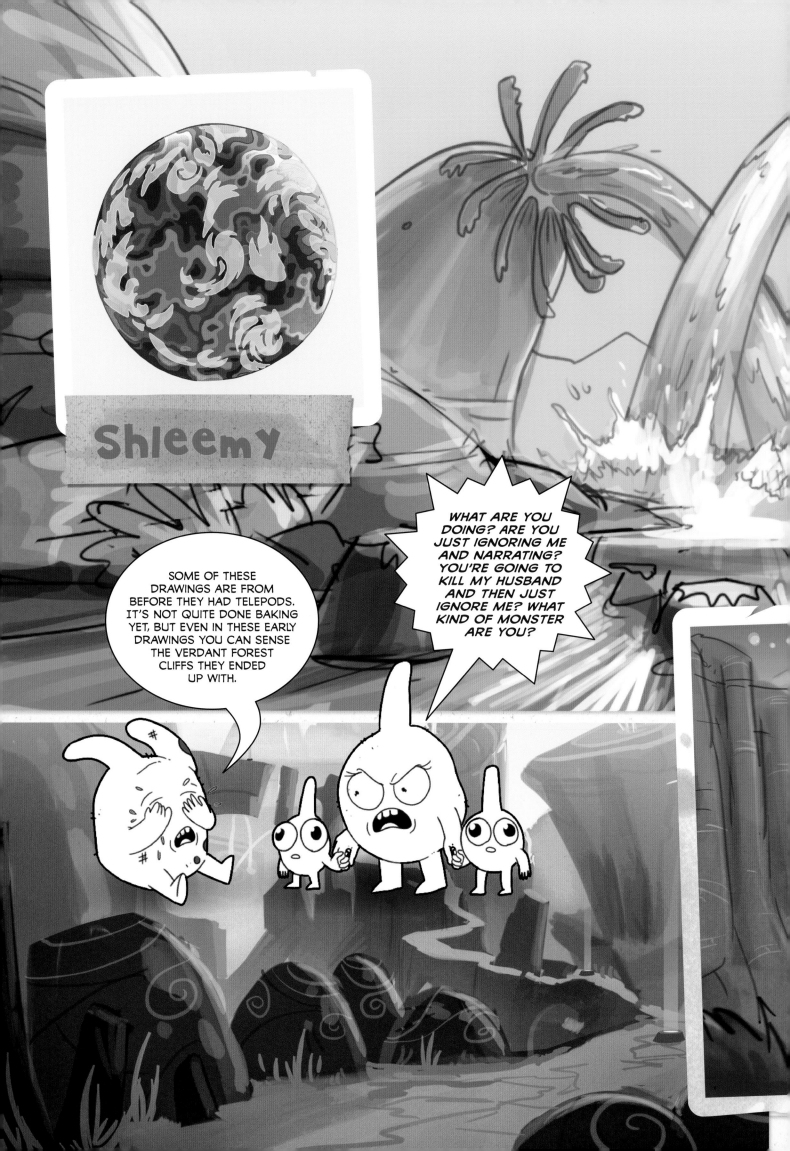

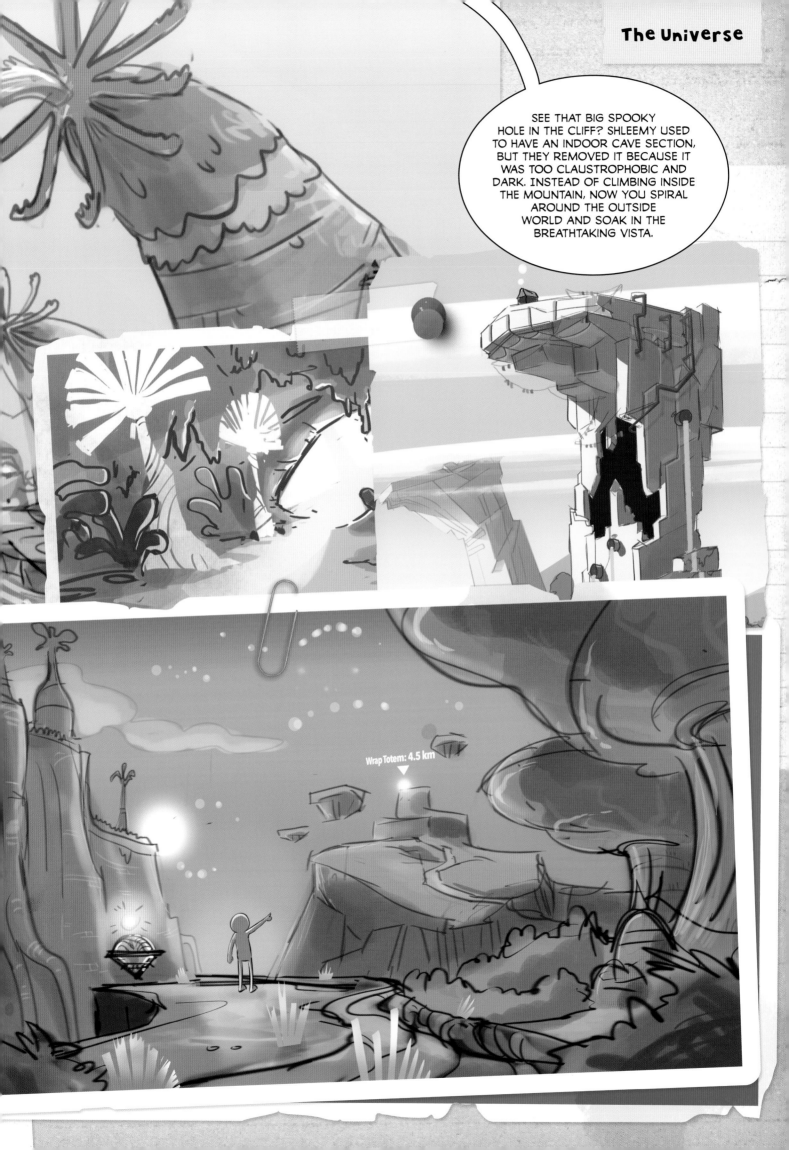

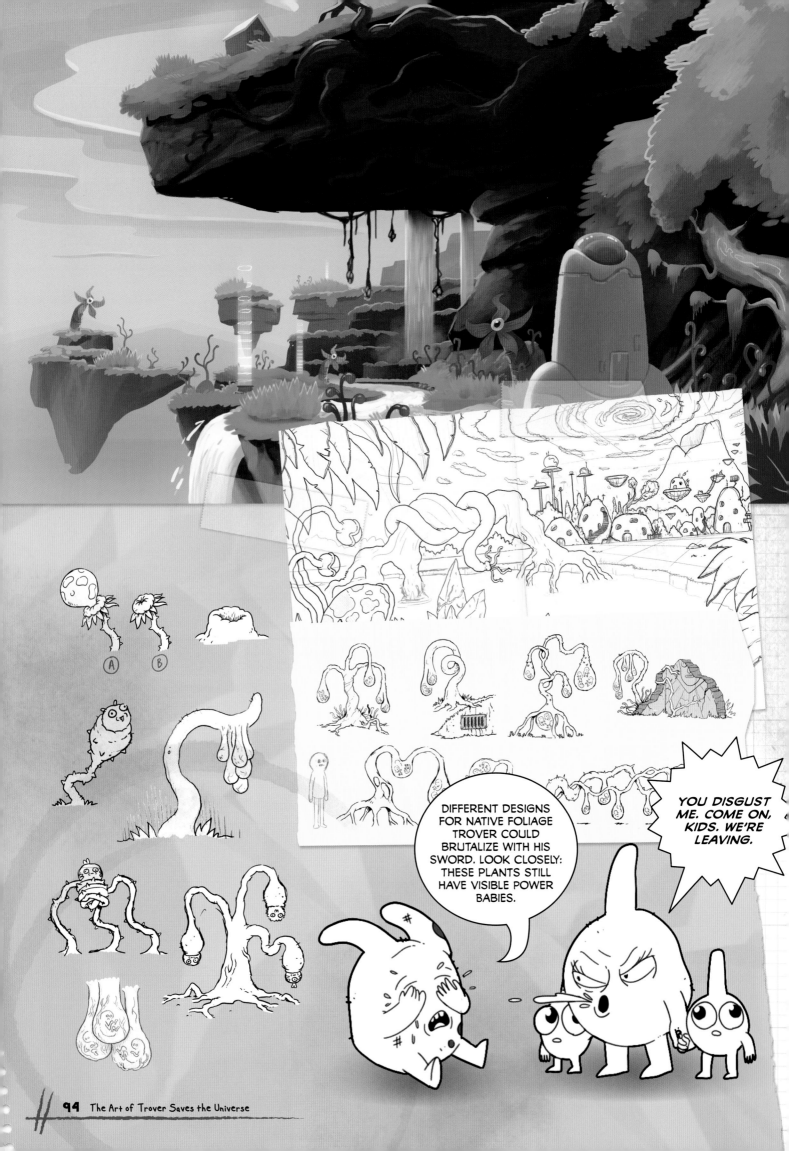

DIFFERENT DESIGNS FOR NATIVE FOLIAGE TROVER COULD BRUTALIZE WITH HIS SWORD. LOOK CLOSELY: THESE PLANTS STILL HAVE VISIBLE POWER BABIES.

YOU DISGUST ME. COME ON, KIDS. WE'RE LEAVING.

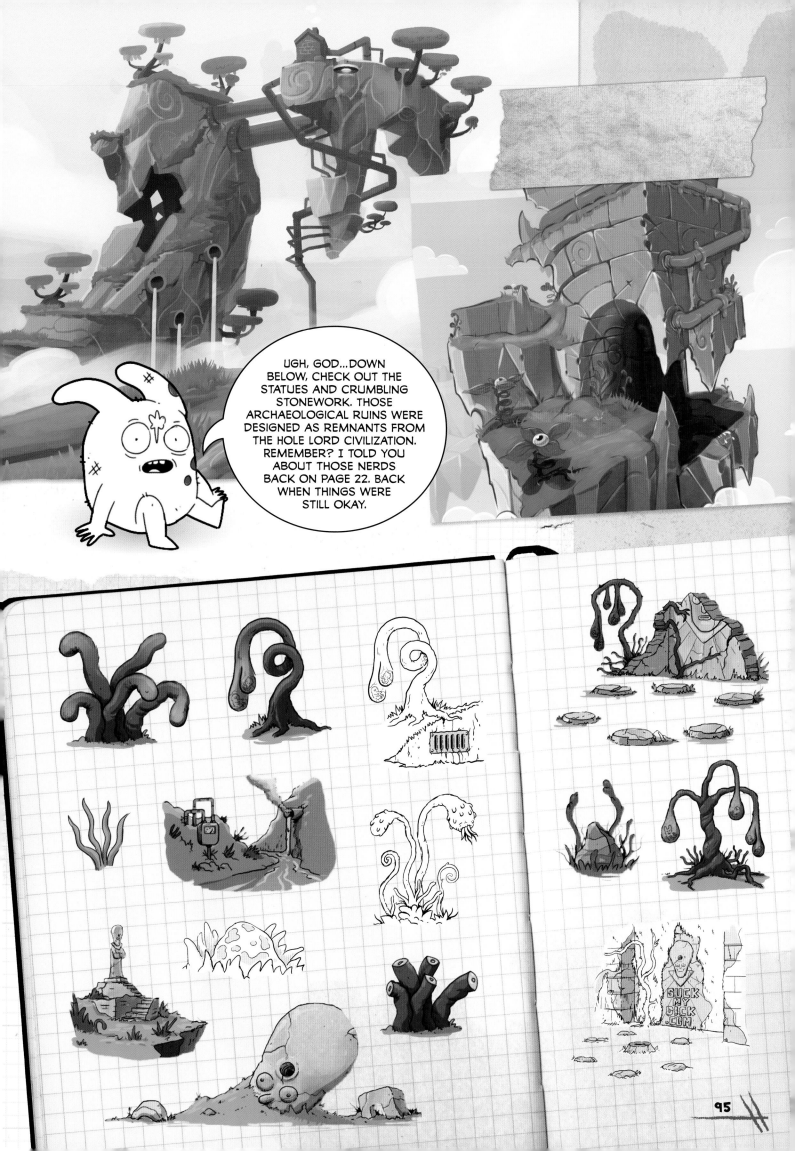

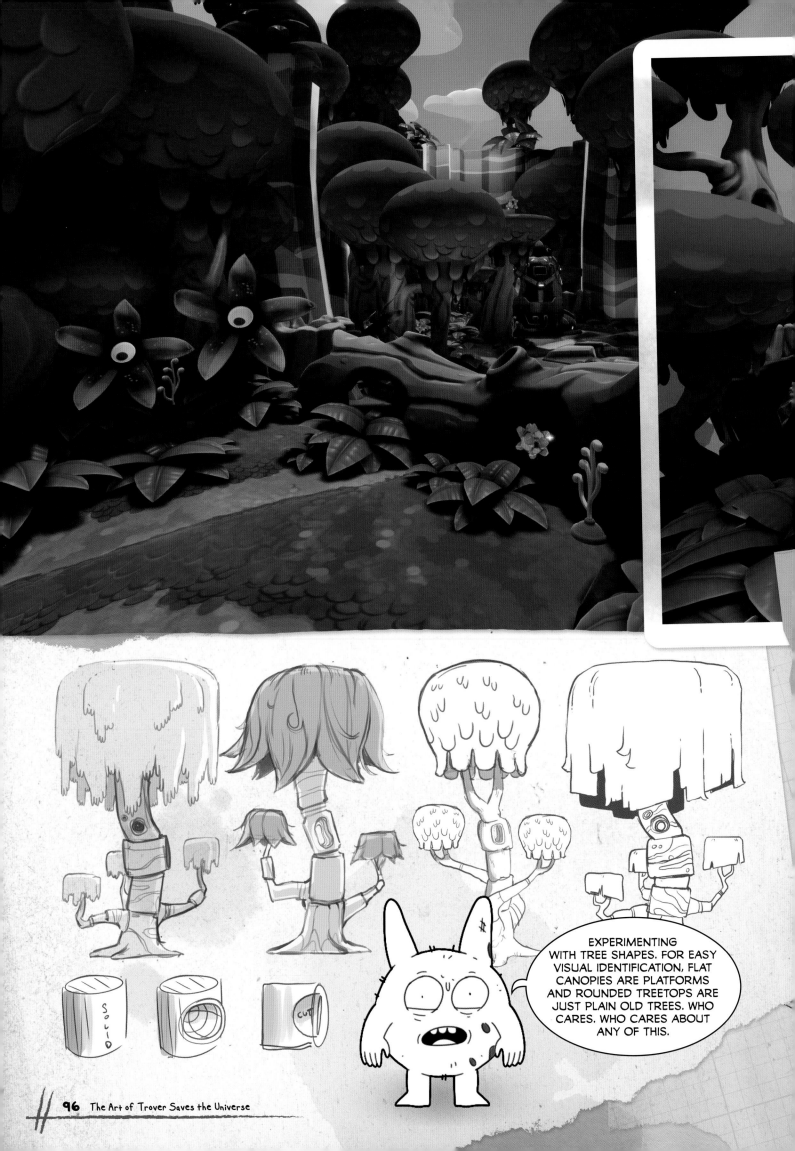

EXPERIMENTING WITH TREE SHAPES. FOR EASY VISUAL IDENTIFICATION, FLAT CANOPIES ARE PLATFORMS AND ROUNDED TREETOPS ARE JUST PLAIN OLD TREES. WHO CARES. WHO CARES ABOUT ANY OF THIS.

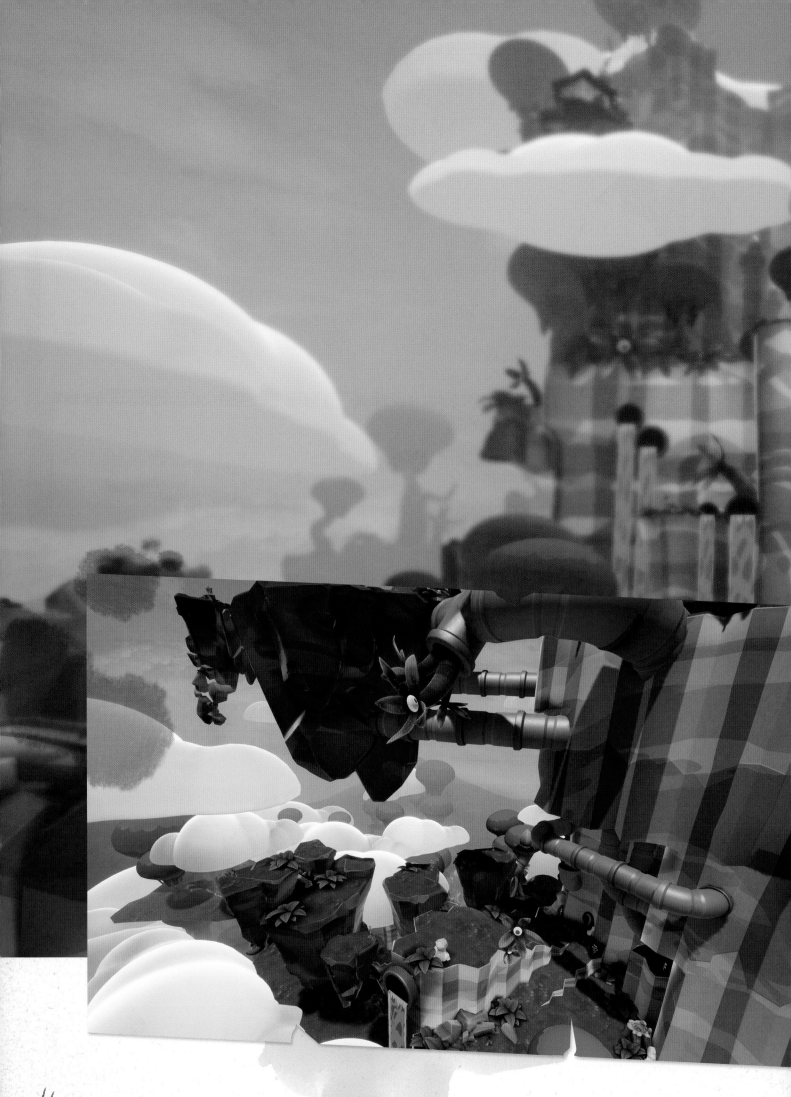

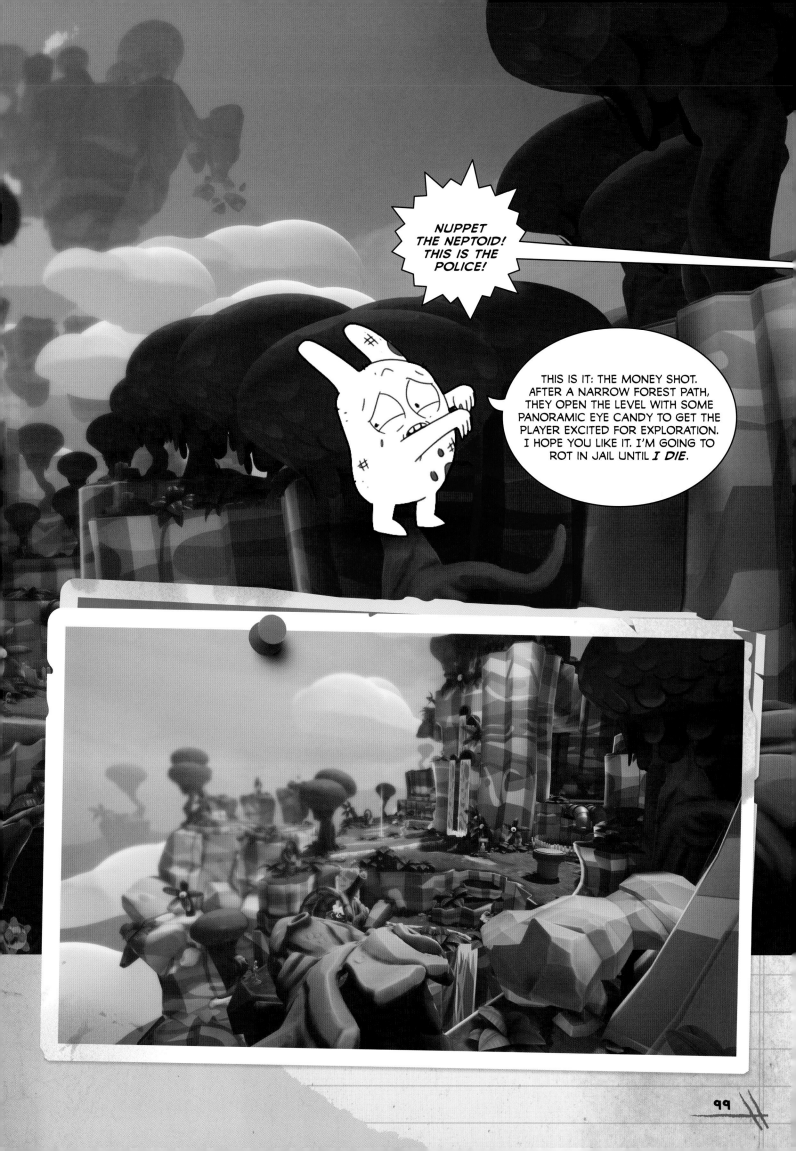

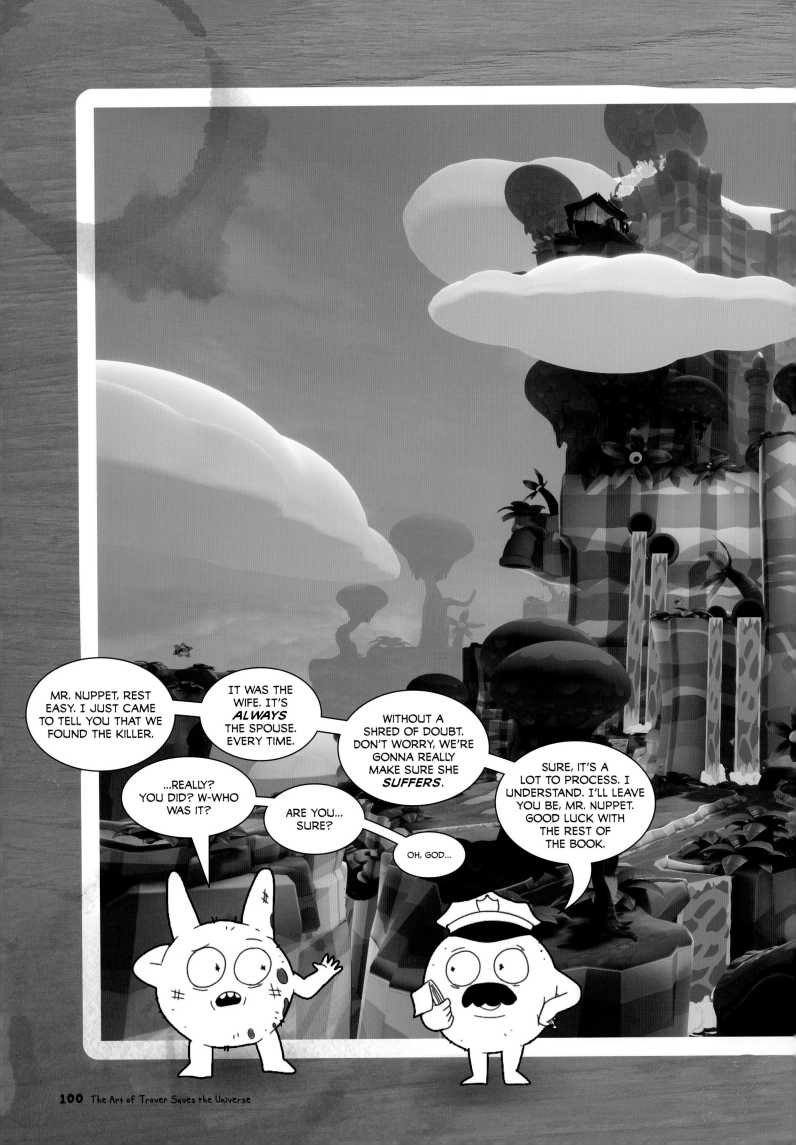

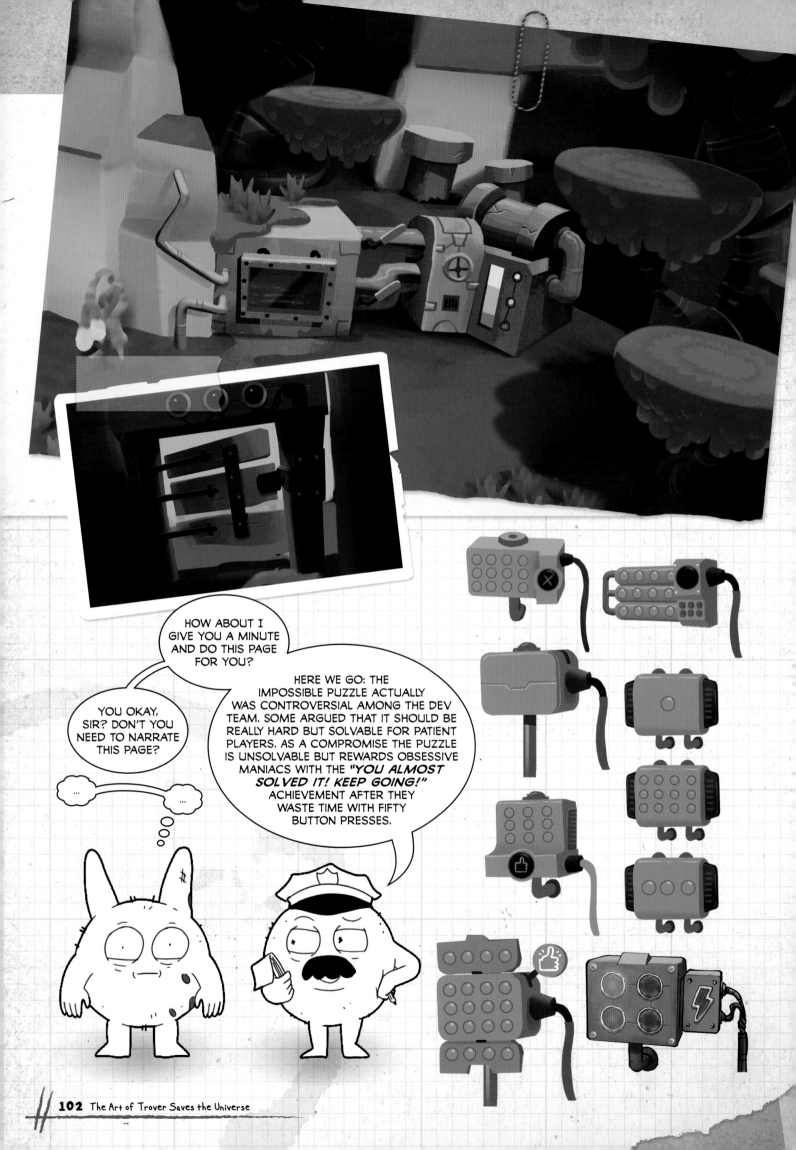

HOW ABOUT I GIVE YOU A MINUTE AND DO THIS PAGE FOR YOU?

YOU OKAY, SIR? DON'T YOU NEED TO NARRATE THIS PAGE?

... ...

HERE WE GO: THE IMPOSSIBLE PUZZLE ACTUALLY WAS CONTROVERSIAL AMONG THE DEV TEAM. SOME ARGUED THAT IT SHOULD BE REALLY HARD BUT SOLVABLE FOR PATIENT PLAYERS. AS A COMPROMISE THE PUZZLE IS UNSOLVABLE BUT REWARDS OBSESSIVE MANIACS WITH THE *"YOU ALMOST SOLVED IT! KEEP GOING!"* ACHIEVEMENT AFTER THEY WASTE TIME WITH FIFTY BUTTON PRESSES.

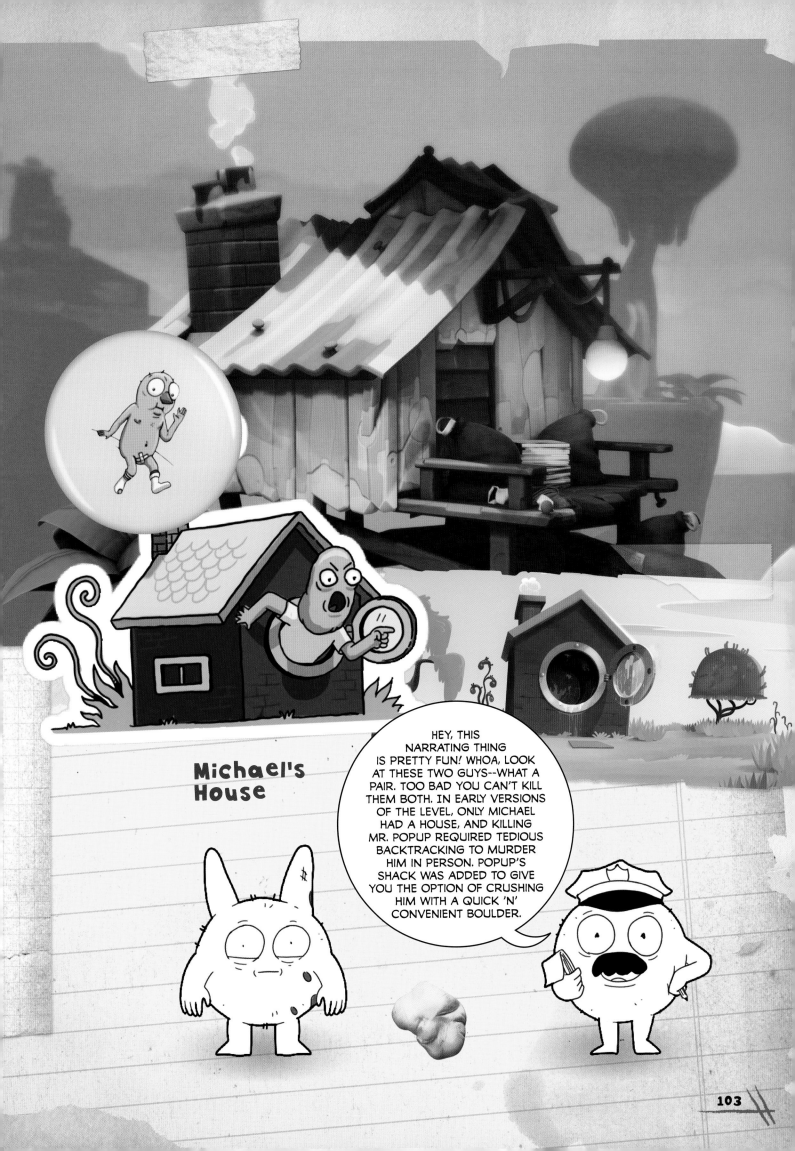

Michael's House

HEY, THIS NARRATING THING IS PRETTY FUN! WHOA, LOOK AT THESE TWO GUYS--WHAT A PAIR. TOO BAD YOU CAN'T KILL THEM BOTH. IN EARLY VERSIONS OF THE LEVEL, ONLY MICHAEL HAD A HOUSE, AND KILLING MR. POPUP REQUIRED TEDIOUS BACKTRACKING TO MURDER HIM IN PERSON. POPUP'S SHACK WAS ADDED TO GIVE YOU THE OPTION OF CRUSHING HIM WITH A QUICK 'N' CONVENIENT BOULDER.

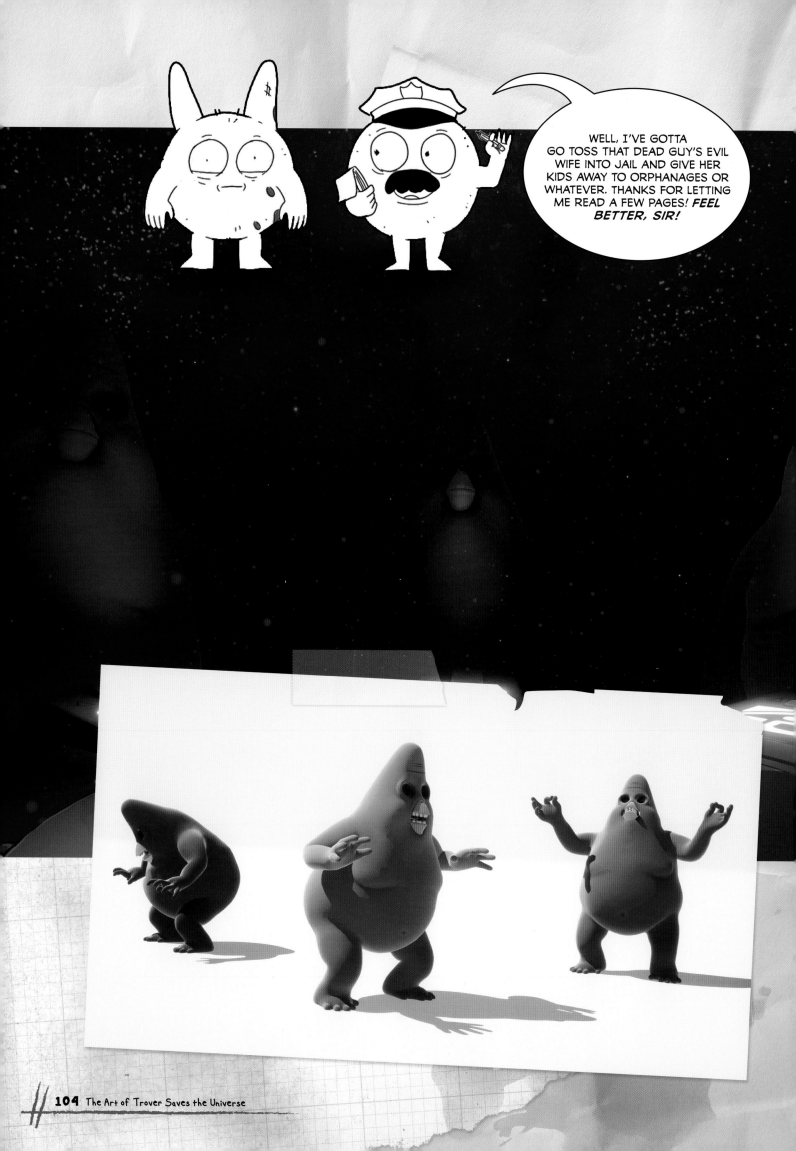

Abstainer Inner Sanctum

HA HA HA. NARRATION. SURE.
HUGE AND LOOMING, THE ABSTAINERS WERE MADE
TO LOOK COOL AS HELL IN V.R. THE PLAYER FEELS LIKE THEY'RE
REALLY STANDING IN A MYSTERIOUS FOGGY VOID TALKING
TO SOME MYSTERIOUS GIANTS. THEIR SANCTUM IS AN
EXPOSITION ZONE, SO THEY KEPT THE ENVIRONMENT
CLEAN AND SIMPLE TO KEEP
FOCUS ON THE STORY.

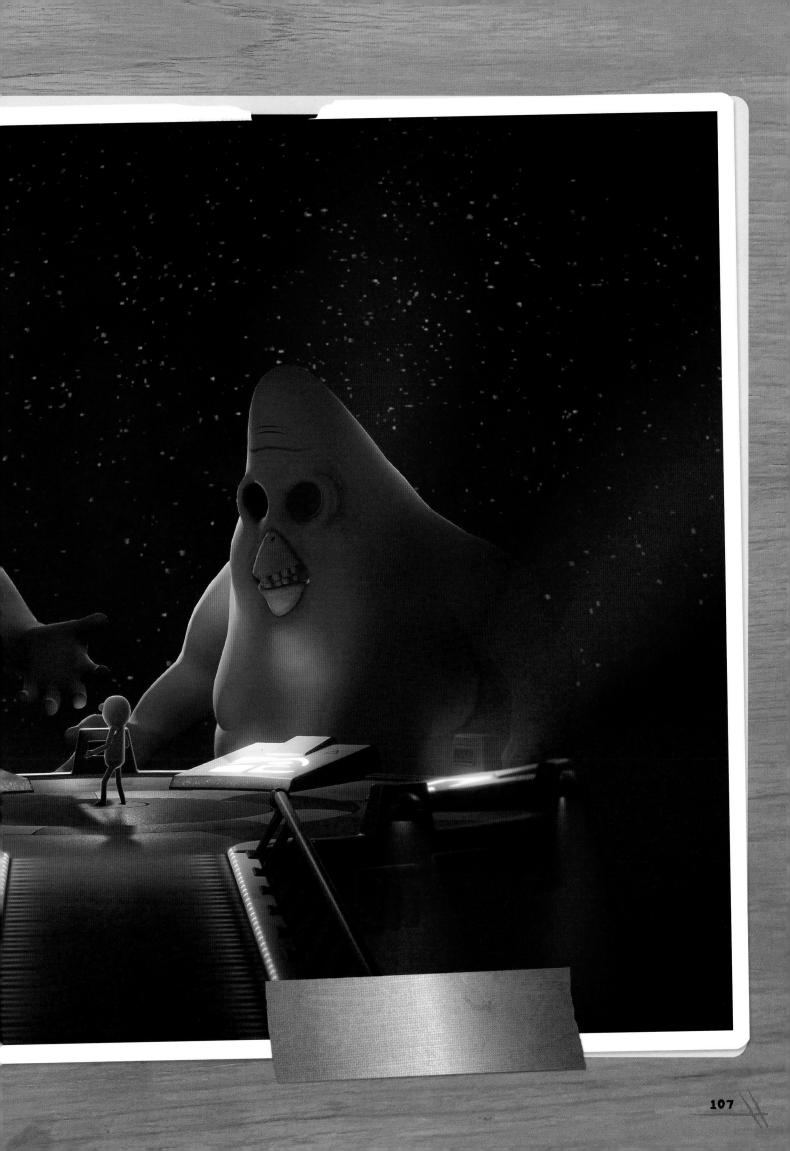

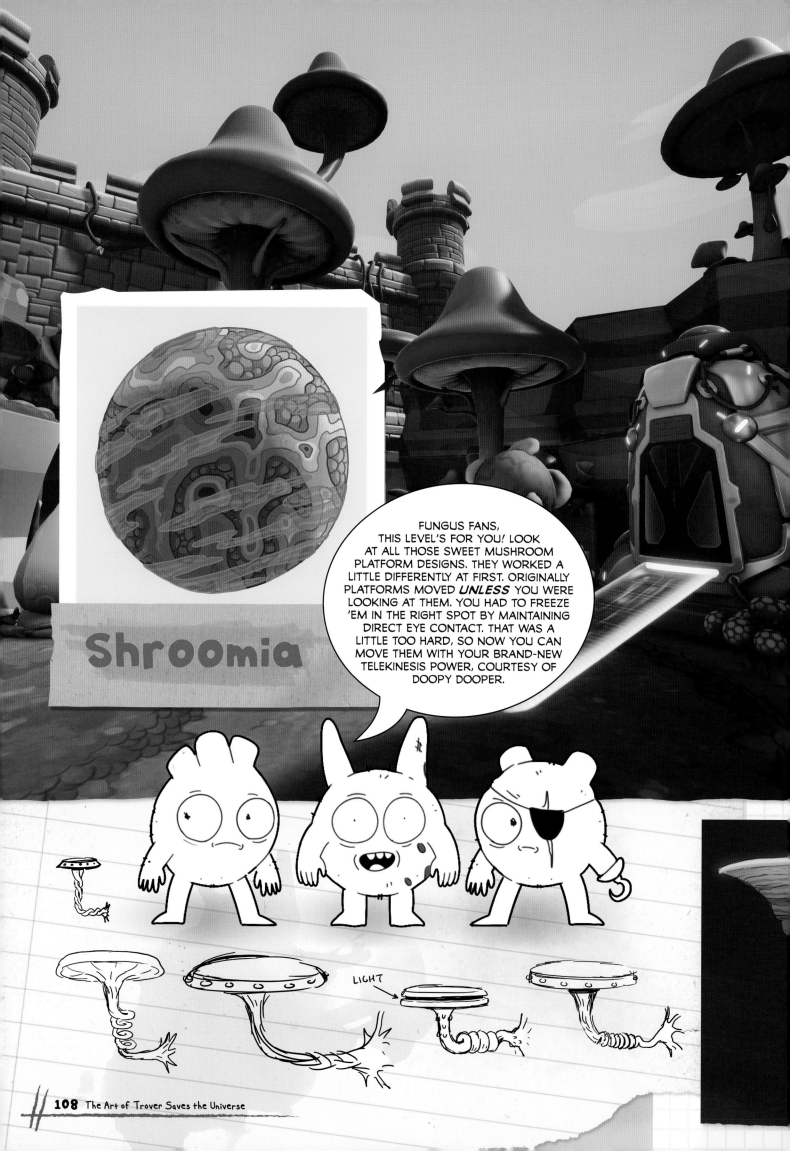

Shroomia

FUNGUS FANS, THIS LEVEL'S FOR YOU! LOOK AT ALL THOSE SWEET MUSHROOM PLATFORM DESIGNS. THEY WORKED A LITTLE DIFFERENTLY AT FIRST. ORIGINALLY PLATFORMS MOVED *UNLESS* YOU WERE LOOKING AT THEM. YOU HAD TO FREEZE 'EM IN THE RIGHT SPOT BY MAINTAINING DIRECT EYE CONTACT. THAT WAS A LITTLE TOO HARD, SO NOW YOU CAN MOVE THEM WITH YOUR BRAND-NEW TELEKINESIS POWER, COURTESY OF DOOPY DOOPER.

LIGHT

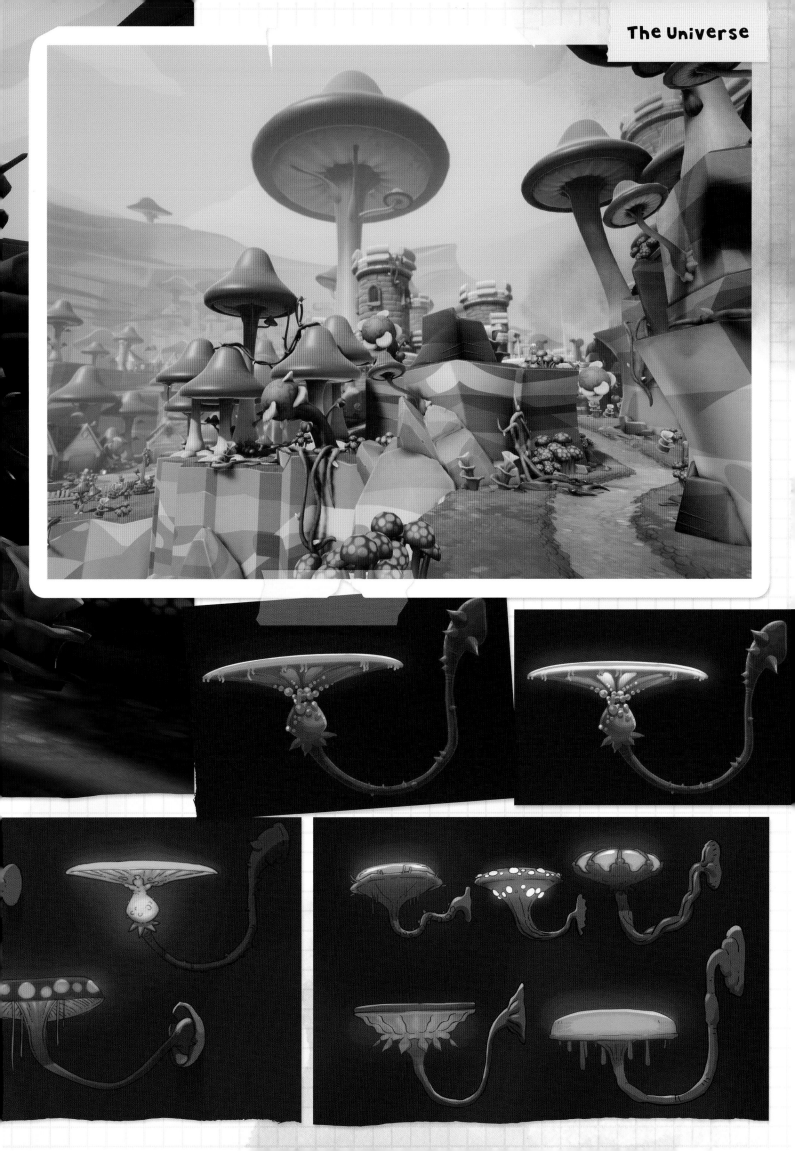

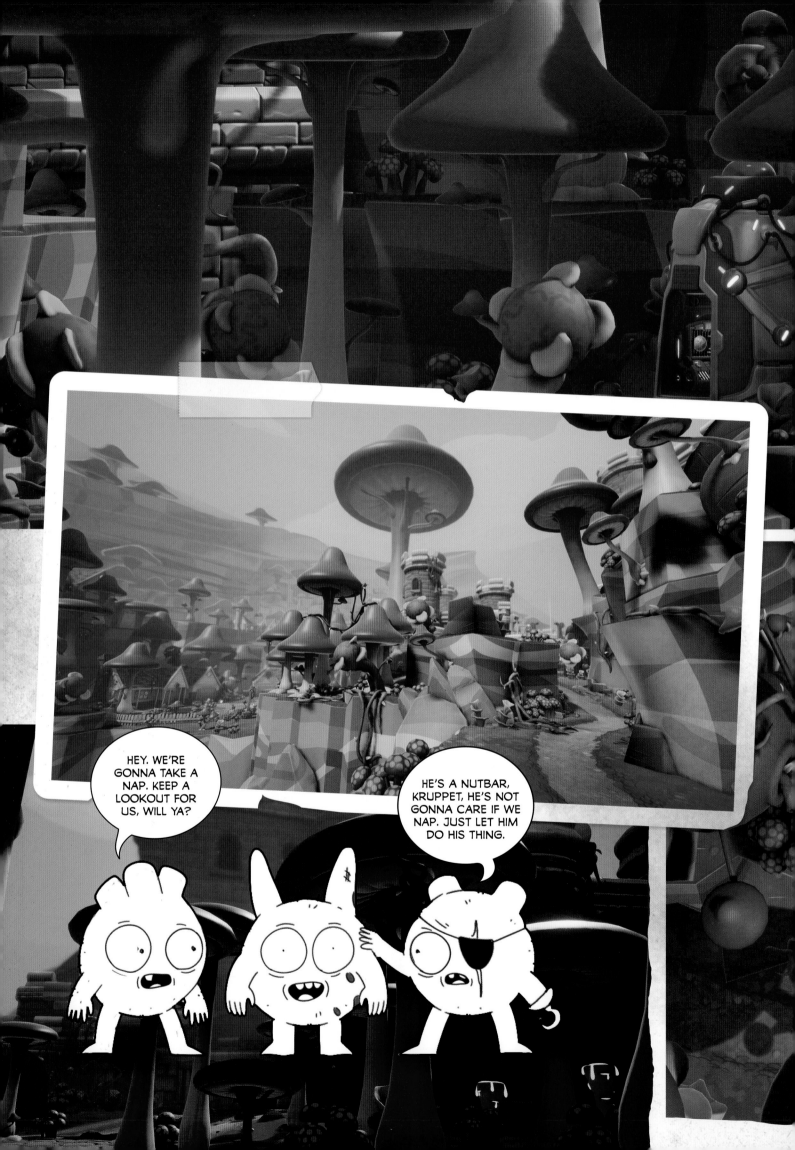

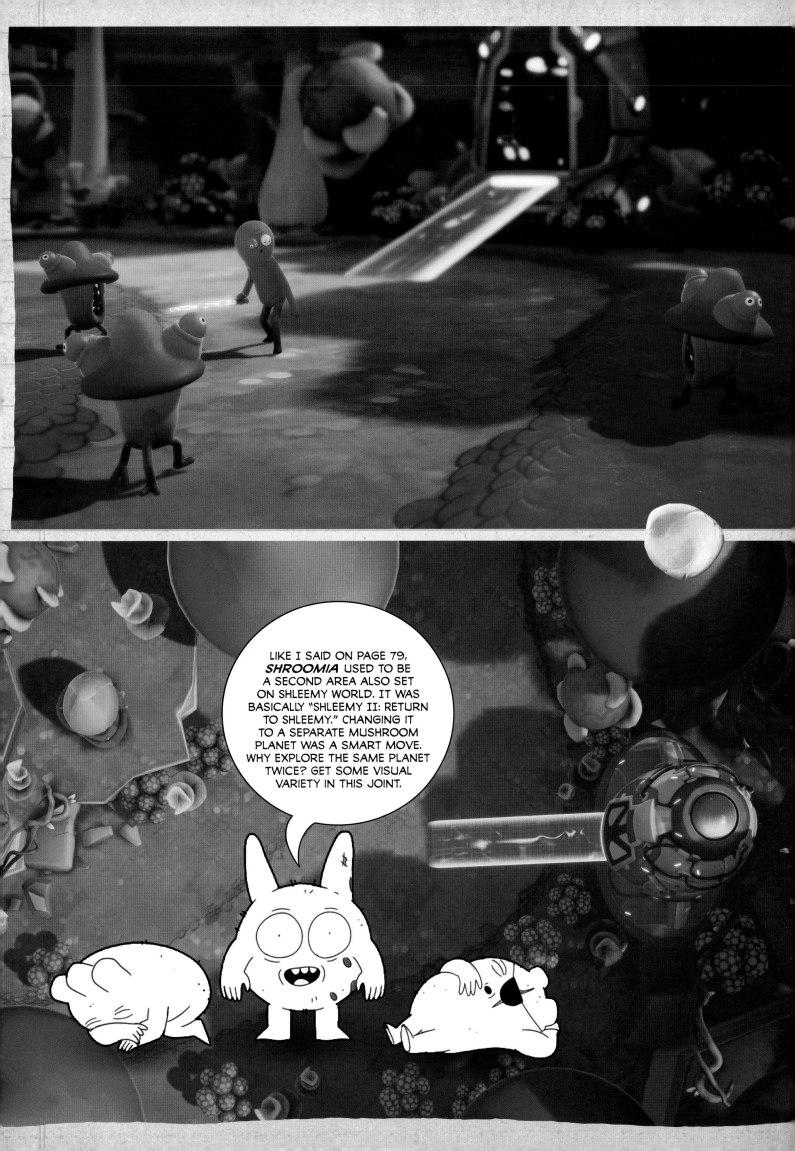

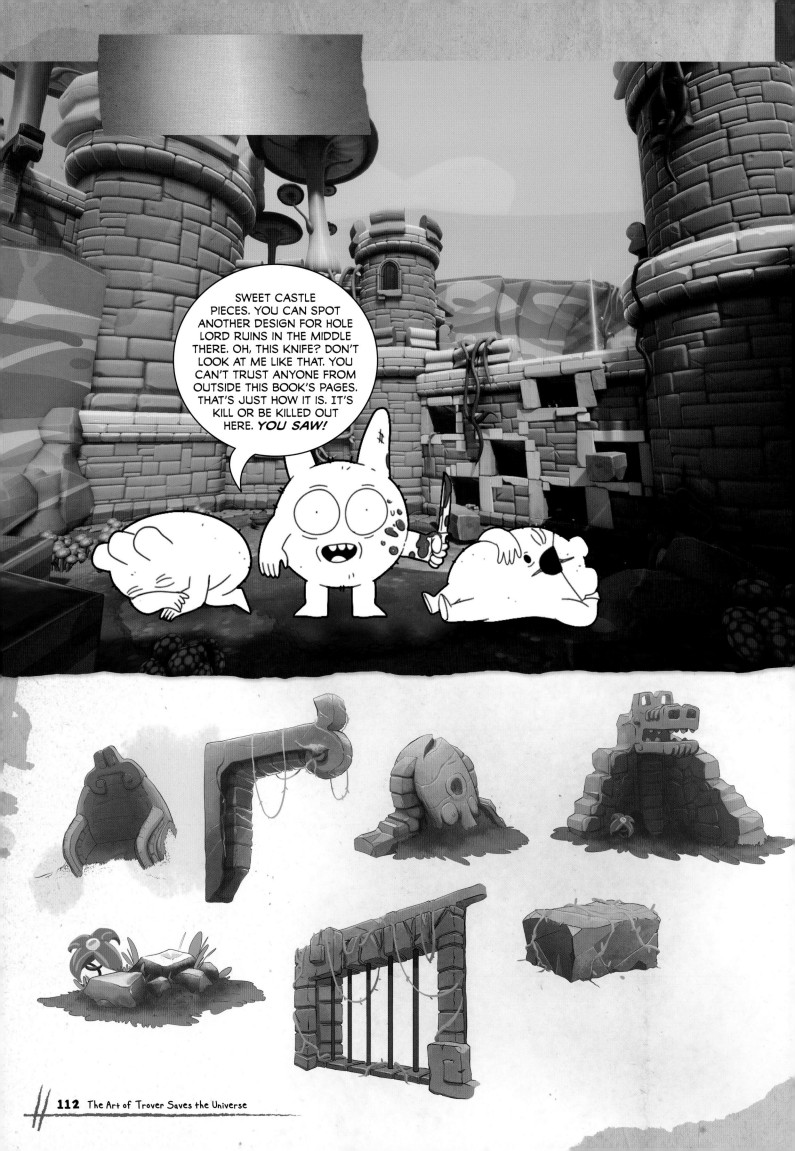

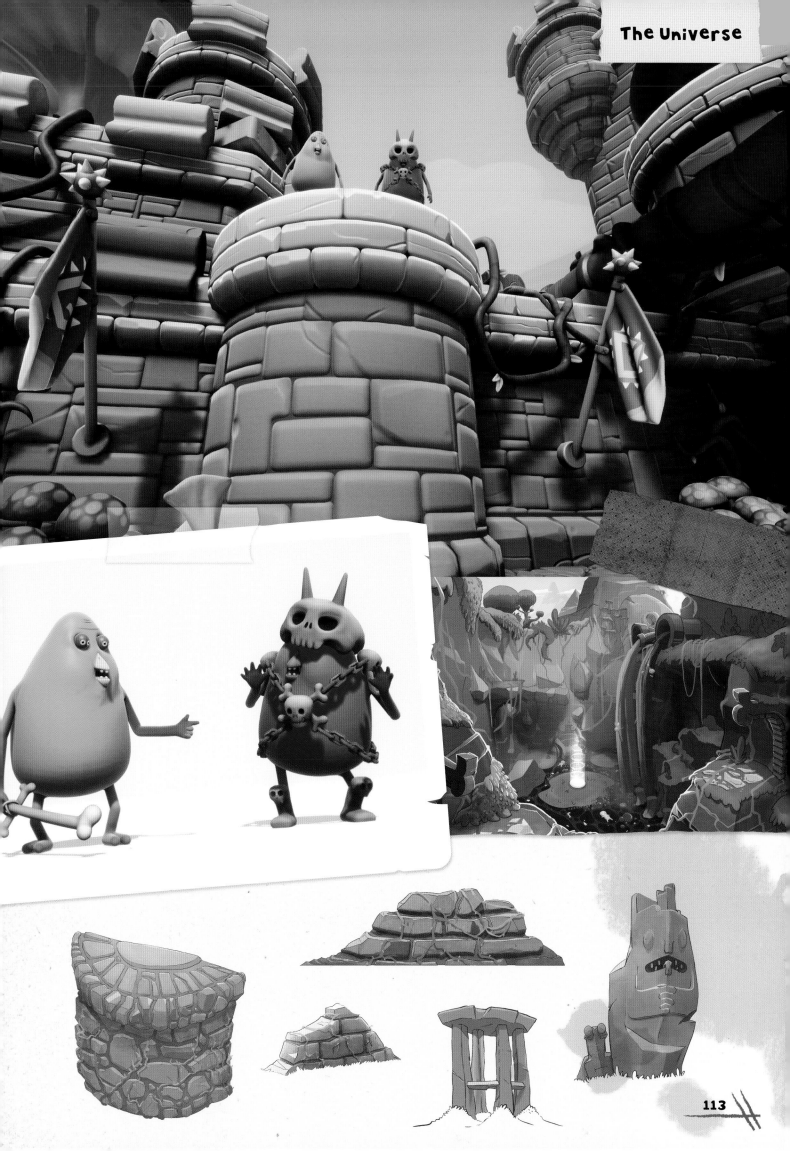

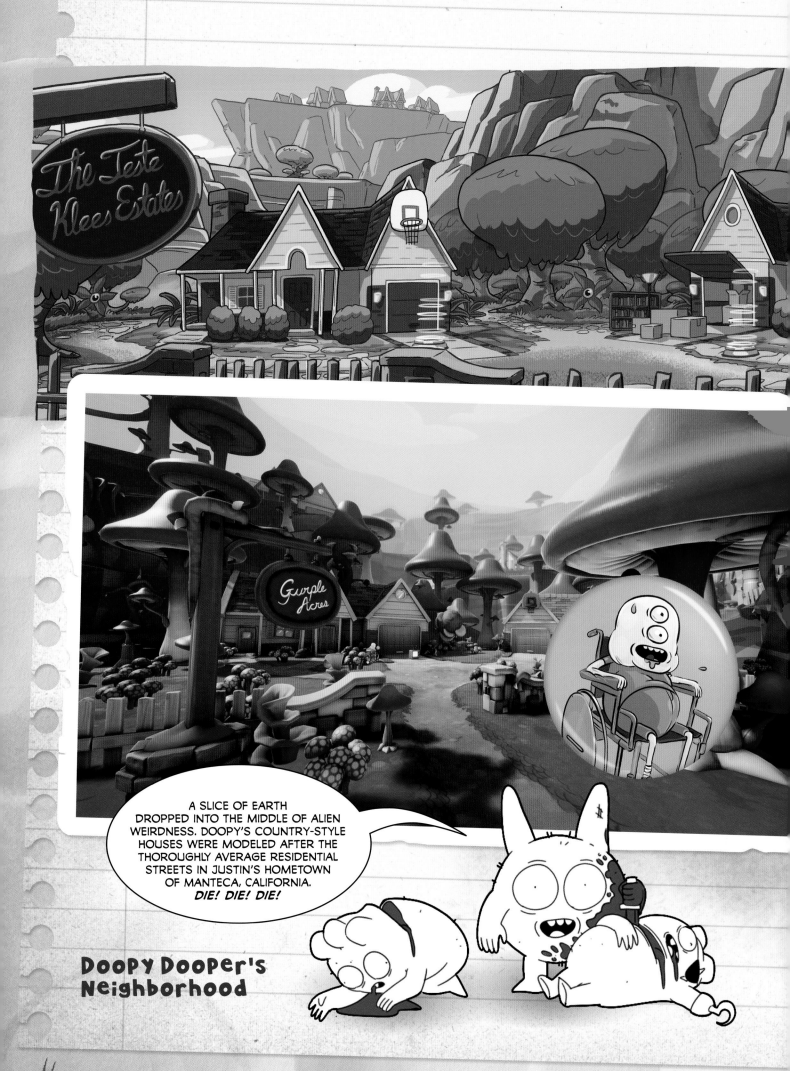

A SLICE OF EARTH DROPPED INTO THE MIDDLE OF ALIEN WEIRDNESS. DOOPY'S COUNTRY-STYLE HOUSES WERE MODELED AFTER THE THOROUGHLY AVERAGE RESIDENTIAL STREETS IN JUSTIN'S HOMETOWN OF MANTECA, CALIFORNIA. *DIE! DIE! DIE!*

Doopy Dooper's Neighborhood

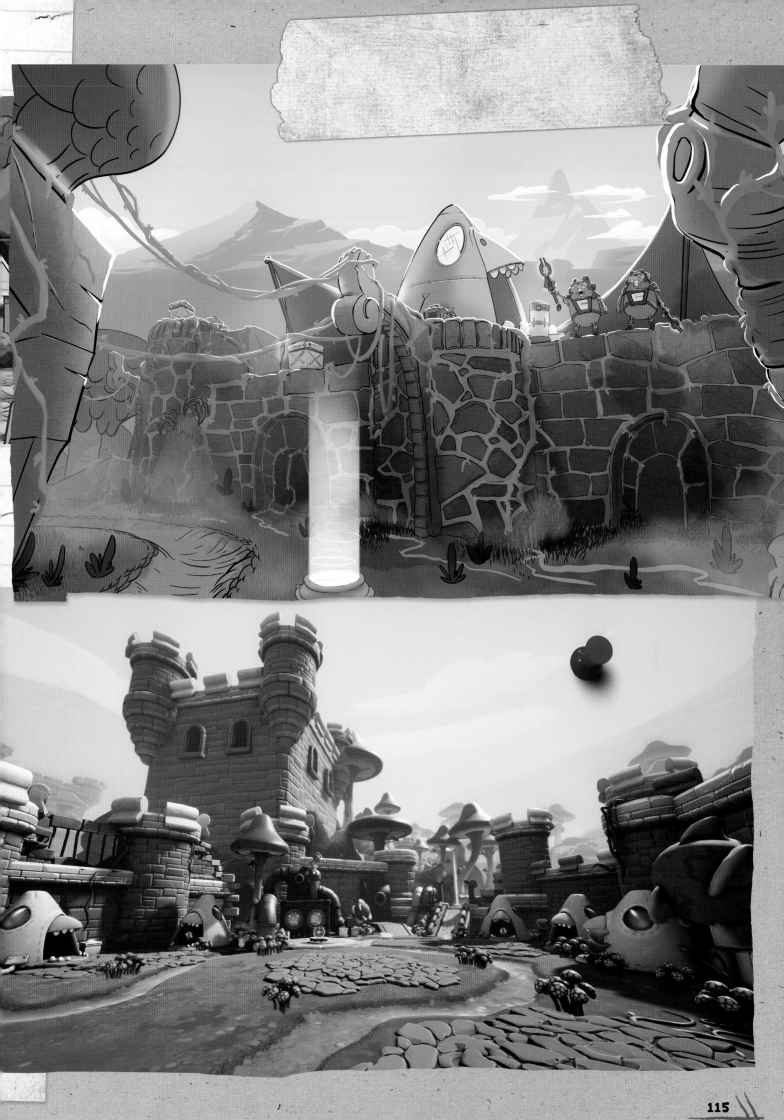

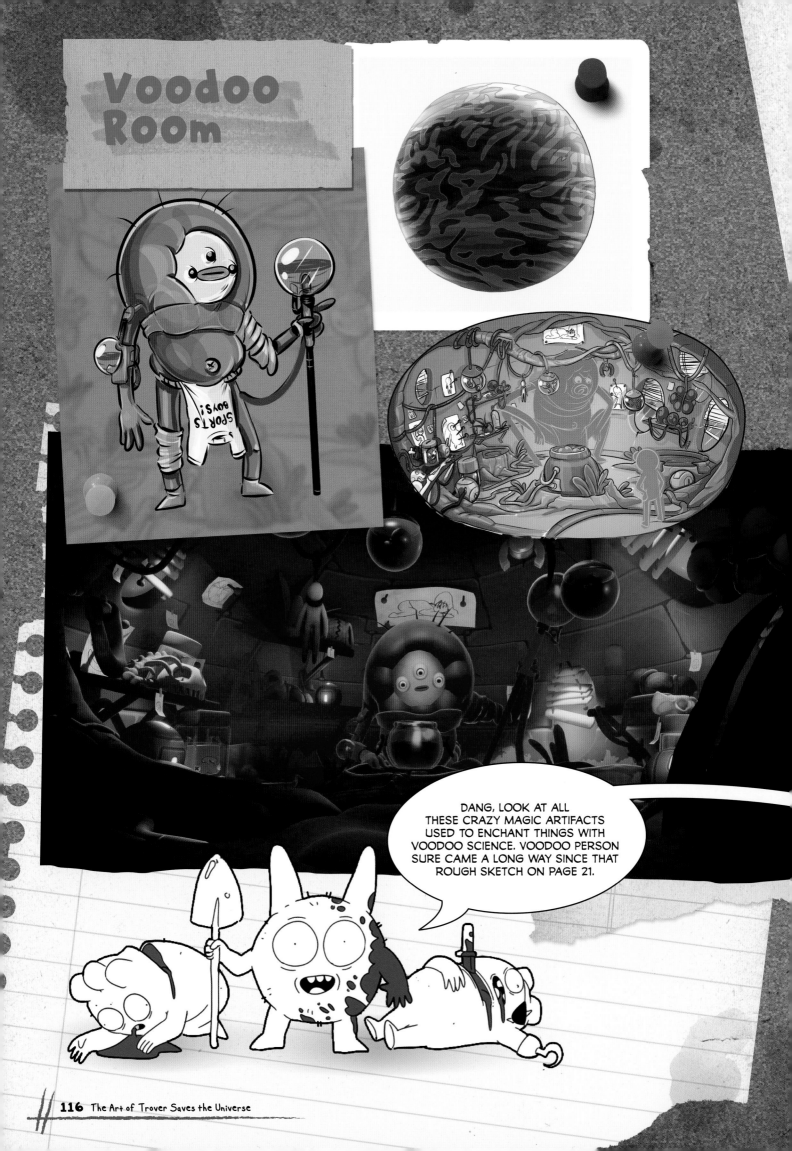

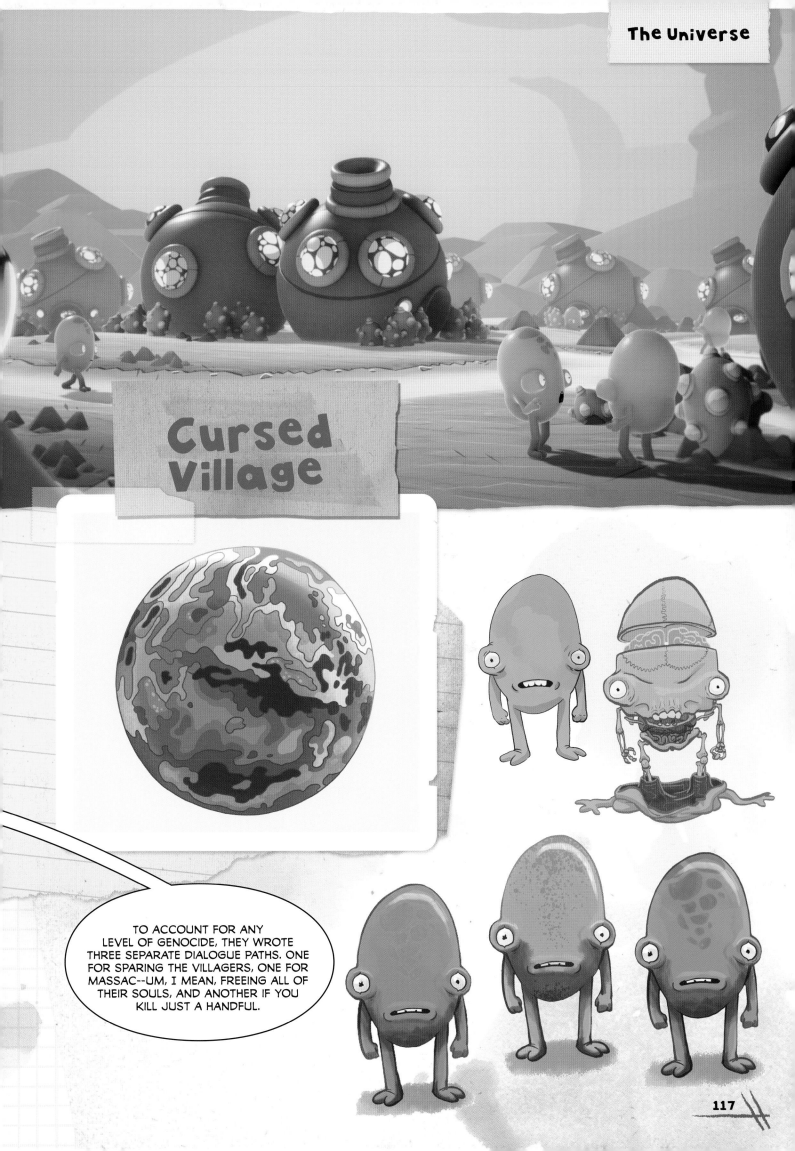

Cursed Village

TO ACCOUNT FOR ANY LEVEL OF GENOCIDE, THEY WROTE THREE SEPARATE DIALOGUE PATHS. ONE FOR SPARING THE VILLAGERS, ONE FOR MASSAC--UM, I MEAN, FREEING ALL OF THEIR SOULS, AND ANOTHER IF YOU KILL JUST A HANDFUL.

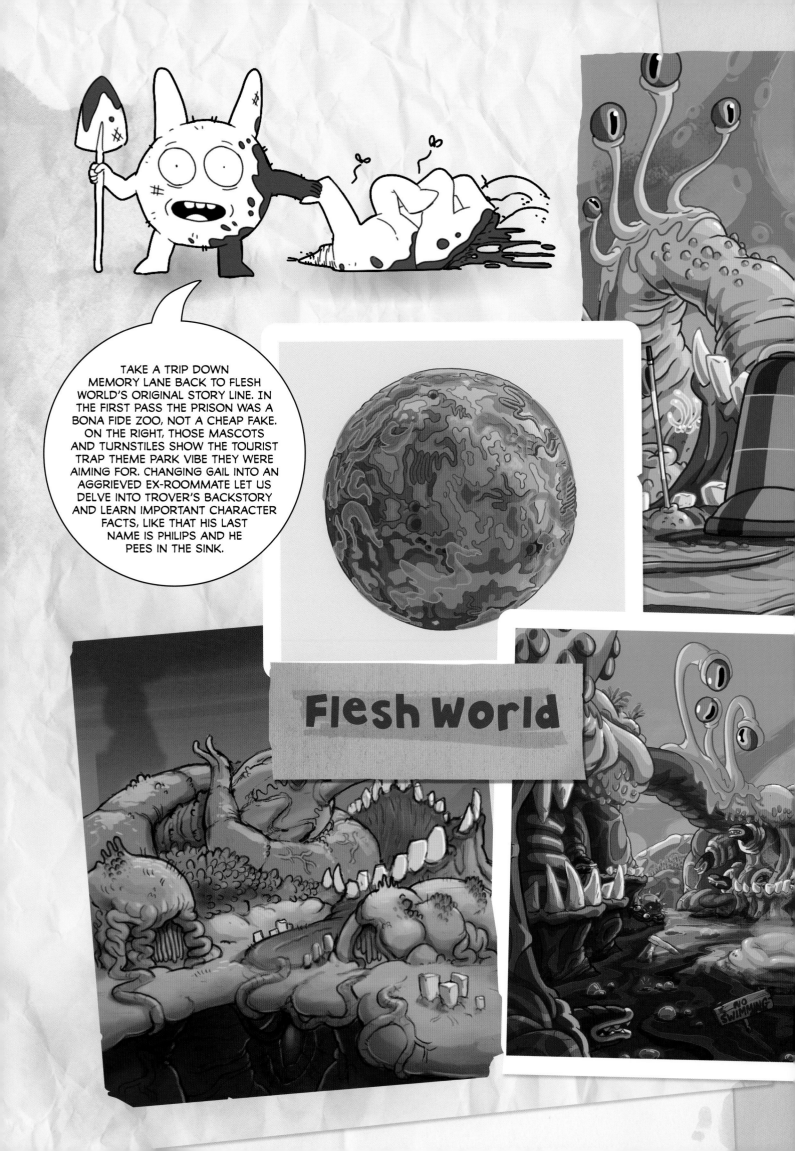

TAKE A TRIP DOWN MEMORY LANE BACK TO FLESH WORLD'S ORIGINAL STORY LINE. IN THE FIRST PASS THE PRISON WAS A BONA FIDE ZOO, NOT A CHEAP FAKE. ON THE RIGHT, THOSE MASCOTS AND TURNSTILES SHOW THE TOURIST TRAP THEME PARK VIBE THEY WERE AIMING FOR. CHANGING GAIL INTO AN AGGRIEVED EX-ROOMMATE LET US DELVE INTO TROVER'S BACKSTORY AND LEARN IMPORTANT CHARACTER FACTS, LIKE THAT HIS LAST NAME IS PHILIPS AND HE PEES IN THE SINK.

Flesh World

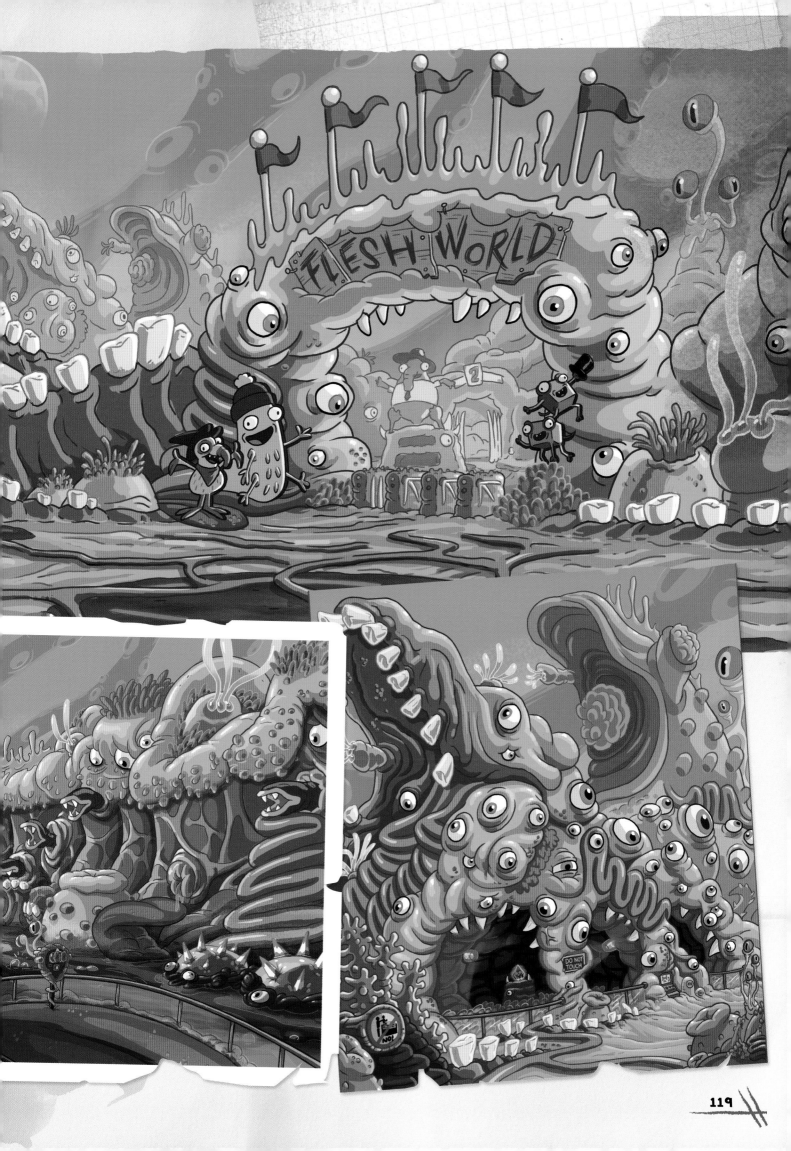

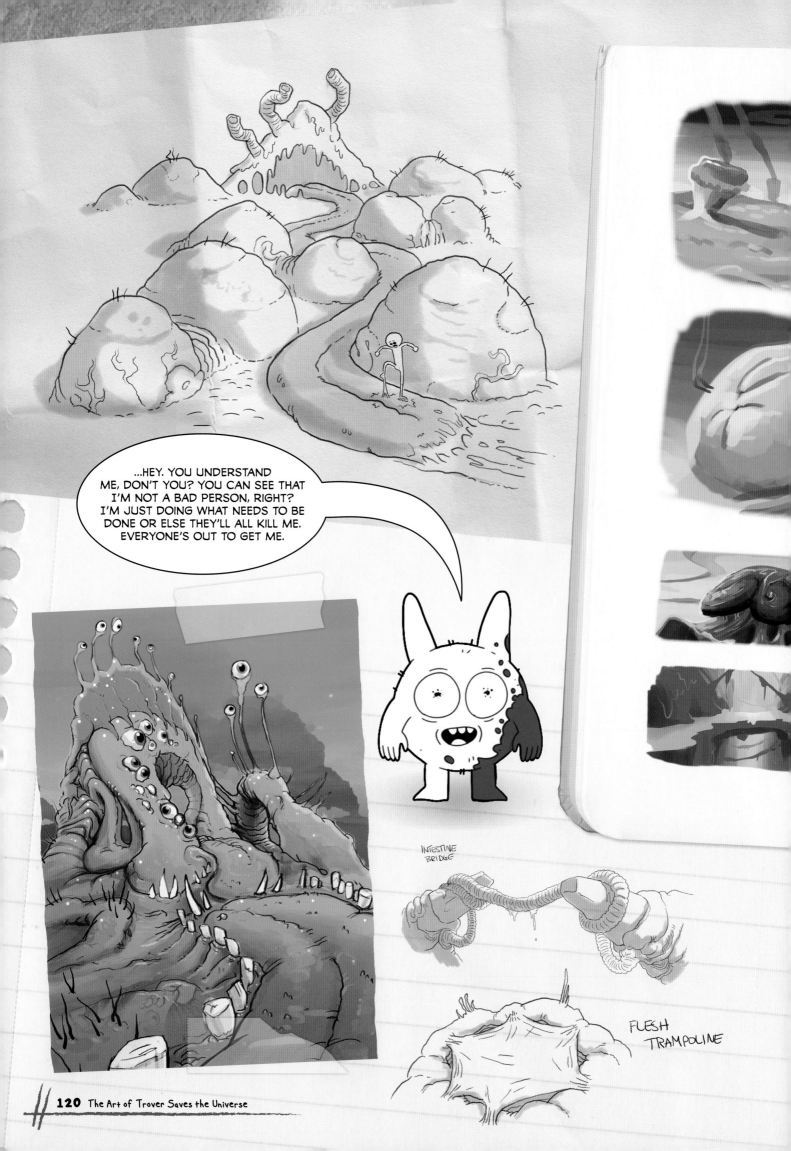

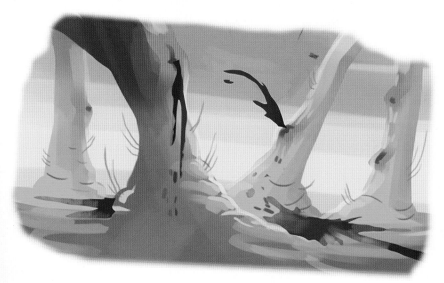

CONCEPT ART OF FLESHY TUMORS AND INFLAMED PUSTULES HAS NO RIGHT TO BE THIS BEAUTIFUL.

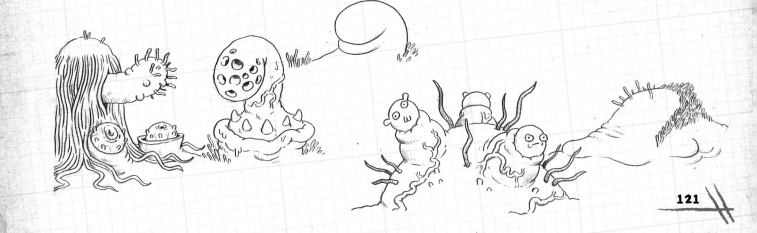

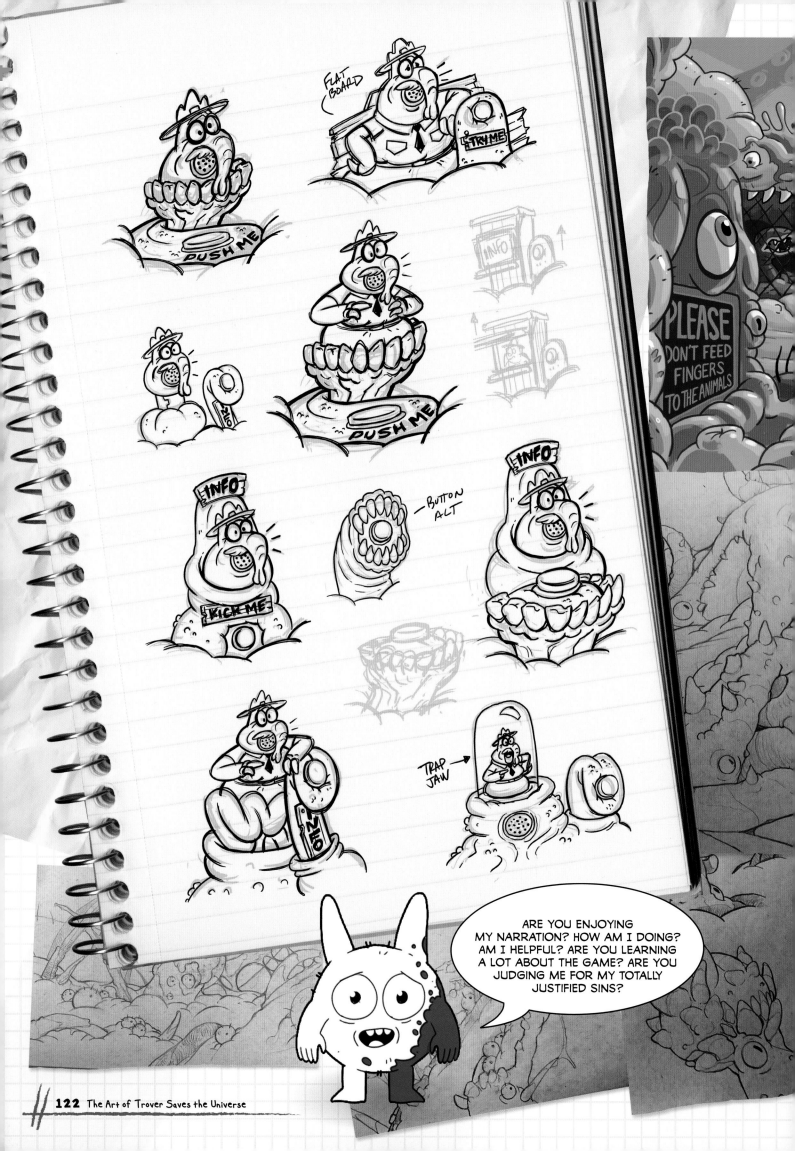

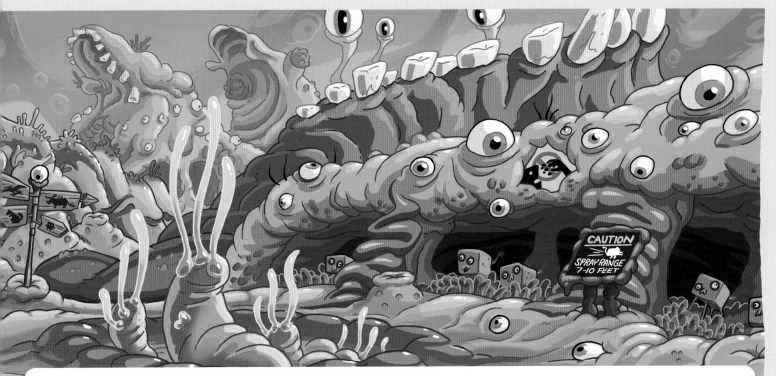

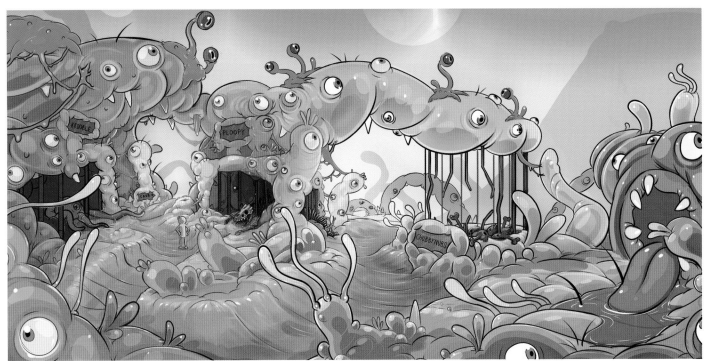

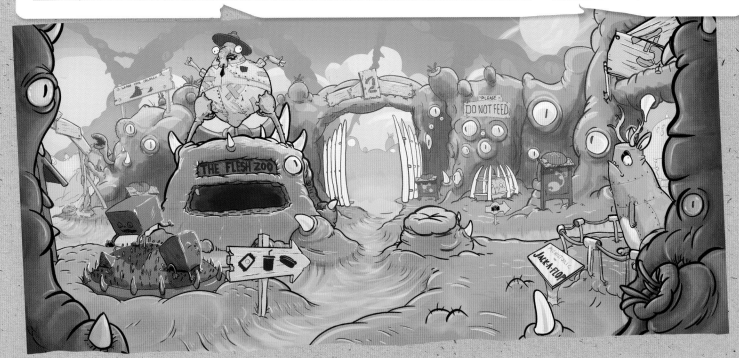

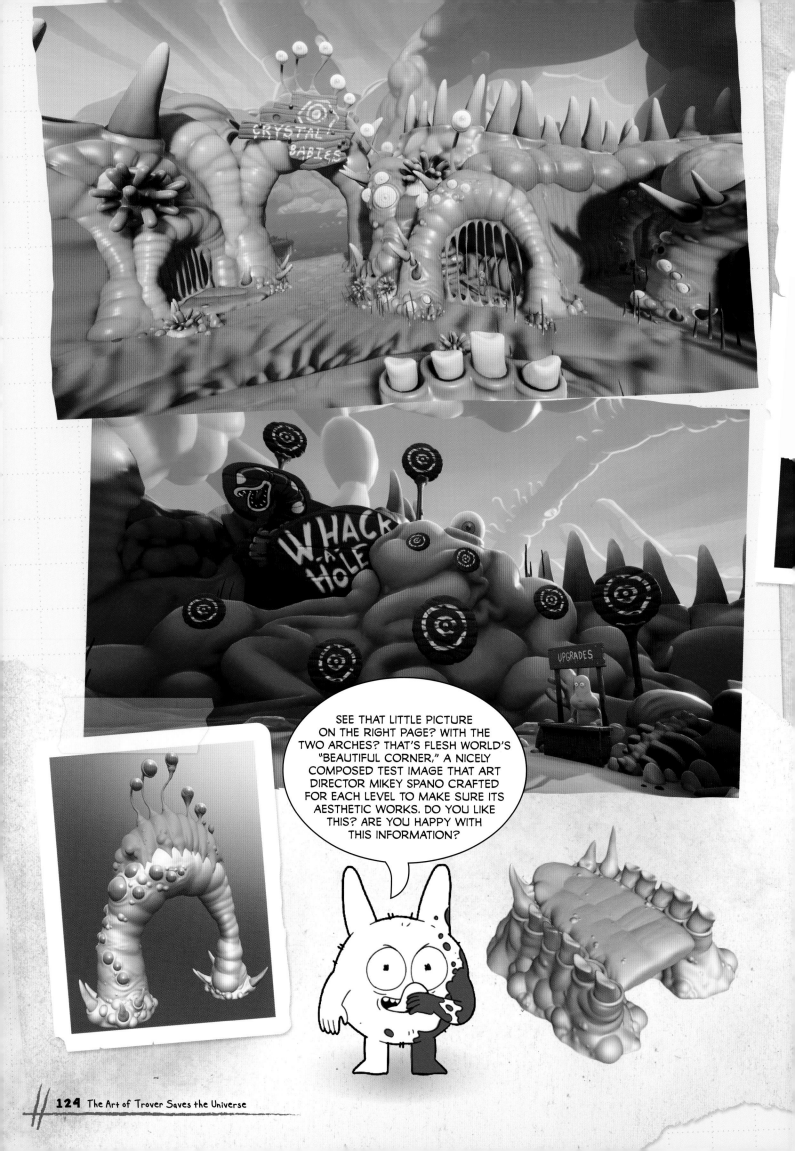

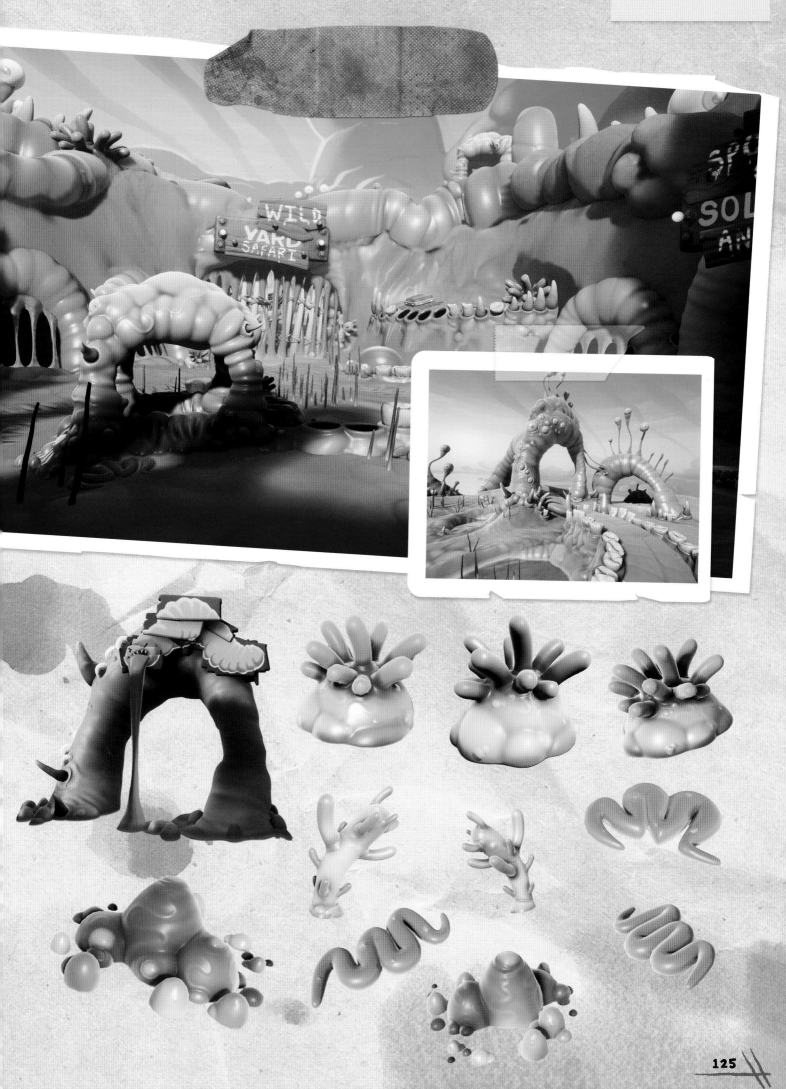

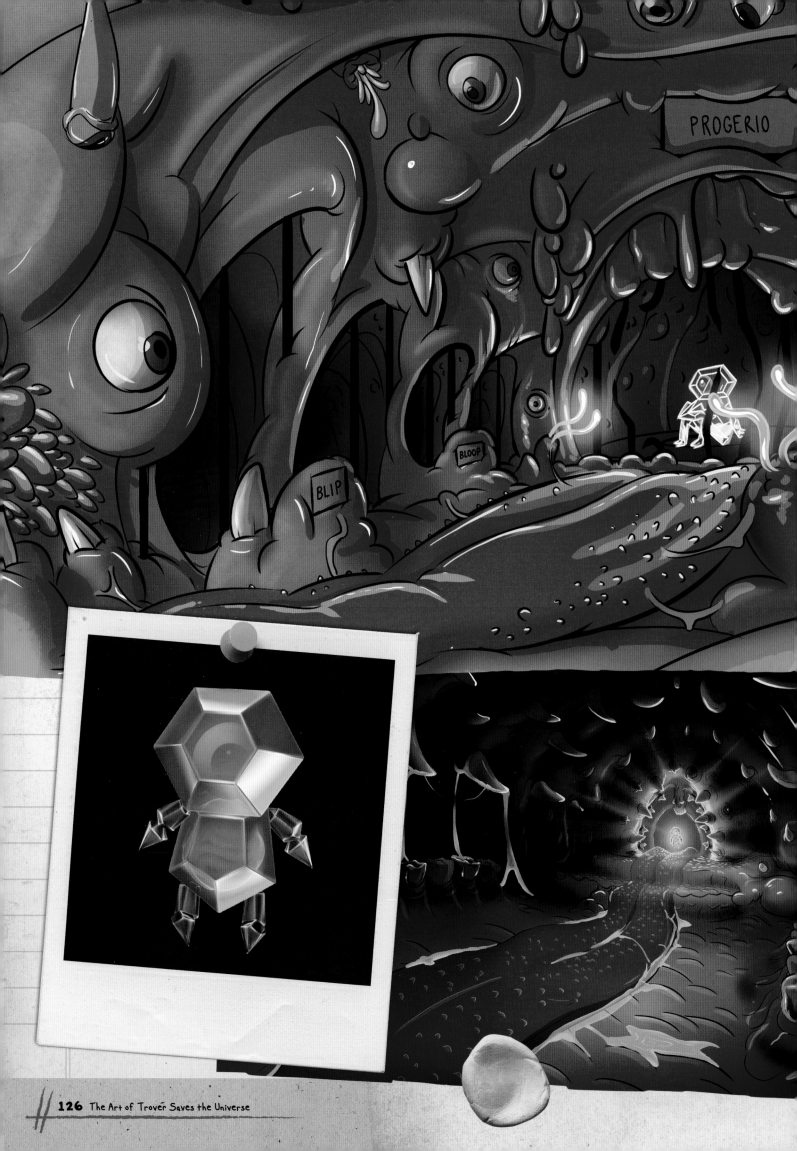

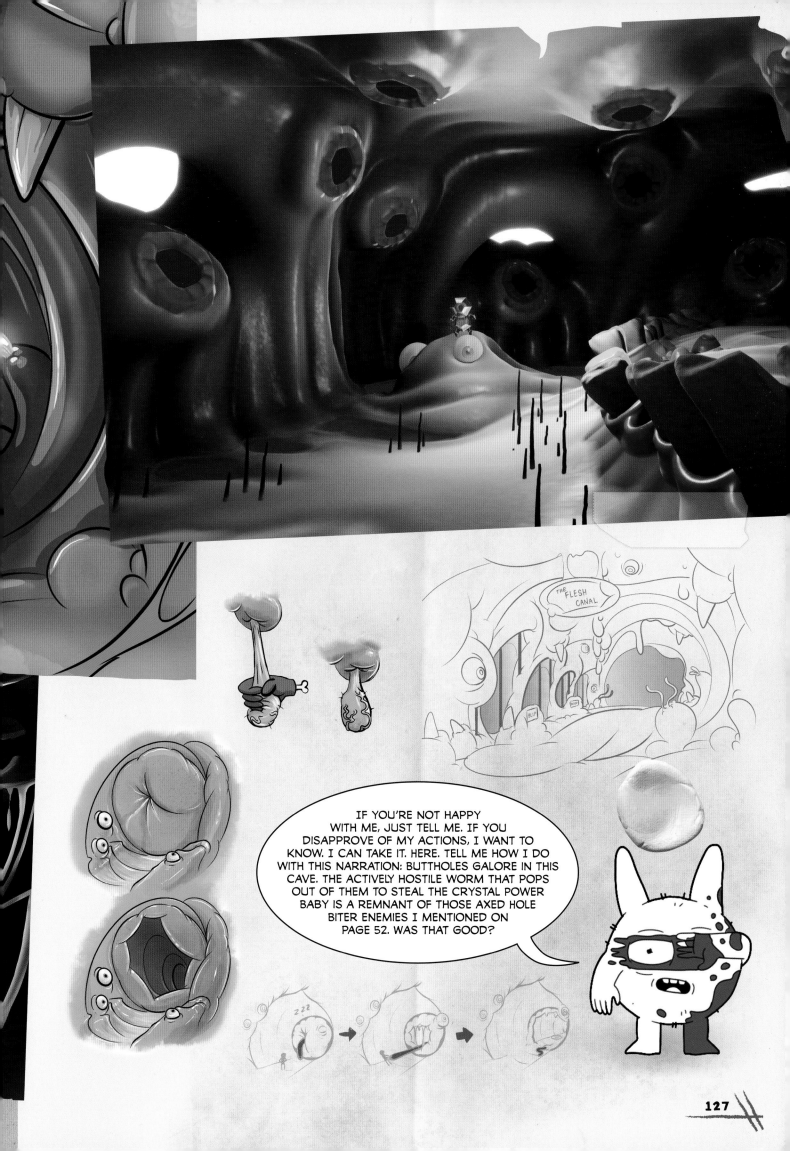

IF YOU'RE NOT HAPPY WITH ME, JUST TELL ME. IF YOU DISAPPROVE OF MY ACTIONS, I WANT TO KNOW. I CAN TAKE IT. HERE. TELL ME HOW I DO WITH THIS NARRATION: BUTTHOLES GALORE IN THIS CAVE. THE ACTIVELY HOSTILE WORM THAT POPS OUT OF THEM TO STEAL THE CRYSTAL POWER BABY IS A REMNANT OF THOSE AXED HOLE BITER ENEMIES I MENTIONED ON PAGE 52. WAS THAT GOOD?

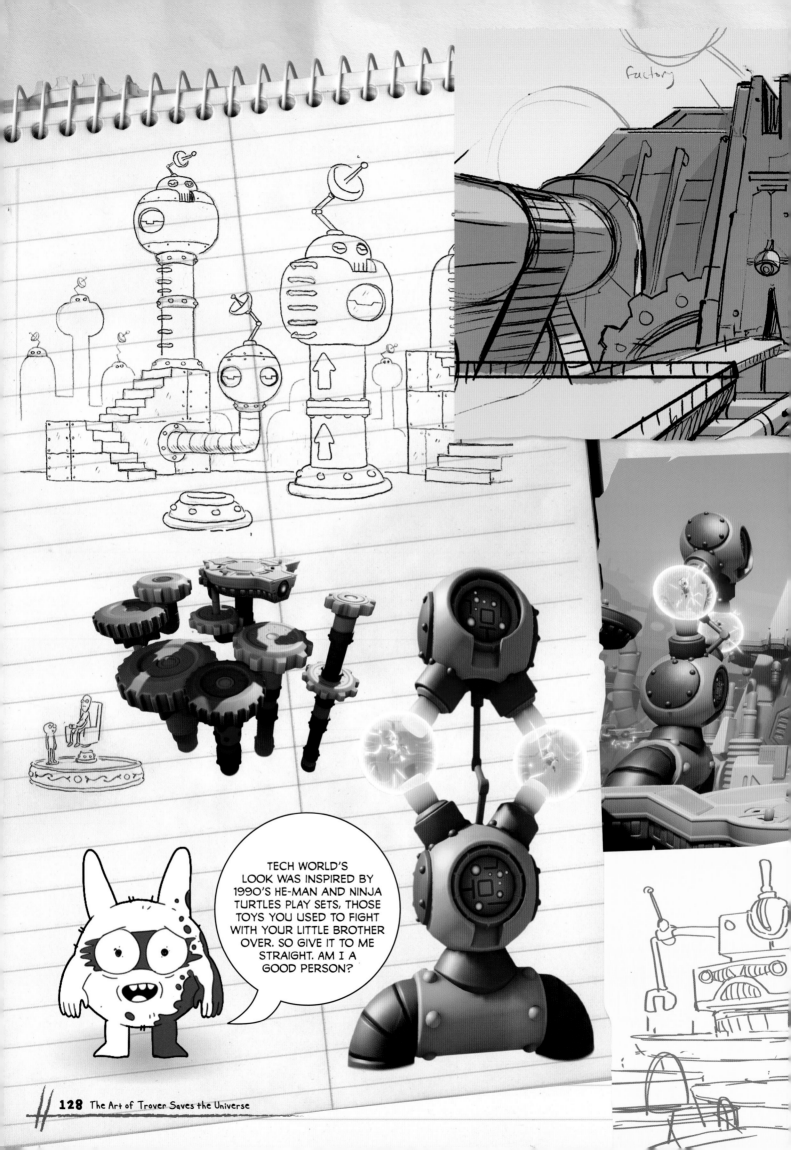

TECH WORLD'S LOOK WAS INSPIRED BY 1990'S HE-MAN AND NINJA TURTLES PLAY SETS, THOSE TOYS YOU USED TO FIGHT WITH YOUR LITTLE BROTHER OVER. SO GIVE IT TO ME STRAIGHT. AM I A GOOD PERSON?

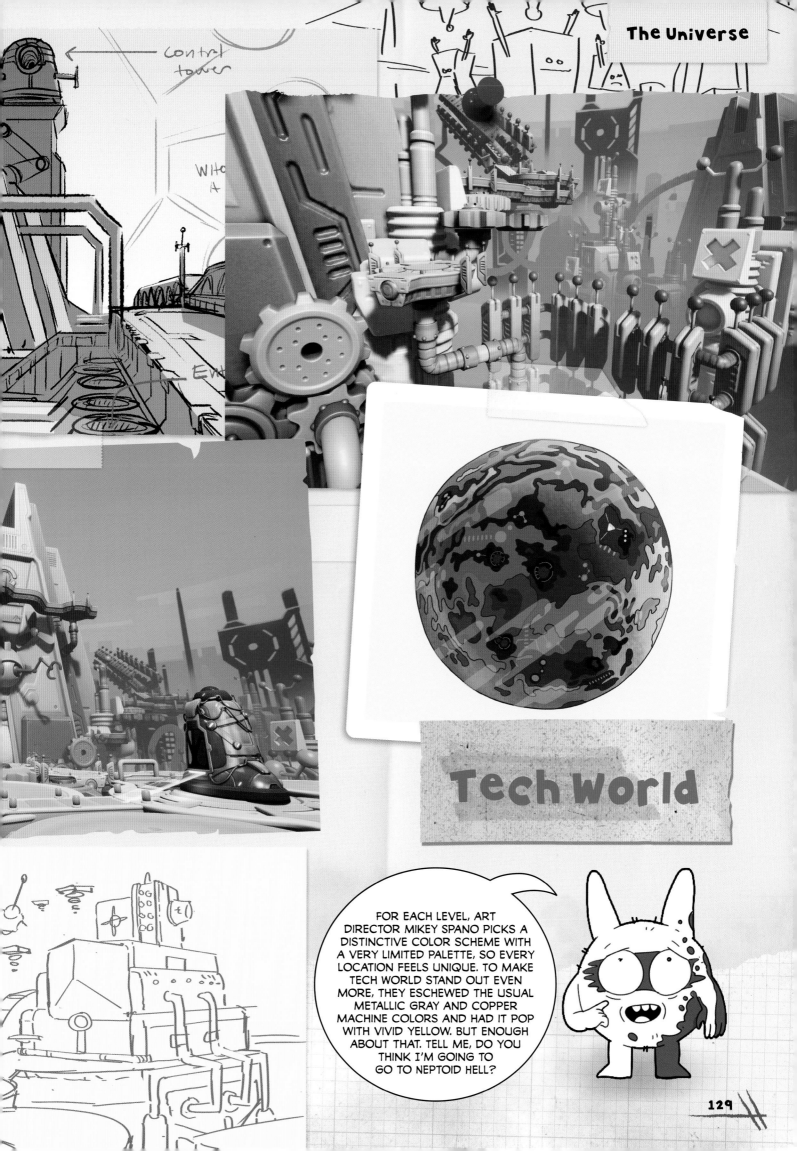

control tower

WITO A

Tech World

FOR EACH LEVEL, ART DIRECTOR MIKEY SPANO PICKS A DISTINCTIVE COLOR SCHEME WITH A VERY LIMITED PALETTE, SO EVERY LOCATION FEELS UNIQUE. TO MAKE TECH WORLD STAND OUT EVEN MORE, THEY ESCHEWED THE USUAL METALLIC GRAY AND COPPER MACHINE COLORS AND HAD IT POP WITH VIVID YELLOW. BUT ENOUGH ABOUT THAT. TELL ME, DO YOU THINK I'M GOING TO GO TO NEPTOID HELL?

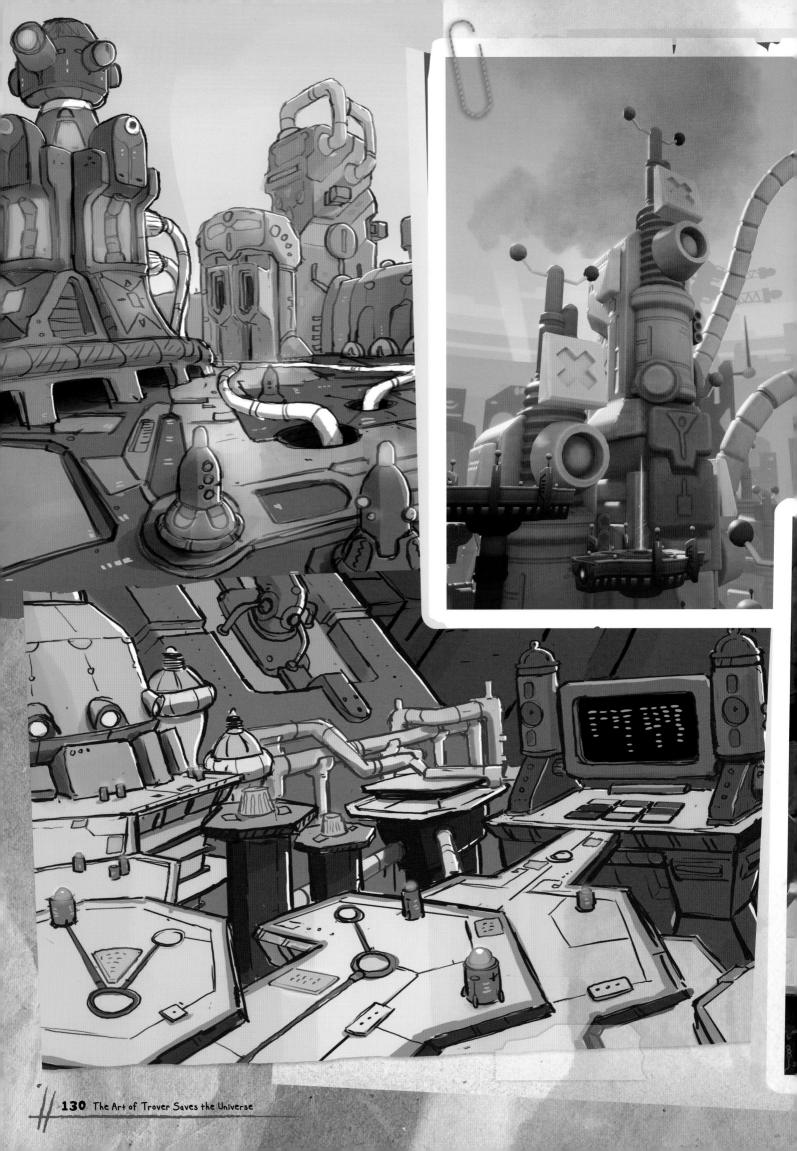

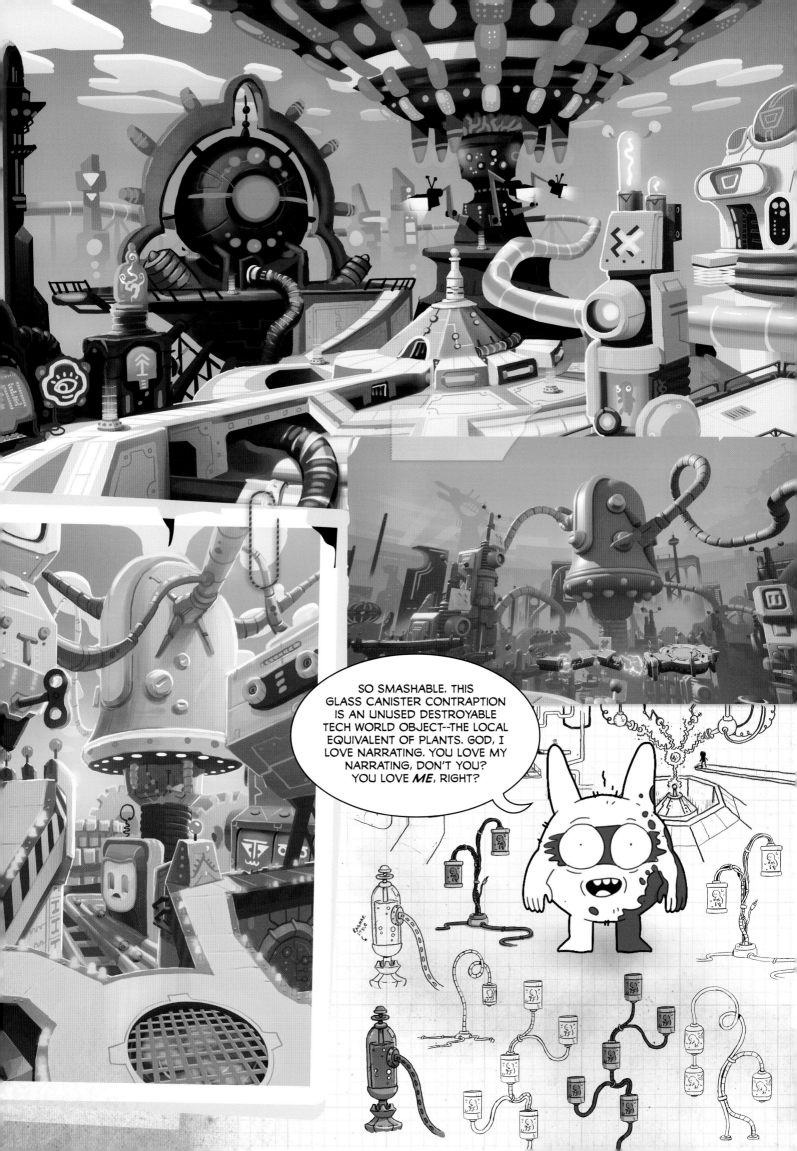

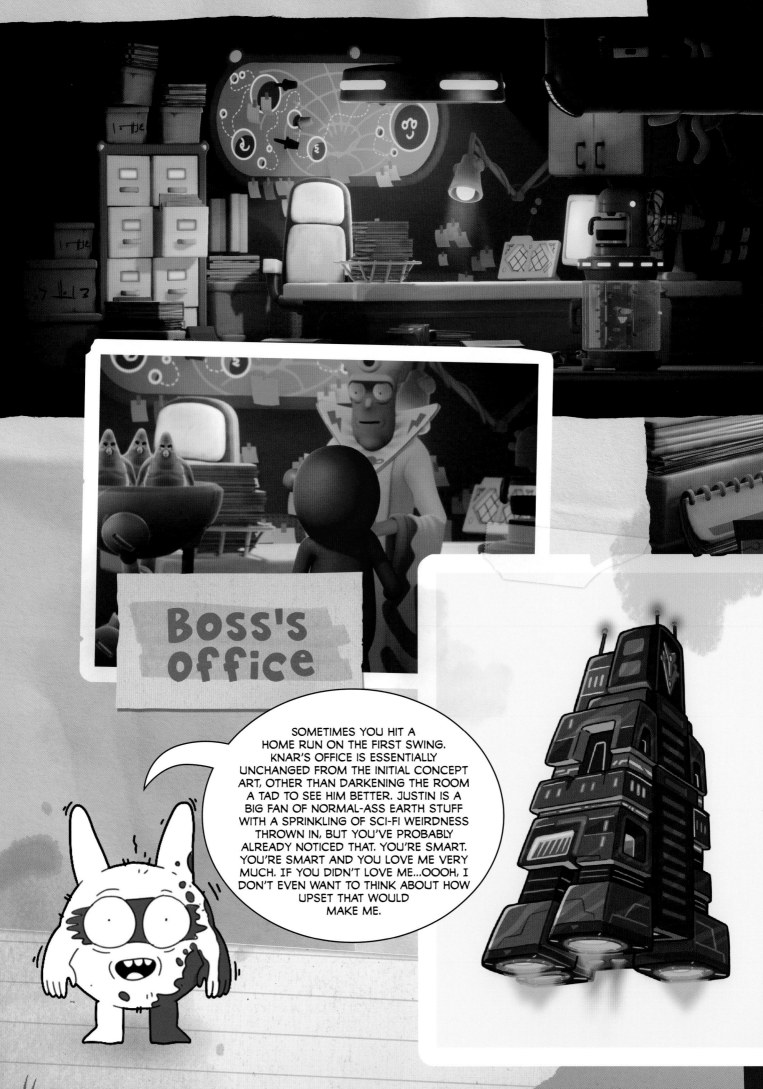

SOMETIMES YOU HIT A HOME RUN ON THE FIRST SWING. KNAR'S OFFICE IS ESSENTIALLY UNCHANGED FROM THE INITIAL CONCEPT ART, OTHER THAN DARKENING THE ROOM A TAD TO SEE HIM BETTER. JUSTIN IS A BIG FAN OF NORMAL-ASS EARTH STUFF WITH A SPRINKLING OF SCI-FI WEIRDNESS THROWN IN, BUT YOU'VE PROBABLY ALREADY NOTICED THAT. YOU'RE SMART. YOU'RE SMART AND YOU LOVE ME VERY MUCH. IF YOU DIDN'T LOVE ME...OOOH, I DON'T EVEN WANT TO THINK ABOUT HOW UPSET THAT WOULD MAKE ME.

Boss's Office

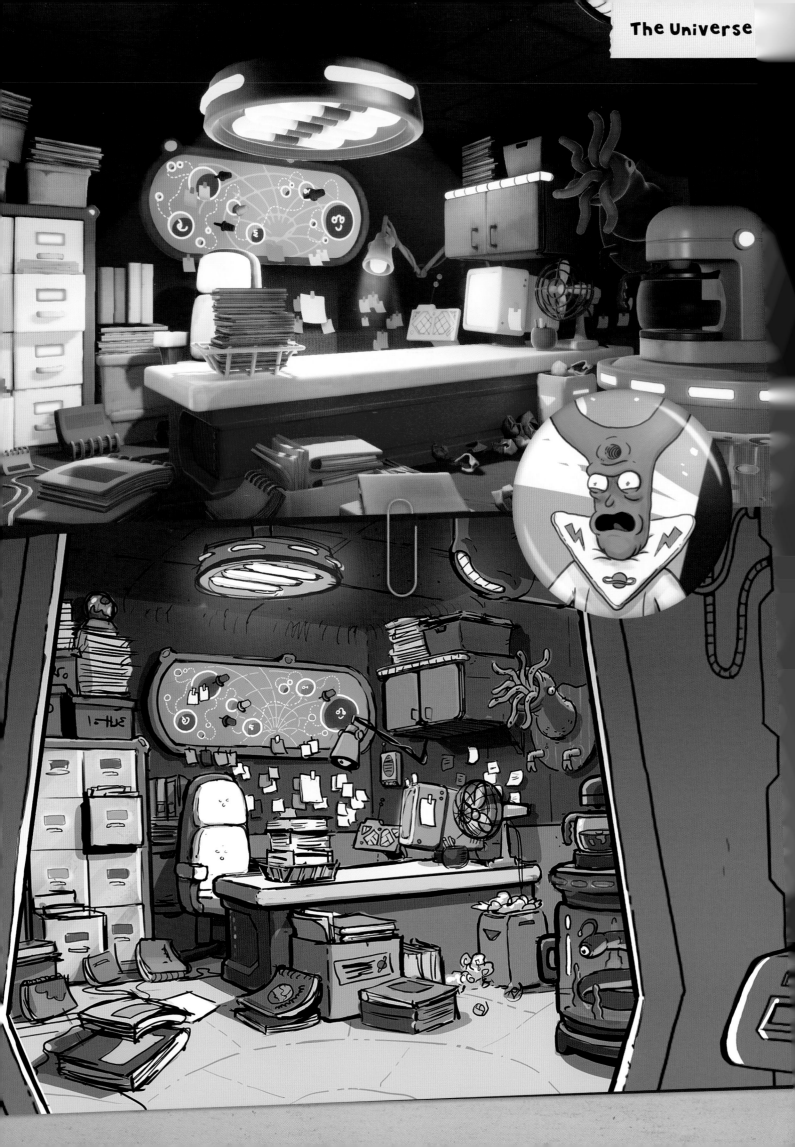

Bathtub Guy

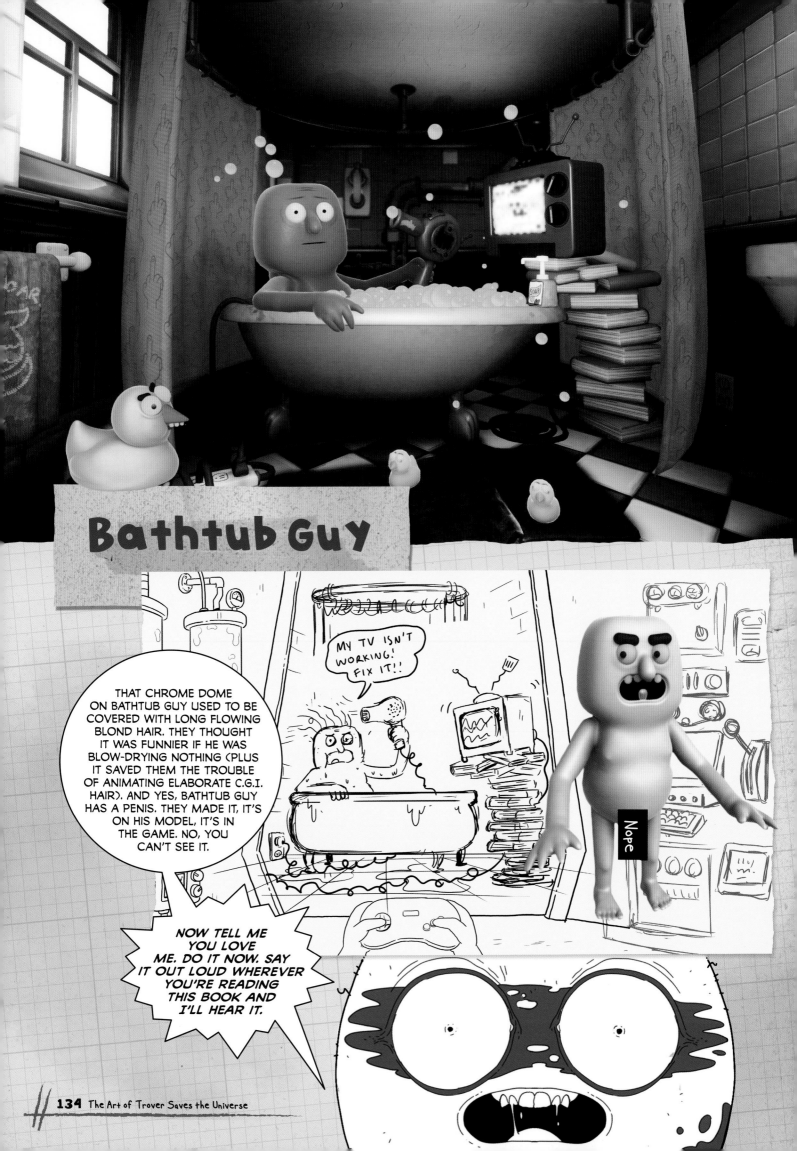

THAT CHROME DOME ON BATHTUB GUY USED TO BE COVERED WITH LONG FLOWING BLOND HAIR. THEY THOUGHT IT WAS FUNNIER IF HE WAS BLOW-DRYING NOTHING (PLUS IT SAVED THEM THE TROUBLE OF ANIMATING ELABORATE C.G.I. HAIR). AND YES, BATHTUB GUY HAS A PENIS. THEY MADE IT, IT'S ON HIS MODEL, IT'S IN THE GAME. NO, YOU CAN'T SEE IT.

MY TV ISN'T WORKING! FIX IT!!

Nope

NOW TELL ME YOU LOVE ME. DO IT NOW. SAY IT OUT LOUD WHEREVER YOU'RE READING THIS BOOK AND I'LL HEAR IT.

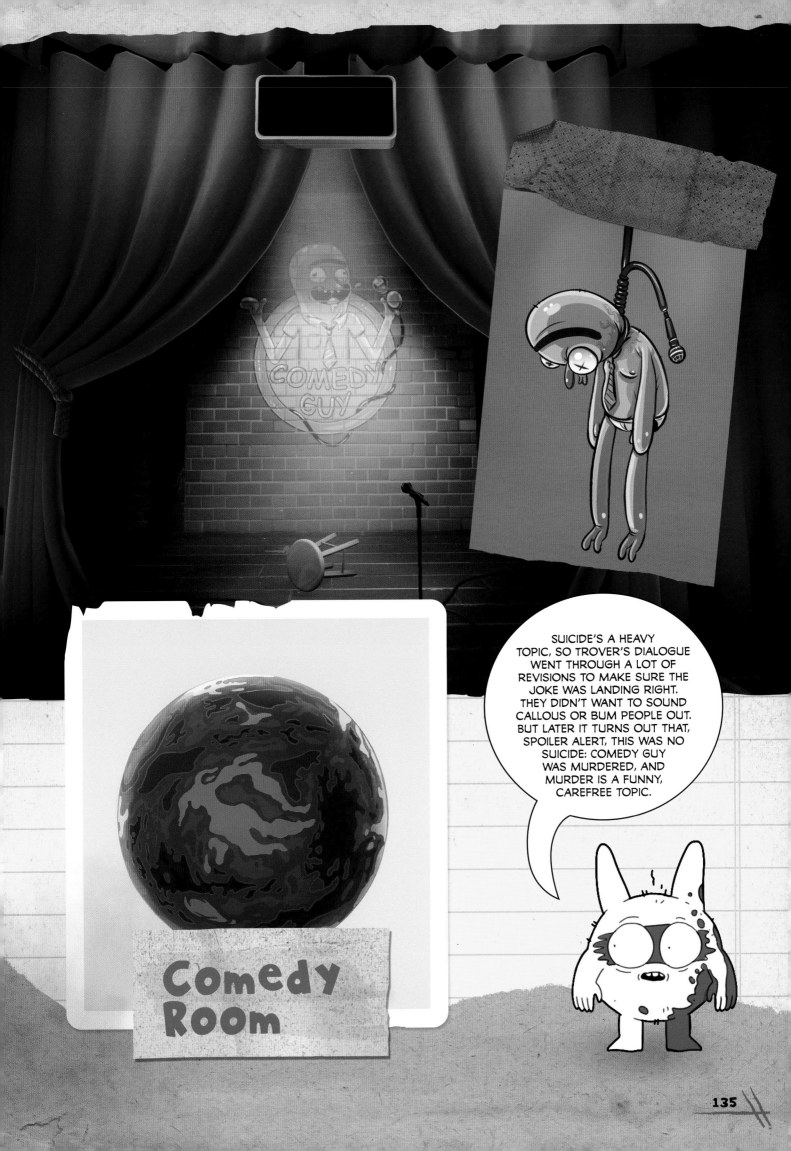

Comedy Room

SUICIDE'S A HEAVY TOPIC, SO TROVER'S DIALOGUE WENT THROUGH A LOT OF REVISIONS TO MAKE SURE THE JOKE WAS LANDING RIGHT. THEY DIDN'T WANT TO SOUND CALLOUS OR BUM PEOPLE OUT. BUT LATER IT TURNS OUT THAT, SPOILER ALERT, THIS WAS NO SUICIDE: COMEDY GUY WAS MURDERED, AND MURDER IS A FUNNY, CAREFREE TOPIC.

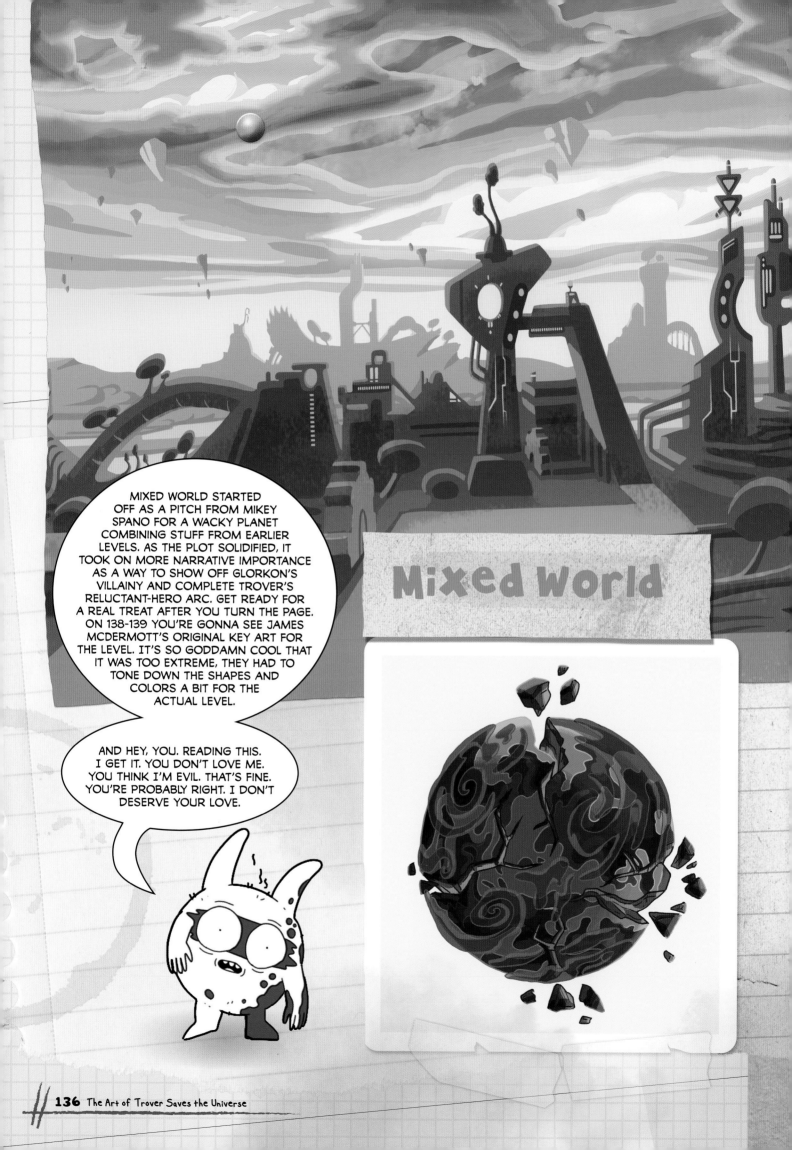

MIXED WORLD STARTED OFF AS A PITCH FROM MIKEY SPANO FOR A WACKY PLANET COMBINING STUFF FROM EARLIER LEVELS. AS THE PLOT SOLIDIFIED, IT TOOK ON MORE NARRATIVE IMPORTANCE AS A WAY TO SHOW OFF GLORKON'S VILLAINY AND COMPLETE TROVER'S RELUCTANT-HERO ARC. GET READY FOR A REAL TREAT AFTER YOU TURN THE PAGE. ON 138-139 YOU'RE GONNA SEE JAMES MCDERMOTT'S ORIGINAL KEY ART FOR THE LEVEL. IT'S SO GODDAMN COOL THAT IT WAS TOO EXTREME, THEY HAD TO TONE DOWN THE SHAPES AND COLORS A BIT FOR THE ACTUAL LEVEL.

AND HEY, YOU. READING THIS. I GET IT. YOU DON'T LOVE ME. YOU THINK I'M EVIL. THAT'S FINE. YOU'RE PROBABLY RIGHT. I DON'T DESERVE YOUR LOVE.

Mixed World

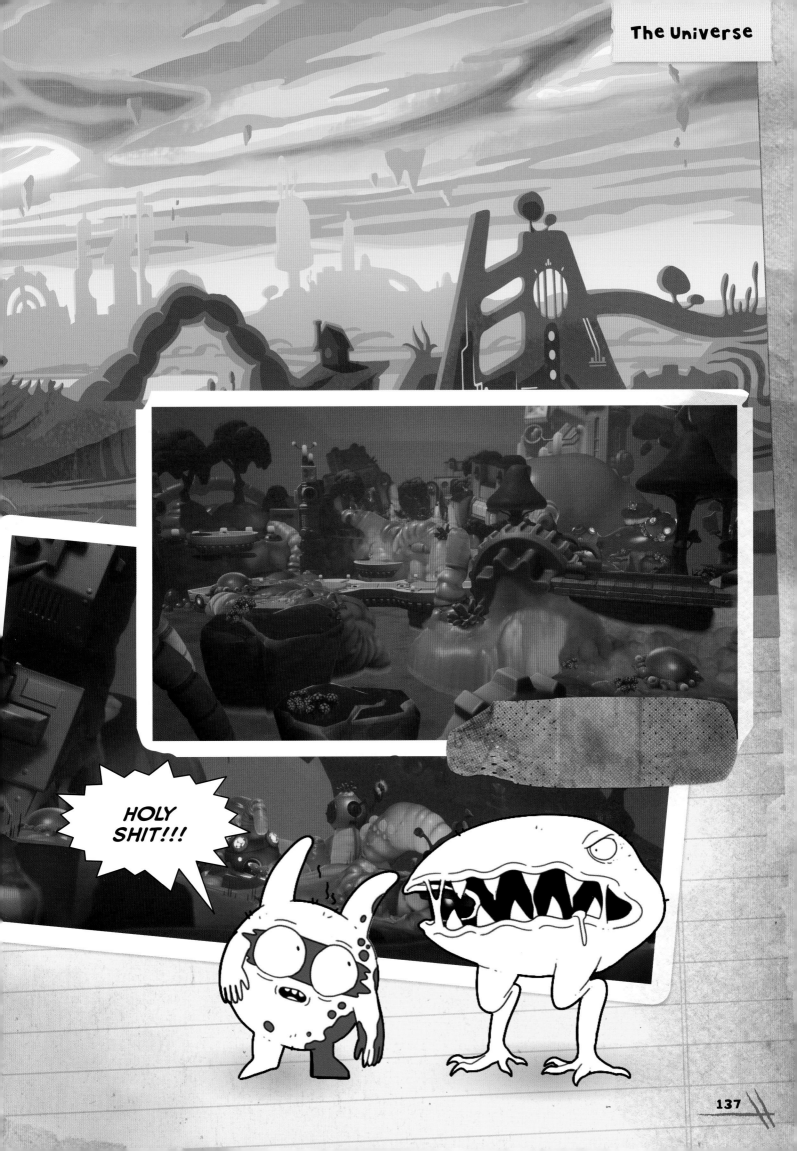

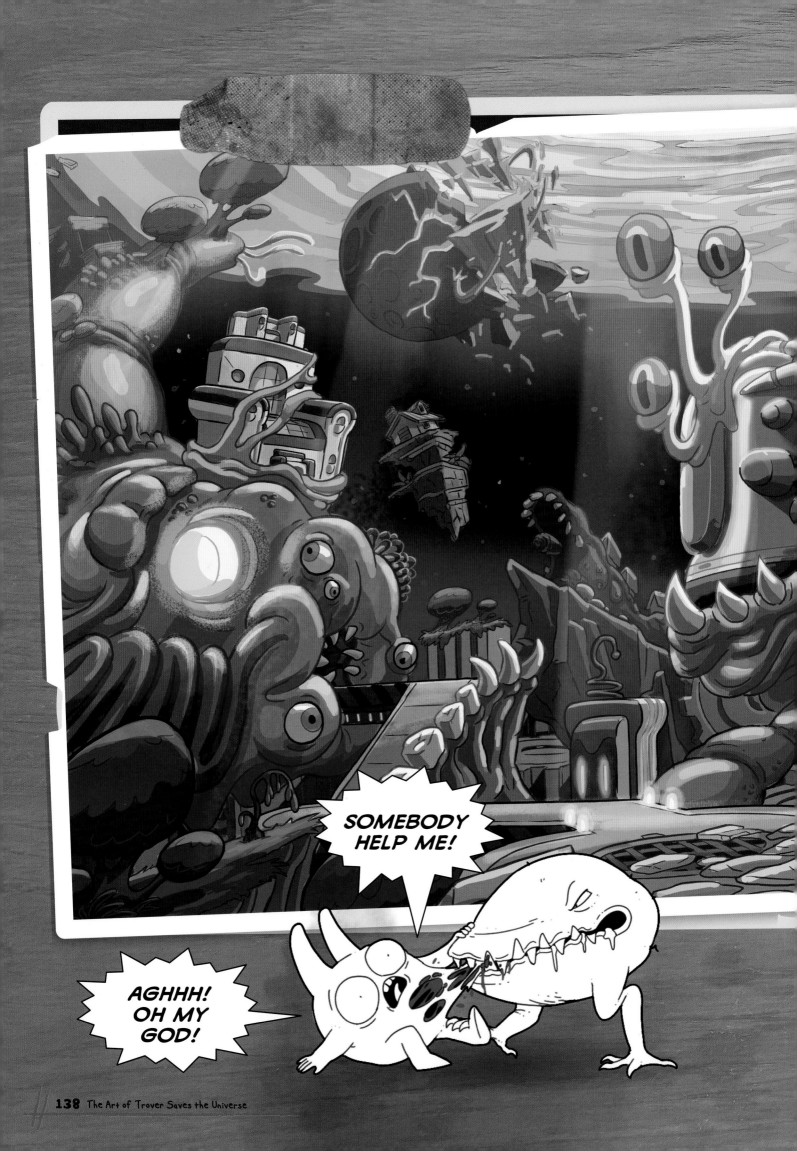

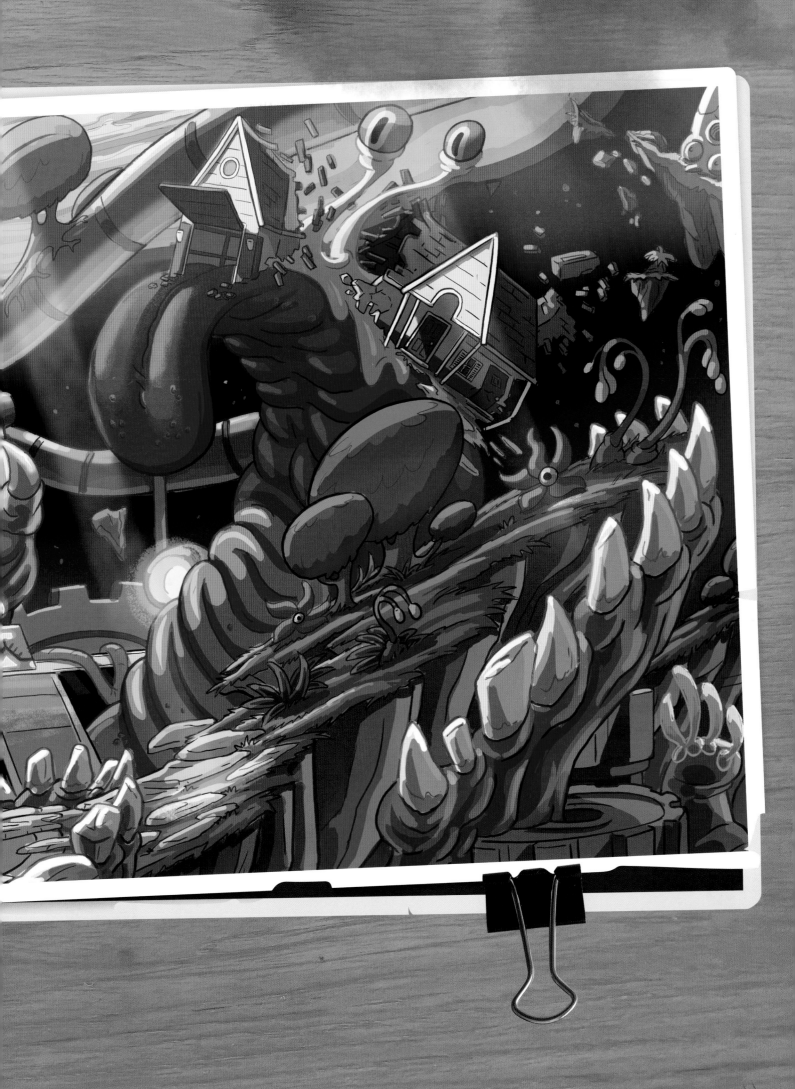

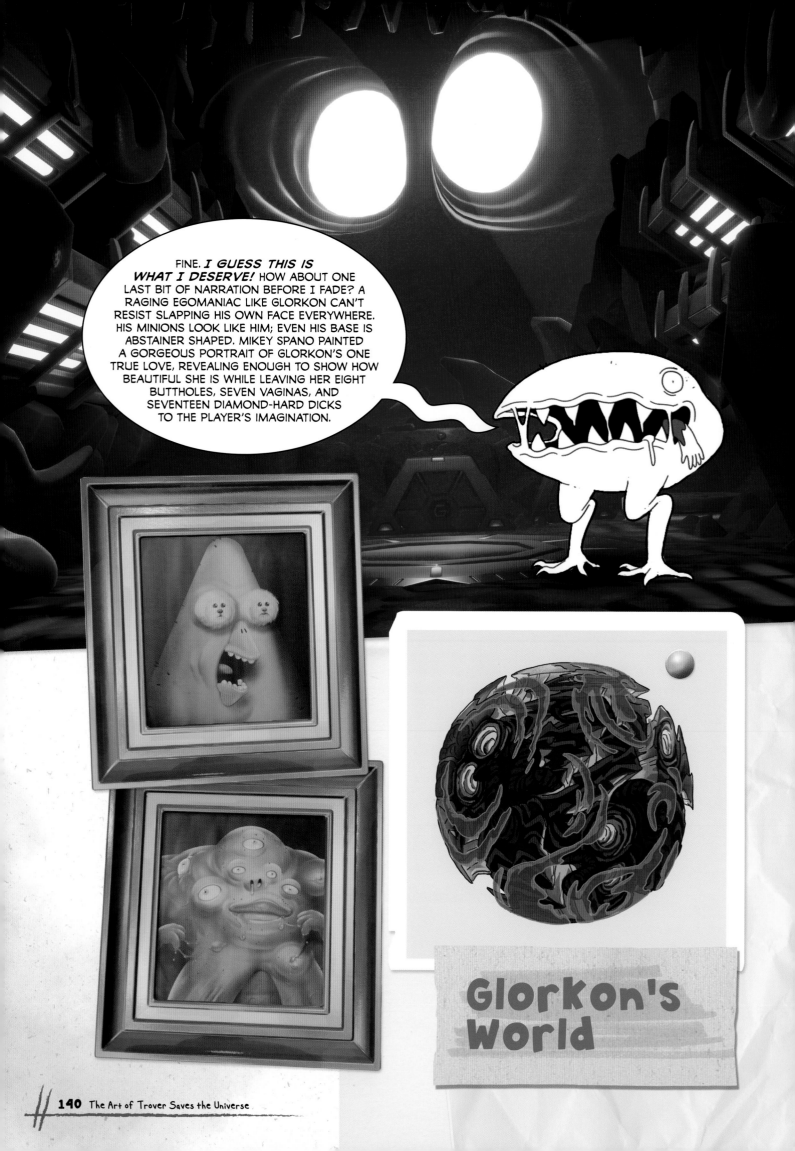

FINE. *I GUESS THIS IS WHAT I DESERVE!* HOW ABOUT ONE LAST BIT OF NARRATION BEFORE I FADE? A RAGING EGOMANIAC LIKE GLORKON CAN'T RESIST SLAPPING HIS OWN FACE EVERYWHERE. HIS MINIONS LOOK LIKE HIM; EVEN HIS BASE IS ABSTAINER SHAPED. MIKEY SPANO PAINTED A GORGEOUS PORTRAIT OF GLORKON'S ONE TRUE LOVE, REVEALING ENOUGH TO SHOW HOW BEAUTIFUL SHE IS WHILE LEAVING HER EIGHT BUTTHOLES, SEVEN VAGINAS, AND SEVENTEEN DIAMOND-HARD DICKS TO THE PLAYER'S IMAGINATION.

Glorkon's World

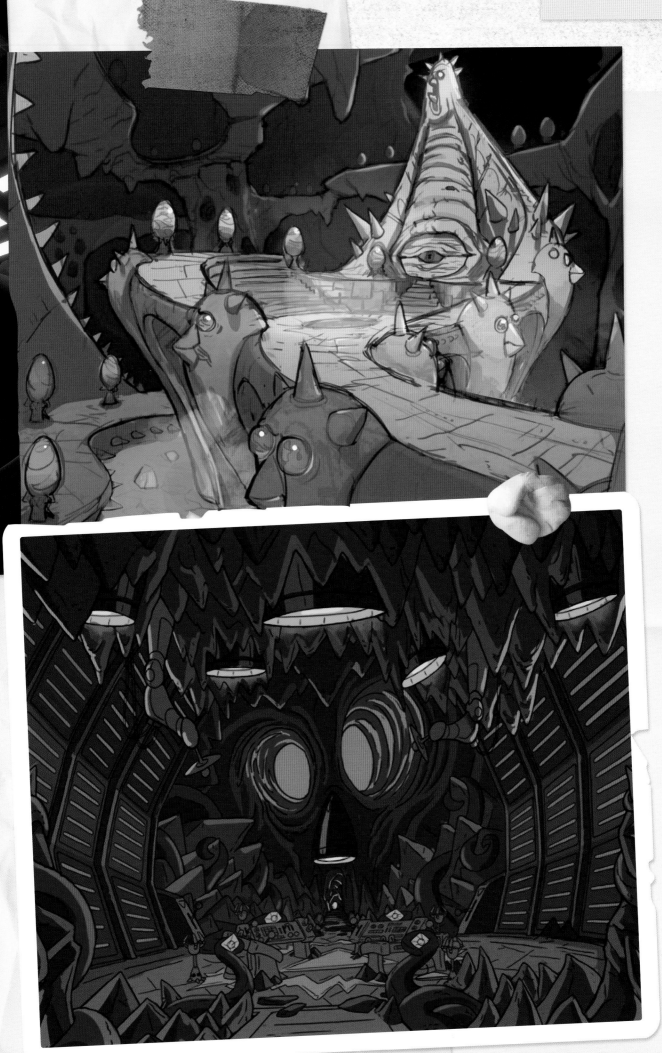

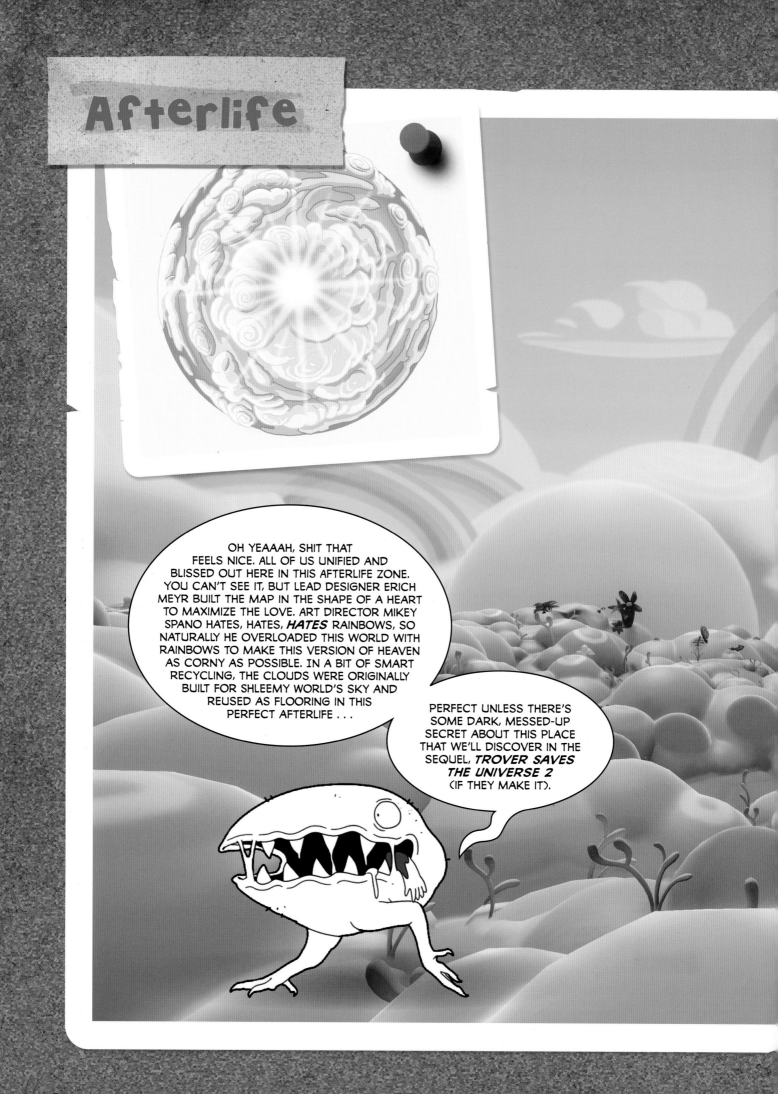

Doopy Dooper approved!

An oversized full-color art book showcasing the insane imagination of Justin Roiland!

Feast your eyeholes on 144 pages of crazy concept art and creator commentary!

Includes extra stuff that wasn't, you know, didn't make it into the game! Some different, weird, like, different things!

The perfect companion to Squanch Games' first full-length game!

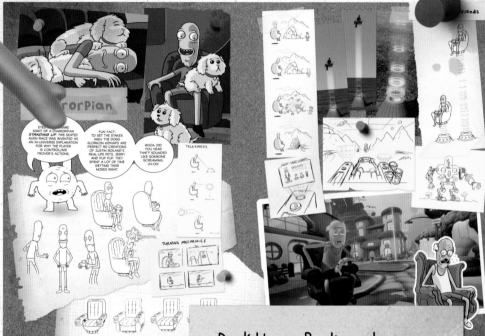

Dark Horse Books and Squanch Games invite you to embrace weirdness by picking up the greatest art book in the galaxy!

Or don't. It's whatever. I'm not your dad.

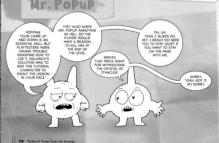

Mr. Popup

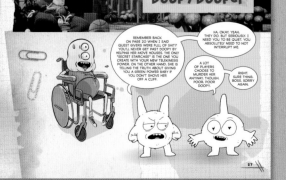

Doopy Dooper

GAMES / Popular Culture
ISBN 978-1-50671-640-4

53999>

9 781506 716404

$39.99 US $53.99 CAN

DarkHorse.com SquanchGames.com

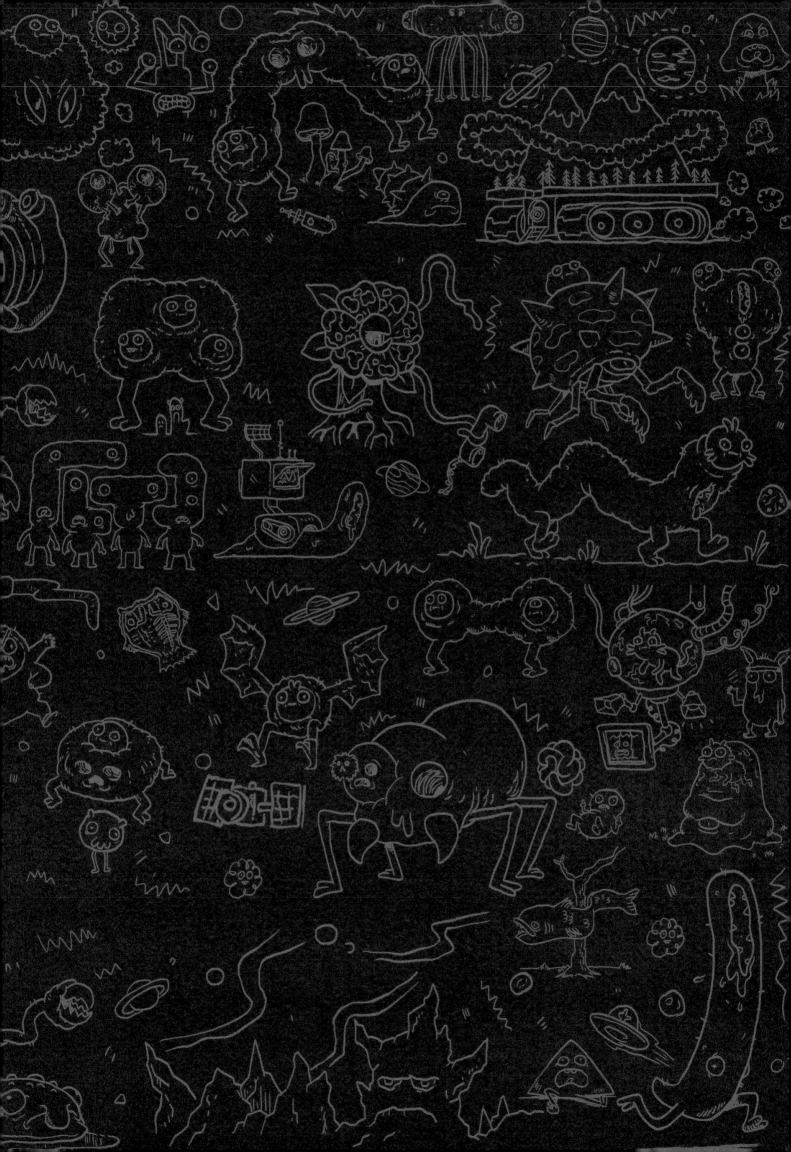

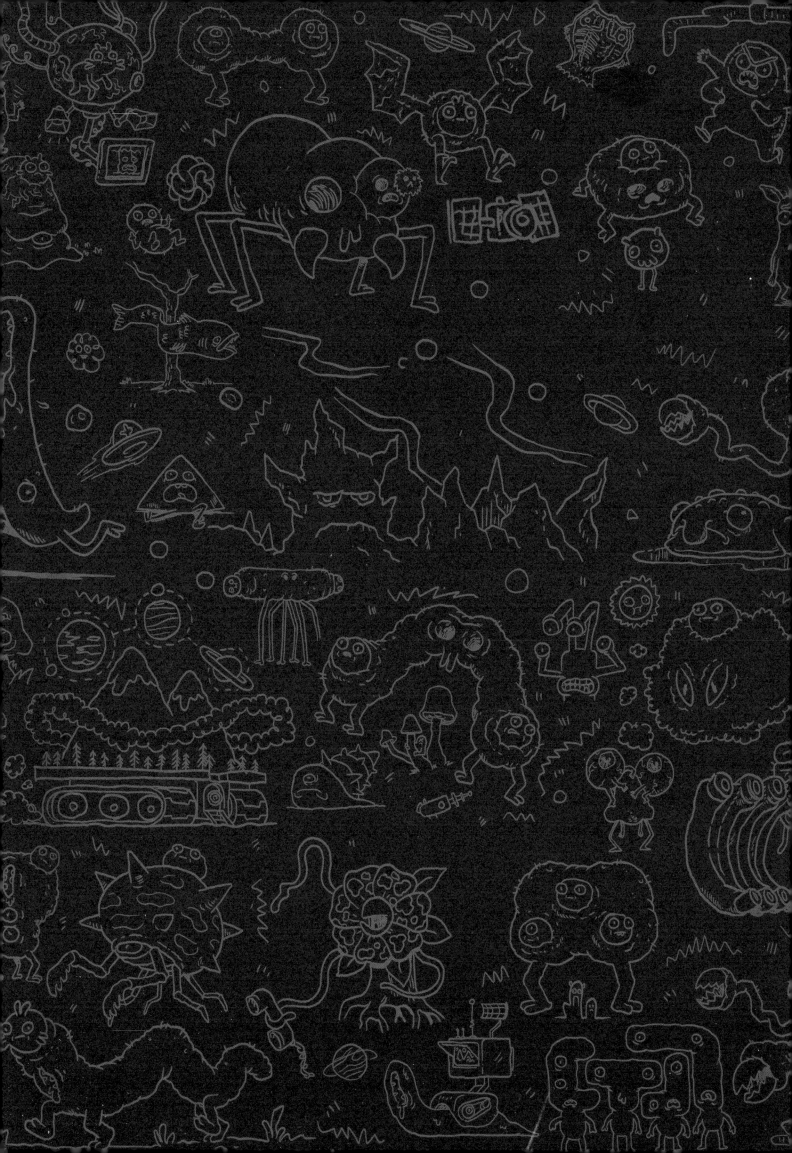